HENRI CARTIER-BRESSON / SCRAPBOOK

HENRI CARTIER-BRESSON

SCRAP BOOK

Photographs 1932–1946

Thames & Hudson

For as long as I remember, I always knew about Henri's 'scrapbook', packed up in an old suitcase that came from his mother's apartment; later he placed it half hidden in a bookcase at home away from indiscreet eyes.

From time to time he would mumble that this was his most precious object – along with the album he prepared for Jean Renoir in hopes of a job – and that I should take great care of it.

Imagine my surprise one day to find him ripping out the photos from his 'scrapbook'. For sure, the pages were disintegrating, but I shall always regret not having photographed them before they were dismantled.

I am more than delighted that Agnès Sire, director of our Foundation, decided to revive this unique album that tells us so much about Henri's choices at a very precise moment in his life – 1946 – prior to his exhibit at MoMA in New York.

Sixty years later, this selection of images remains highly relevant.

Martine Franck
President
Fondation Henri Cartier-Bresson

This book is published on the occasion of the exhibition
"Le Scrapbook d'Henri Cartier-Bresson" at the Fondation HCB, Paris,
September 21–December 23, 2006
and "Henri Cartier-Bresson's Scrapbook" at the International Center
of Photography, New York, January 19–April 29, 2007.

The Fondation HCB warmly thanks the Museum of Modern Art, New York,
and especially Peter Galassi, Suzan Kismaric and Béatrice Gross.
Our profound gratitude to Pierre Assouline, Célia Bertin, Anne Cartier-Bresson,
Marthe Cartier-Bresson, Pascale Froment, Howard Greenberg, Gilles Mora,
Magnum Photos and Gerhard Steidl.

www.henricartierbresson.org

CONTENTS

SCRAPBOOK STORIES

On 22 June 1940, the day of the Franco-German armistice, Corporal Henri Cartier-Bresson was taken prisoner at Saint-Dié in the Vosges Mountains and sent to Stalag VA, number 845. The French army had first assigned him to the infantry but he was soon transferred to the Film and Photo unit in Metz (fig. 1). On 10 February 1943, after two failed attempts, he escaped with fellow prisoner Claude Lefranc: '... hidden away in a ditch, we waited for the changing of the German sentinels to cross over the symbolic line called the border'[1]. For the rest of his life, Cartier-Bresson would define himself as an escaped prisoner: 'Nationality: escapee!'. Writer Raymond Guérin, another companion in captivity, opted not to flee with them because he did not feel up to it physically and was afraid of holding them back[2]. He later wrote of his comrade 'Cartier': '"Cadum Baby" had an enormous skull, already balding, which jutted over the blue eyes of an archangel and the pink cheeks of a chubby child... Educated by numerous voyages, widely read and discerningly expert in painting, Cadum Baby proved to be a subtle partner'[3].

The Resistance and the Liberation

Cartier-Bresson hid for three months with other escaped prisoners in Indre-et-Loire, where he made contact with the National Movement of War Prisoners and Deportees (MNPGD) and obtained false demobilization papers[4]. In Lyons, he sketched as he waited on the banks of the Rhône River. He was obsessed with the idea of retrieving his Leica, which he had buried in the Vosges before the war, and in spite of the difficulty and risks involved, he managed to do

so. While he was in the region, he met publisher and gallery owner Pierre Braun in Mulhouse. Braun wanted to launch a series of monographs on artists and writers and his suggestion that Cartier-Bresson take their portraits met with enthusiastic approval.

His hideout in Indre-et-Loire was Les Fontaines farm in Luzillé, not far from Chouzy, where his first wife, Ratna Mohini (a Javanese dancer he had married in 1937), was staying (fig. 6). But he regularly left the farm to carry out the assignment Braun had given him: he met Matisse first of all, in winter 1943, followed by Bonnard at Le Cannet in February 1944 (fig. 14) and many others. In addition, he continued to participate actively in the MNPGD (fig. 2). When he was in Paris, where he often saw Guérin, he stayed in an apartment loaned by the mother of his friend Zwoboda, whom he had met on Jean Renoir's film sets[5].

Cartier-Bresson was talking away with Braque (cf. photos 240 and 241) in his studio on 6 June 1944 when he heard the news of the Allied landing in Normandy on the BBC. He continued his comings and goings while remaining in contact with the MNPGD and connected up with General Koenig, Army Chief of Staff. In July 1944 he photographed the ruins of the village of Oradour-sur-Glane, where the Waffen-SS had massacred the civilian population a few weeks earlier (cf. photo 266).

In August, from his hideout in Indre-et-Loire, he learned that General Leclerc's troops were heading for Paris and returned to the capital by bicycle. There, he joined a group of photographers (Robert Doisneau, Robert Capa and others) preparing to 'cover' the Liberation of Paris, with

1 Letter from Claude Lefranc to Henri Cartier-Bresson, 15 January 1985. / **2** French writer (1905-1955), known for the autobiographical *L'Apprenti* (The Apprentice). He became an insurance agent in Bordeaux a few years before the war. The period of his captivity in a German camp is recounted in *Les Poulpes* (Octopuses) (Paris: Gallimard, 1953). / **3** *Les Poulpes*, pp. 280-281. 'Cadum Baby' refers to a well-known advertising image used for Cadum soap. / **4** The MNPGD (Mouvement National des Prisonniers de Guerre et des Déportés) was created on 15 March 1942. Most of its member groups were integrated into the FFI (Forces Françaises de l'Intérieur). / **5** As Guérin explains in his notebooks, published posthumously as *Retour de Barbarie* (Return from Barbary) (Paris: Editions Finitudes, 2005), Andrei Zwoboda (1910-1994) was Renoir's assistant director for *La Vie est à nous* (The People of France, 1936) and *La Règle du jeu* (The Rules of the Game, 1939). After directing a number of his own films, he switched to production.

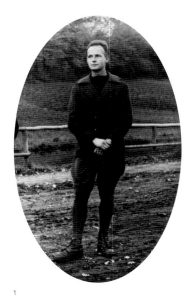

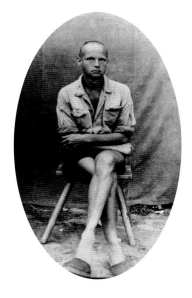

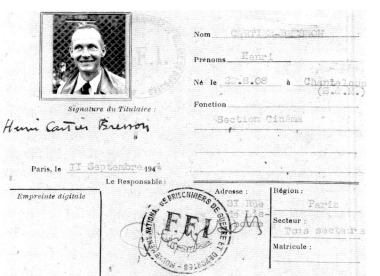

1 Henri Cartier-Bresson as a soldier in June 1940 and as a prisoner in Germany in 1942
2 FFI card issued to Henri Cartier-Bresson on 2 September 1944
3 Authorisation from the Ministry of Prisoners, Deportees and Refugees to make *Le Retour* (12 September 1944)

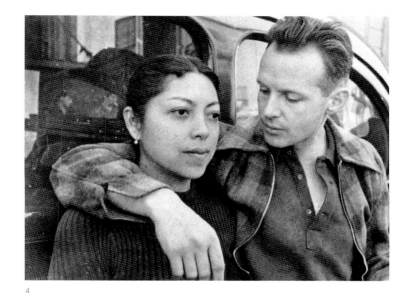

4

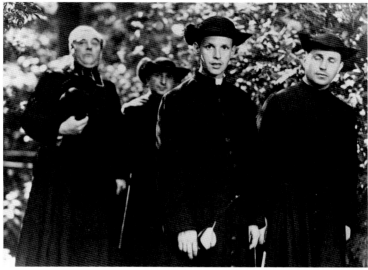

5

6

4 Henri Cartier-Bresson and Ratna Mohini, Madrid, 1936
5 Henri Cartier-Bresson during the filming of Jean Renoir's *Une partie de campagne* (A Day in the Country), 1936
6 Henri Cartier-Bresson and Ratna at Chouzy

June 15, 1945

Dear Henri Cartier:

Chim writes me that he has been talking to you about my project, now some years old, of having an exhibition of your photographs here at the Museum.

At that time, I had considerable difficulty in locating more than about thirty in good enough condition to exhibit. Nicholoas Nabokoff promised to send me his collection, but never did so. Most of the work available here, of course, dates from about 1933-34, and only through the good offices of Life have I seen any of your later work. Are there any sources, outside of Julien Levy, Life and Harpers Bazaar, where I may see other things that you have done?

I understand that the paper shortage is even more acute in Europe than it is here, and that it would probably not be possible for you to make new prints for some time to come.

Our own program here at the Museum will probably not permit such an exhibition to be scheduled for over a year, but I should like to start thinking about it now.

Is there any possibility of your coming to America? Do let me have news of you.

 Faithfully,

M. Henri Cartier-Bresson
31, rue de Lisbon
Paris, France

NN:vh

Please return

7 Letter from Nancy Newhall to Henri Cartier-Bresson, 15 June 1945

bicycle in hand 'so it wouldn't get stolen'. On 1 September 1944, he was with Capa at the Hotel Scribe and a week later, he obtained the authorisation to make a film (fig. 3) on the return of the prisoners[6].

The posthumous exhibition

It was at this point that he learned from David 'Chim' Seymour (fig. 10) that the Museum of Modern Art in New York had been trying to organise an exhibition of his work for several years[7]. Convinced that he had died in captivity, Nancy and Beaumont Newhall (fig. 26) had already sought out existing prints in the United States with the idea of organising a posthumous exhibition8. Indeed, in a long letter written in 1942 on Warner Brothers Pictures stationery and addressed to Nancy Newhall, Jay Leyda lists the prints which were to his knowledge available and indicates people likely to have additional information, such as photographers Helen Levitt or Walker Evans, whom Cartier-Bresson had met during his first stay in New York in 1935[9]. This episode is recounted with humour in an article by Dorothy Norman which appeared in the *New York Post* on 26 August 1946 (fig. 9).

Preparations

In a 15 June 1945 letter to Cartier-Bresson (fig. 7), Nancy Newhall mentions her conversation with Chim about the project; the biggest problem would seem to have been the shortage of photographic paper, which made the preparation of the exhibit extremely complicated. At this time, Cartier-Bresson was working on the film *Le Retour* (The Return) for the OWI[10].

All the correspondence of Nancy and Beaumont Newhall with Cartier-Bresson has been carefully preserved in the museum's archives. This documentation permits an accurate reconstitution of Cartier-Bresson's *Scrapbook* – and the exhibition itself, which was to be crucial for his subsequent career. On 22 August 1945, two months after Nancy Newhall's initial letter, and on Cartier-Bresson's thirty-seventh birthday, he wrote back with enthusiasm (fig. 8). Apologising for his late reply, he explained that the film was taking up all his time; according to his co-director, Lieutenant Richard Banks, he spent long hours working on it from April to November of that year[11].

Beaumont Newhall was still on active duty in the US Army, which explains why his wife, Nancy, was initially the only contact for the preparations. Her essential task was to send him the photo paper he needed to make the final prints for the exhibition. In December 1945, Beaumont Newhall was demobilised from the Air Corps and promptly wrote to Cartier-Bresson to express his tremendous interest in the project (fig. 13). In this letter, he proposes a date (autumn 1946) and an order of magnitude (about 75 photos) for the exhibit.

At that stage, the idea was to track down all the existing photos in order to show them along with the prints Cartier-Bresson would make in Paris (fig. 11). But obviously, the museum's Board of Directors would have to approve the idea of an exhibit: 'I anticipate that the proposed exhibition will meet with the entire approval of the board, but unfortunately I am not in the position to make the decision. I feel it is a vital contribution to photography' Newhall writes him on 18 December. In a second letter, dated 27 December, he announces that the exhibit had been approved and expresses the hope to see Cartier-Bresson rapidly in New

6 Hungarian-born Robert Capa (1913-1954), whose real name was Andre Friedman, became a photographer and journalist in Paris. He covered the Spanish Civil War (1936) and the Sino-Japanese War (1938) and landed in Normandy on D-Day, 6 June 1944. He was killed during the Indochina War. / 7 David Seymour (1911-1956), known as 'Chim', was a Polish-born photojournalist who covered the Spanish Civil War in 1936. After emigrating to the United States in 1939, he served as a photographer in the US Army. He was killed during a reportage on the Suez War. / 8 Beaumont Newhall (1908-1993), photographer, curator and, above all, photo historian, was the founding director of the Museum of Modern Art's Department of Photography in 1937. He later became director of George Eastman House. He was the author of numerous books, catalogues, and articles, including his classic *History of Photography*, originally written in 1937. Nancy Newhall (1908-1974) was a photography critic, editor and conservationist. She served as Acting Curator of Photography at The Museum of Modern Art from 1942 to 1945. / 9 Jay Leyda (1910-1988), photographer and filmmaker in his youth, became known as an outstanding film scholar for his work on Soviet cinema – and in particular director Sergei Eisenstein. He was assistant curator at the Museum of Modern Art from 1936 to 1940. / 10 The US Office of War Information (OWI) was set up during the Second World War (1942) to reinforce government information services. It was responsible for co-ordinating the distribution of news about the war in the United States as well as an information and propaganda campaign abroad. / 11 Banks was a US Army officer based in Paris.

31 Rue de Lisbonne
Paris, France
August 22, 1945

Dear Miss Newhall,

It was a surprise and a pleasure to hear from you again. You must know that there are many problems today, otherwise I should have answered sooner.

I am deeply interested in your proposal for an exhibition of my photographs. I do have new work to show. However, as you realize, the paper situation here, both now and for the future, is bad. There is a shortage and the paper obtainable is of very poor quality. If you could possibly arrange it, I think that only print paper from the States would guarantee the exhibition in which you are interested.

How many pictures would you suggest? Many of my recent things have been complete picture stories. I feel that these, with the addition of certain individual prints, plus a half dozen or so of the older pictures, previously shown, could make up a show. Most of the pictures will be 24 x 30 centimeters, a few 18x 24, double weight, mat finish. Regarding picture matts, I would prefer plain white ingrain board, as I am very anxious that there be no distraction due to a grained surface or yellowish cast to the matts.

On the assumption that 75 photographs will meet your planned needs I wonder if you could send me the following amount of paper, in size and quality indicated. I give this figure of 75 merely as an example, not as a suggestion.

Kodabromide semi mat. E	Size 24 x 30 -- *11 X 14*	50	sheets of	soft	E 1	½ gr. 7.43	
	10 x 12	280	"	normal	2	2 gr 26.78	
		100	"	hard	3	1 gr. 13.39	
		50	"	extra hard	4	½ gr 7.43	55.08
	Size 18 x 24 -- *8 X 10*	25	"	soft	1	½ gr. 3.97	
	7½ — 10	100	"	normal	2	1 gr 7.02	
		50	"	hard	3	½ gr 3.97	
		25	"	extra hard	4	½ gr 3.97	18.93
							73.96

Of course, I shall defray the expenses of paper and shipment.

As my other commitments take up a great deal of my time I would like to start preparation of the exhibition prints right away. May I urge you, therefore, to send any portion of the paper as soon as possible.

Thank you very much for your interest in my work and I trust sending the necessary supplies will not cause you too much inconvenience.

Sincerely,

Henri Cartier-Bresson

Henri Cartier Bresson

Ex. Contingencies — Cartier please return

Miss Nancy Newhall
Museum of Modern Art
New York, U. S. A.

8

A Visitor Falls in Love—With Hudson and East Rivers

By DOROTHY NORMAN

Rumor had it that France's most talented young photographer, Henri Cartier-Bresson, had been killed in action in Africa. So New York City's Museum of Modern Art planned a posthumous show of his touchingly lovely photographs.

Fortunately the rumor was false. He is very much alive.

Now the museum is planning to proceed with its exhibition of his photographs, at any rate—to begin in November. Cartier-Bresson himself is safely in America, recently arrived here from France, busily making prints for the proposed show.

"Everyone has his own little story from the war," he says modestly, shy about commenting on his harrowing experiences.

Like so many young Frenchmen, he was captured by the Germans just before the time of the French Armistice, was held in prison camps for some 35 months (escaping three times) and worked in the organized illegal movement of prisoners, after escaping "successfully." He helped to develop resistance activities in motion pictures and photography, and our own OWI had the good sense to see that "Le Retour"—our film about the tragic homecoming of French prisoners and displaced persons of every variety—had his help.

Back in Paris before the Germans were forced out, one of his main tasks was to organize—with friends—the underground movement of news photographers.

Attacked North Africa With a Brownie

Born in the country near Paris in 1908, Cartier-Bresson developed an early interest in both painting and literature. Headed for a business career, he decided instead to become a painter. He attended Cambridge, continued to study painting, completed his military service, and then went to the West Coast of Africa, where he first began to photograph. At that time he used a Brownie box camera which, he concedes, "is an excellent camera, too."

The climate of Africa made it impossible to photograph with any consistency: his camera became filled with moisture, and he himself contracted fever. It was only after his return that he acquired a Leica camera and became more absorbed in photography than in painting—although

he has never completely deserted the latter.

He subsequently photographed in France, Poland, Spain, Italy, Greece, Morocco, Mexico, England, America. His interest in movies developed in 1936, when he worked as assistant director with Jean Renoir, France's great film director; the war intensified his interest in the documentary film.

Did his wartime and resistance experience have any marked effect on his own style of photographing, and on his approach to photography? "Most certainly," he states. "I became increasingly less interested in what one might call an 'abstract' approach to photography. Not only did I become more and more interested in human and plastic values, but I believe I can say that a new spirit arose among photographers in general; in their relationships not only to people, but to one another."

Has it not been difficult to get photographic materials in France? "You cannot imagine the difficulties," he admits. "There were so few chemicals. Flash bulbs cost 100 francs. Paper was strictly rationed. Electricity would be cut off without warning right up until this spring. Paper was not only scarce but of bad quality. And don't think it is any better now. Paper is still scarce. There is still little film to be had. I could not possibly have gotten my exhibition ready had I not been able to come here."

"Must Be Relationship Between Eye and Heart"

As for his own photographic creed, he finds it most important that "in whatever one does, there must be a relationship between the eye and the heart. One must come to one's subject in a pure spirit. One must be strict with oneself. There must be time for contemplation, for reflection about the world and the people about one. If one photographs people it is their inner look that must be reflected. One must reveal what goes on inside them, as

well as their relation to the outer world.

"As I photograph with my little Leica," he says, "I have the feeling that there is something so right about it: with the one eye that is closed one looks within. With the other eye that is open one looks without; one sees the shapes, the living quality of what moves one to photograph. Without passion, without working with the emotion of the heart and the enjoyment of the eye, nothing vital can be put down.

"Yes, one is preoccupied with technique, but even more impor-

tant, with style. You can tell the pictures of a good photographer by his style. You can copy a man's technique, but his style is something else. There can be no standardized way of working."

What American photographers does he like? "Alfred Stieglitz was of course the father of all of us—and each of us needs a father. I admire Steichen also, and I like Weston and Walker Evans and many others of the younger generation too; also the anonymous photographs exhibited in Paris after the liberation, sent over by your Army and OWI;

those photographs meant a great deal to us in France. Many things here I admire."

He is convinced that "there is great eagerness in France for further contact with America. It is not enough for us to receive your magazines with reproductions of photographs. It would be exceedingly important for America to send originals of the work of her best photographers to Europe."

Fortunately for America, itself, Cartier-Bresson's exquisite and talented Javanese wife, Ratna Mohini, is here with him. (She plans to lecture and give dance recitals in our colleges and theatres.)

At the moment, Cartier-Bresson is finding New York enormously rich to photograph, having fallen in love particularly with the Hudson and East Rivers. In collaboration with Alfred Kazin, he has been photographing "The Brooklyn Bridge" for Harper's Bazaar (a magazine that has had the good judgement to use his photographs often).

In fact, as you walk along the streets of New York you may see him any day now, modestly putting down our inner life, how we really look and feel, in photographs that must themselves live because they are so deeply felt.

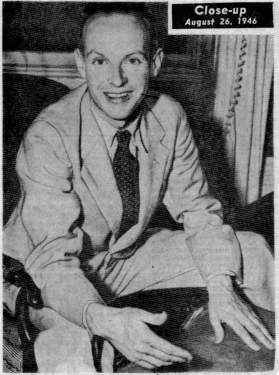

Close-up
August 26, 1946

BACK FROM the dead with a camera.

NEW YORK POST, MONDAY, AUGUST 26, 1946

9

10

THE MUSEUM OF MODERN ART

Date October 3, 1945

To: Mrs. Newhall **Re:** Cartier-Bresson

From: Mr. Wheeler

Dear Nancy,

I approved the purchase of photographic paper for Cartier-Bresson. In writing to him I hope you will ask him to make perfect prints rather than rough ones, because I think the trouble and expense of a new series should be avoided. Therefore, I think, we should send him paper that can be used for prints of exhibition quality.

MW

11

WESTERN UNION

1207

A. N. WILLIAMS
PRESIDENT

CHECK

ACCOUNTING INFORMATION

TIME FILED

Send the following telegram, subject to the terms on back hereof, which are hereby agreed to
(PLEASE PRINT NAME AND ADDRESS)

3 JAN 1946 19__

To HENRI CARTIER-BRESSON

Care of or Apt. No. 31 RUE DE LISBONNE

Street and No. PARIS

FOR VICTORY
BUY
WAR BONDS
TODAY

Place

EXHIBITION APPROVED XXXX SENDING PAPER

NEWHALL

CARTIER BRESSON EXHIBITION

Sender's name and address
(For reference only)

Sender's telephone
number

12

M. Henri Cartier-Bresson
31 Rue de Lisbonne
Paris, France:

Dear M. Cartier-Bresson,

 I have your letter of 24 October addressed to my wife.
I have been released from the Air Corps and have returned to the Museum. One of
the most interesting projects which I found was the proposed exhibition of your work,
and I am very happy to carry on the plans.

 It is our hope that we shall be able to schedule the
exhibition in the autumn of 1946. We wish to have adequate space and our program
does not offer an earlier opportunity. As to the number which we should hang, I
should think that 75 would be a good figure to aim at. Obviously it is difficult for
us to make any definite plans because we are not familiar with your recent work.
It would be of great assistance to us if you could send on a certain number of finished
prints as soon as possible, because we shall want to take up the proposal with the
authorities here in order to make definite plans, and obviously it will be most ad-
vantageous to have some samples of your recent work to present together with the few
earlier prints which we own. I hope that some of the paper has reached you. We are
having considerable difficulty in getting hold of paper, but with patience we shall
succeed in filling your needs.

 Both Mrs Newhall and I are very happy to learn that you
propose a trip to America and we look forward to meeting you very much. As soon as
we are able to make more definite plans I shall let you know.

 Yours sincerely,

 Beaumont Newhall, Curator of Photography

13

13 Letter from Beaumont Newhall to Henri Cartier-Bresson, December 1945

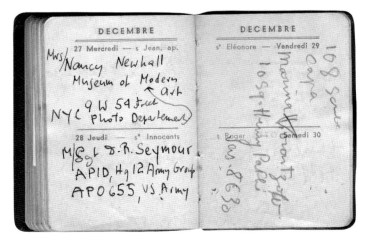

14

14 Henri Cartier-Bresson's pocket diary for 1944, where he noted his appointments with Bonnard, Matisse, Capa etc.

31 rue de Lisbonne Feb 18th

yrs - please return

Cher Monsieur

Merci infiniment de votre lettre du 5 fev. et du papier que j'ai bien reçu hier! I am very glad of what you are telling me about the date of the exhibit and of the way you are planning it. I am most interested of what you say about "the approach". I feel too that the approach is the primely thing in photography and not stunts and gadgets, — well it will be so pleasant to talk about all this with you. We plan sailing April 15th.

I have written to Mrs Crosby what you told me about the circulating exhibition.

I want to thank you for all the trouble you took for the paper, I don't need any more till we have selected them in NY.

I have written to tell Miss Barry how nice it is of her to show our picture "Le Retour" at the Museum in it's full version — 3 reels. I think it will touch the American audience as it did the French.

Are they any things you'd like me to bring you from France?

A bientôt
Bien cordialement à vous
Henri Cartier Bresson

15

apr. 25

Dear Mr. Newhall

Just a line to let you know that we are sailing on the Oregon on the 5. I think it's due in NY on the 15th may. — I have printed all my pictures in 9 x 12 cm it should make our selection easier.

Je me réjouis de vous voir bientôt

Bien à vous
Cartier

16

15 Letter from Henri Cartier-Bresson to Beaumont Newhall, 18 February 1946
16 Letter from Henri Cartier-Bresson to Beaumont Newhall, 25 April 1946

York in order to finalise the preparations and make the prints in what he describes as the museum's 'well-equipped darkroom'.

This letter was followed by a telegram on 3 January 1946, probably intended to speed up the news (fig. 12). The mail was not working well and exchanges could be extremely slow. Nonetheless, Cartier-Bresson's contacts with the US Army helped him a great deal in this operation: 'Cartier now making small prints under great difficulties. Electric current variable and turned off most of the time, no heat, material poor and source and so on. . .' Lieutenant Banks wrote to Nancy Newhall in January 1946.

In his 21 January 1946 reply to the telegram, Cartier-Bresson indicates that, in view of the first set of prints he now has before him, he thinks the exhibition could include between 150 and 200 photos (in the end, there were 163)[12]. Numerous letters back and forth attest to the difficulties concerning the photographic paper, which, after many efforts, including the use of the diplomatic pouch and the US Army's entire information network (thanks to Banks), were finally resolved.

The time had now come to give the exhibition its form. 'I think we can make together a new type of exhibition, this museum is most interested in pioneering in new fields, we are ready for experimentation,' Beaumont Newhall wrote on 5 February 1946. In this same letter, Cartier-Bresson also learned that the museum's Department of Film (which had been set up on the model of the Film Society initiated by his dealer Julien Levy) had decided to program his film, *Le Retour*, on the evening of the exhibition opening (fig. 17).

Cartier-Bresson went about selecting and printing his photos while continuing to make portraits. On 18 February 1946 (fig. 15), he wrote that he was getting ready to take the boat for New York on 15 April with his wife Ratna, known as 'Eli' (fig. 4). But another brief note (fig. 16) then indicates that they would only be leaving on 5 May, on the *Oregon*, and that they would arrive around the 15th. 'I have printed all my pictures in 9 x 12 cm,' he writes at the end.

In the meantime, however, in a letter dated 29 March 1946 which Cartier-Bresson would not receive before his departure, Beaumont Newhall writes that he has resigned from the museum and that the director of exhibitions, Monroe Wheeler, who will be taking over the project, is now his contact. 'I am most anxious that your exhibition here should be the outstanding one which your work deserves,' he adds.

In mid-May, Henri and Ratna Cartier-Bresson landed in New York. A photo taken by Cartier-Bresson many years later, in 1959, perfectly captures the joyous expectations of this arrival (fig. 18). The trip offered enormous hope to a 38-year-old man who no longer wanted to make films, who had lived through the war in Europe and who still did not know what his future held in store.

New York

On his arrival in New York, Cartier-Bresson bought the large *Scrapbook* (cf. p. 5) into which he was to glue his photos one by one in order to show them in a more convincing way. Since there was not enough space in the album, certain images were to remain loose at the end.

Jimmy Dugan, whom Cartier-Bresson had met in Paris through Paul Éluard, housed the couple in an apartment on Manhattan's east side, around 58th St. near the Queensboro Bridge. Nicole Cartier-Bresson later joined them there, as did Claude Roy[13]. They also stayed with Dorothy Norman (fig. 9), a writer and photographer close to Alfred Stieglitz.

12 Letter from Cartier-Bresson to Beaumont Newhall. / **13** Nicole Cartier-Bresson (1924-1989), Henri's youngest sister, was a poet. Raymond Guérin indicates that she was introduced to the respected writer and critic Jean Paulhan, who found her work quite promising and encouraged her to keep writing (*Retour de Barbarie*). Claude Roy (1915-1997), writer and poet. Taken prisoner during war in 1940, he escaped and began writing poems. He became a war correspondent and joined the Communist Party (which he left in 1957, after the Hungarian Uprising). In 1985 he received the first Goncourt Prize for poetry.

AN EXHIBITION OF
PHOTOGRAPHS BY

HENRI CARTIER-BRESSON

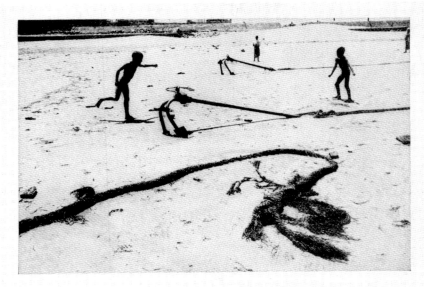

THE MUSEUM OF MODERN ART REQUESTS THE
HONOR OF YOUR PRESENCE AT THE PRIVATE
OPENING, TUESDAY, FEBRUARY 4, 1947.
11 WEST 53 ST. NEW YORK, 8 TO 11 P. M.
THE EXHIBITION WILL CLOSE APRIL 6.
THIS INVITATION ADMITS TWO PERSONS

17

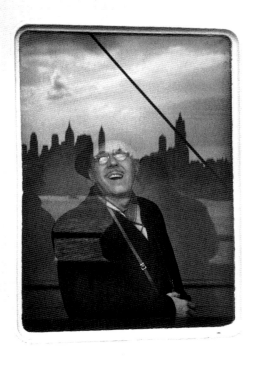

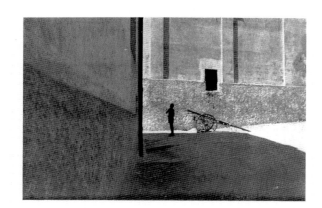

THE PHOTOGRAPHS OF

HENRI CARTIER-BRESSON

THE MUSEUM OF MODERN ART

18 19

17 Invitation card for the Museum of Modern Art exhibition
18 A transatlantic liner arriving in the harbour, New York, 1959
19 Cover of the Museum of Modern Art catalogue, 1947

The only address Cartier-Bresson gave out, however, was that of *Harper's Bazaar*. Before he left Paris, the museum had looked for possible sources of income, a few commissions which would help him to get by. Thus, Lieutenant Banks, the faithful partner from *Le Retour*, reported to Nancy Newhall: 'Henri Cartier-Bresson has usual resistance and dislike of assignments. He would like to do something he really feels on America while here' (24 January 1946). Alexey Brodovitch and Carmel Snow were the mainstays of *Harper's Bazaar*, which won Cartier-Bresson over with its layout, and both of them believed a great deal in this up-and-coming photographer.

During the summer, he went to New Orleans on assignment for *Harper's Bazaar* with a young writer named Truman Capote, then 22 years old. Years later, in his book *Dogs Bark: Public People and Private Places*, Capote was to describe Cartier-Bresson as follows: 'Cartier-Bresson is another *tasse de thé* entirely – self-sufficient to a fault. I remember once watching Bresson at work on a street in New Orleans – dancing along the pavement like an agitated dragonfly, three Leicas swinging from straps around his neck, a fourth one hugged to his eye: click-click-click (the camera seems a part of his own body), clicking away with a joyous intensity, a religious absorption. Nervous and merry and dedicated, Bresson is an artistic "loner", a bit of a fanatic'[14].

This trip gave Cartier-Bresson the desire to do a book like Walker Evans and James Agee's *Now Let Us Praise Famous Men*, published in 1941[15]. A selection of the New Orleans photos were shown at The Museum of Modern Art, along with certain images from his stay in New York. They do not appear in the *Scrapbook*, however, because they did not yet exist when Cartier-Bresson was making the prints in Paris. The museum's archives contain several good photographs of the exhibition but they unfortunately do not show all the works included (fig. 25). From the very precise lists of the content, we know that there were fifteen prints of New Orleans, six of New York (the San Gennaro festival), six of Brooklyn and two portraits, one of Steichen and the other of Stieglitz[16].

Chim (see note 7), whom Cartier-Bresson had met in 1933 in Montparnasse and with whom he worked at the communist daily *Ce soir*, offered to help him print the photos (cf. the letter of 18 December 1945 where Newhall speaks of Lieutenant Seymour who thought it preferable to make the exhibition prints in New York with his assistance). The exhibition included 30 x 40 cm and 40 x 50 cm prints mounted on wood, plus a few 'giant' enlargements. A second set, made for the three-year tour organised by the museum, included only a hundred photographs. These prints came back to the museum on 27 June 1949, after twelve presentations throughout the United States[17].

During an exhibition, the museum generally had the right to sell prints to collectors with the photographer's authorisation. Among the papers in the archives, there are three invoices counter-signed by Cartier-Bresson and mentioning the prints sold. The prices were $60 for a mounted 30 x 40 cm print, $75 for a mounted 40 x 50 cm print and $100 for a selection of images which were already more sought after. There is also an internal museum note asking Cartier-Bresson to make a selection for the museum collection 'while he's here', because it seemed clear that the exhibition prints would come back damaged (19 prints were to be ordered for the collection).

14 *Dogs Bark: Public People and Private Places* (New York: Random House, 1973), p. 391. Capote evokes Cartier-Bresson in contrast to Cecil Beaton. / **15** Cartier-Bresson was to accomplish at least one part of his dream in April 1947, after the exhibition, when he set out with John Malcolm Brinnin, a recognised young poet, with whom he covered some 20,000 km. The projected book did not come into being, but years later, Cartier-Bresson was to publish *America in Passing*, with an introduction by Gilles Mora (New York: Bulfinch Press/Little, Brown & Company, 1991). / **16** Edward Steichen (1879-1973), who came to the US from Luxembourg as a child, worked as a photographer for *Vanity Fair* and *Vogue* before becoming director of the photography department at The Museum of Modern Art. In 1955, he organised the exhibition 'The Family of Man'. Cartier-Bresson took the portrait of Alfred Stieglitz (1864-1946) the first time they met. Stieglitz died a month later. / **17** A 27 June 1947 letter from V. Pearson of the museum's photography department signals the return of the exhibition and notes that 'the condition of the photographs is generally good.'

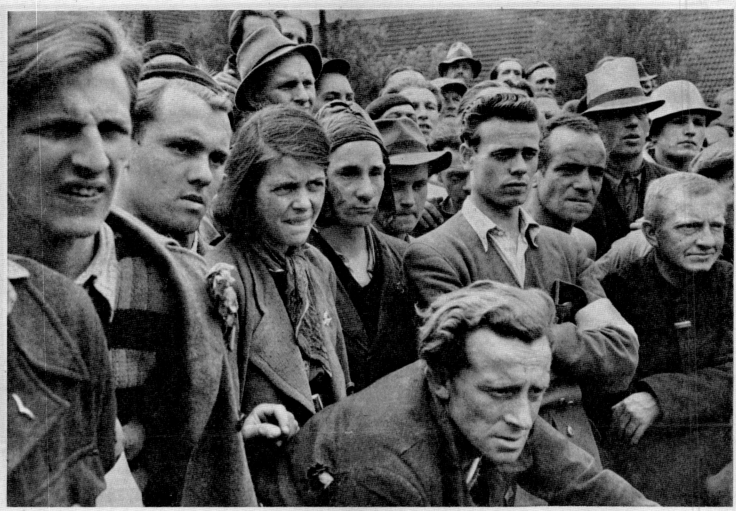

HATE—French D. P.s watch the interrogation of a one-time Gestapo informer found in their midst.

Artist With a Camera

Henri Cartier-Bresson portrays, in the faces of the world's peoples, a history of our time.

By LINCOLN KIRSTEIN

THE photographs of Henri Cartier-Bresson, which go on exhibition at the Museum of Modern Art this Tuesday, have a triple interest. Primarily, they are pictures of human incidents caught during a historical epoch (roughly the last decade), which are so intensely observed and masterfully photographed that they can serve among the chief pictorial symbols of their time. Secondarily, they are beautiful pictures, artfully seized, composed with shrewd characterization—not only in the arrangement of faces, of light, or the balance of elements within a frame, but also in their entire technical formula. It is clear that a skillful, informed and highly intelligent eye first saw them. Finally, they stimulate, in their impersonal, disciplined integrity, a number of important considerations on the past, present and future uses of photography.

Cartier-Bresson knows well most of Europe and a great part of North America. His series documenting New Orleans, the

LINCOLN KIRSTEIN, best known for his interest in ballet, is also active in several other fields of art. In Paris during the war he met Henri Cartier-Bresson and later arranged the special showing at the Museum of Modern Art.

Bowery and Mexico have a revelatory completeness and a marked quality of surprise. How can one still find something new in such familiar scenes? His patient lens lies in wait among sights made almost invisible by their banality. Then, in the endless sequence of events, some new combination occurs—in the way a man shoots across a puddle on his bicycle or in the lift of a chin or the shift of a shawl. Sometimes this gives a new meaning and Cartier-Bresson catches it.

He was in Spain during the civil war and made a film of Loyalist hospitals in Valencia, Madrid and Barcelona. In 1940, as a French soldier, he was captured by the Germans, escaped,

Henri Cartier-Bresson.

twice more was captured and escaped, spent the last part of the war hiding in the Vosges. After the Liberation he made for the OWI a film of the return of French prisoners from Germany to France, which is one of the most deeply moving human documents to come out of the war. His still-photographs are by no means fragments cut out of a film. Yet they have their cinematic drama, a sharpness and —particularly in the scenes of the denunciation of informers at Dessau—an almost classic ferocity.

His pictures presuppose a painter's knowledge of the craft of composition, of texture and light. This is not surprising, for Cartier-Bresson was

trained as a painter and still paints. He composes his pictures within the frame of his lens and does not crop his image after the picture is developed. That is, his first choice in the arrangement of a given subject is his last. But these plastic considerations are left aside at the instant of shooting to permit the significance and emotion in the subject to take their proper importance.

PERHAPS the most remarkable thing about these photographs is the attitude they reflect toward the camera as a medium. On the one hand, contemporary photography is often indiscriminate journalism—pictures flatly seen and shot by routine. On the other, there has been a great overemphasis on purely esthetic ends —the exaggeration of surface textures, the blowing up of trick shots, the dependence on technique for the sake of technique.

Cartier-Bresson is a responsible artist, responsible to his craft (and his art, for there is no question that his pictures have their value as good art) and to his society. As an artist working in our time he has managed to be in places where history was being made. He has taken pictures which are permanent records of this history, which help us to remember more vividly what has happened, to see more clearly what is happening.

THE NEW YORK TIMES

12

The catalogue

A small catalogue was published, with texts by Lincoln Kirstein and Beaumont Newhall introducing the forty-two photographs reproduced[18] (fig. 19). A 'new version', printed in France by Draeger, was published in 1963[19]. It was Cartier-Bresson's first book.

In his 1947 catalogue essay, entitled 'Documentary Humanism', Kirstein quickly skims over what was then the short history of photography to show just how much the new medium, far from marking the 'end' of painting, in fact drew its strength from the older one through the study of composition. For him, Cartier-Bresson was the one who 'has taken a sequence of trial shots, dancing about his subject on tip toe, like a boxer or fencer, until he chooses the ultimate frame and instance, then traps it in time'. And he adds, 'But the more he effaces himself . . . the more his pictures sign themselves. For his sight, divested of superficial prejudice or preference, focusing itself on what is most essential in his subject also reflects what is most essential in himself'[20].

This was first serious analysis of Cartier-Bresson's work, for which he always remained grateful. From Africa to the portrait, Kirstein traced a very precise history of these fifteen years of photography ('he never loses himself in mere nostalgic strangeness') which clearly brings out the specific nature of his talent: 'Cartier-Bresson's best shots could not have been drawn or painted, but only photographed'[21].

Beaumont Newhall, who also contributed to the catalogue in spite of his departure from the museum, addressed Cartier-Bresson's photographic technique which, he wrote, was developed 'to the point of almost instinctive reaction'. As for the quality of the prints, 'he alone is able to recreate the tonal values which he visualised at the time of the exposure'[22]. Indeed, at that time, Cartier-Bresson printed his own photos; it was only later that he entrusted the printing to Pierre Gassman, who perfectly understood what he wanted[23].

The exhibition ran from 4 February to 6 April 1947. The film *Le Retour* (see below, note 38) was screened twice on the evening of the opening. The new head of the photography department, Edward Steichen, was not involved in the exhibit, which was inaugurated by Monroe Wheeler (fig. 24).

The press reported the event with enthusiasm. Cartier-Bresson was hailed as an 'artist-historian'[24]. His freedom of movement, the sharpness of his eye and his slight attention to technique fascinated the Americans (fig. 20).

The founding of Magnum

This was the time when friendships were renewed, when Cartier-Bresson caught up again with Robert Capa and David Seymour and the plans for a photographers' co-operative evoked before the war re-emerged. 'I became a professional photographer in 1946,' recalled Cartier-Bresson years later. 'Before, I was doing photography but I didn't know what I was going to be doing'[25].

In the course of their many conversations, Capa had told Cartier-Bresson, 'Watch out for labels! They are reassuring. But they're going to stick you with one you won't get rid of: that of a little Surrealist photographer. You're going to be lost, you'll become precious and mannered.' And, he added, 'Take the label of photojournalist instead and keep the rest tucked away in your little heart'[26].

They founded Magnum Photos during a meeting in the museum's penthouse restaurant, basking in the success of the Cartier-Bresson exhibit. William Vandivert, who initially joined them, did not stay. The certificate of incorporation for Magnum Photos was officially filed on

18 *The Photographs of Henri Cartier-Bresson*. Texts by Lincoln Kirstein and Beaumont Newhall (New York: The Museum of Modern Art, 1947). Lincoln Kirstein (1907-1996) co-founded the School of American Ballet with Georges Balanchine in 1934; in 1948 they created the New York City Ballet. He had also been one of the founders of the Harvard Society for Contemporary Arts, a forerunner of The Museum of Modern Art. He was the author of over 500 works in various fields, including criticism, poetry, novels and essays. / 19 *Photographs by Cartier-Bresson*. With introductions by Lincoln Kirstein and Beaumont Newhall. (New York: Grossman Publishers, 1963). / 20 *The Photographs of Henri Cartier-Bresson*, pp. 9, 10-11. / 21 *Ibid.*, pp. 9, 11. / 22 *Ibid.*, p. 14. / 23 In 1950, Pierre Gassman (1914-2004) founded Picto (short for 'Pictorial Service'), the first professional photo lab, which was used notably by Robert Capa, David Seymour, William Klein and Josef Koudelka. Cartier-Bresson had met him in Montparnasse during the 1930s. / 24 'Such photographers as Cartier-Bresson are true historians because they are true artists', *Tomorrow* (May 1947). / 25 'Henri Cartier-Bresson à la question: entretien avec HCB en Arles,' interview with Alain Desvergnes, *Photo* no. 144 (September 1979). / 26 Henri Cartier-Bresson citing Robert Capa, 'HCB, Gilles Mora: Conversation', in Gilles Mora, ed. *Henri Cartier-Bresson*, special issue of *Les Cahiers de la Photographie* no. 18 (January 1986), p. 122.

21

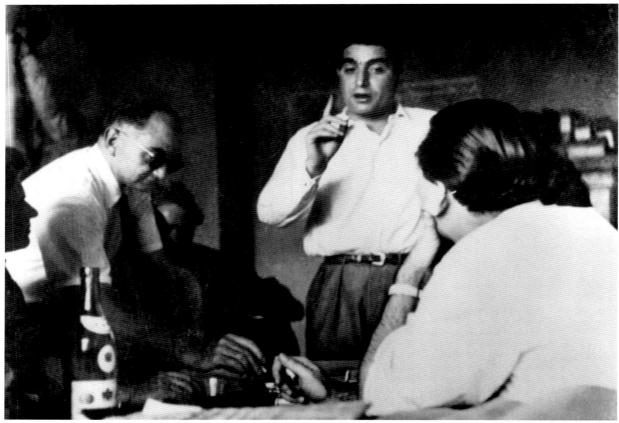

22

21 Henri Cartier-Bresson, Robert Capa and David 'Chim' Seymour among others, celebrating the Liberation of Paris, 27 August 1944
22 Robert Capa and 'Chim' at Magnum's Paris office, 1947

22 May 1947, when Cartier-Bresson travelled to the United States with John Malcolm Brinnin[27]. 'As a co-founder of Magnum, Henri Cartier-Bresson was now a full-time professional. One day, perhaps, he might abandon the business and become an artist again,' observes his biographer, Pierre Assouline (fig.22) [28].

The new associates 'divided up' the world: Europe for Capa and Chim, Africa for George Rodger (who had joined now them) and Asia for Cartier-Bresson, who was quite attracted by his wife's native region. In late August 1947, just after independence was declared, the couple left for India on a freighter.

This was the beginning of a new chapter in Cartier-Bresson's life: the Magnum co-operative would take care of distributing his photos. Although he led a very nomadic life during this period, he did not lose his *Scrapbook*, which was to hibernate on a shelf in his Paris apartment until the late 1980s. Because of the poor quality of the paper, the yellowed pages of the album were seriously damaged, and the wear and tear on the edges had effaced the numbers of the negatives originally noted there.

The rediscovery

It is not known whether the *Scrapbook* accompanied Cartier-Bresson to Asia or was stored somewhere in New York, but some forty years after its creation, it suddenly reappeared and there was an urgent need to 'do something with it'. Cartier-Bresson asked his assistant to detach the prints carefully from the album sheets and place them in protective envelopes. Unfortunately, these pages were not photographed before they were dismantled; the seven (13 recto-verso) which remain intact are all reproduced here. In fact, it was photographer Martine Franck (Cartier-Bresson's wife since 1970) who realised, when the photographs were being unglued, that it was necessary to keep a trace of the original mounted sheets and advised him to stop the process. The 346 prints from the *Scrapbook* are now part of the Fondation Henri Cartier-Bresson collection[29]. The unglued prints have all been mounted and carefully restored.

The missing photographs

As our research progressed, it became increasingly clear that certain prints were missing, since the images exhibited at The Museum of Modern Art must have been part of the *Scrapbook*. Cartier-Bresson gave some of them away, as was the case, for example, with the two prints loaned for this exhibition by Howard Greenberg (who acquired them from Steichen's wife). Others have not yet been rediscovered, however, and where the comparison of the photographs of the museum installation (fig. 25) and the very detailed list of the images on show clearly establishes the absence of certain photos, we have had new prints made to replace them, while hoping that the originals will reappear some day. Only a small number of the photos are involved – some fifteen prints – but an exact representation of Cartier-Bresson's personal choice is essential[30].

Certain major images do not appear in the album, such as the famous photo of two nude women entwined on a bed in Mexico (fig. 23), 'the spider of love' in the words of André Pieyre de Mandiargues.[31] This photo, which had been exhibited at Julien Levy's gallery, was part of the so-called Renoir album and had been sold to collectors by Levy[32]. In the correspondence from 1942, when Nancy Newhall started looking for existing prints for the 'posthumous' exhibition, there are three different mentions of an 'indecent' image, including in Stieglitz's collection. This can only be the two nude women, which Cartier-Bresson, quite familiar with American Puritanism, would not have included in his selection to avoid the risk of shocking his viewers.

27 John Malcolm Brinnin (1916-1999) was an American critic, biographer and poet. / **28** Pierre Assouline, *Henri Cartier-Bresson, The Biography*, translated by David Wilson (London: Thames & Hudson, 2005), p. 158. / **29** With the exception of two prints loaned for the exhibition by Howard Greenberg. / **30** The modern prints are indicated in the captions at the end of the book. / **31** André Pieyre de Mandiargues, French writer and poet (1909-1991), childhood friend of Cartier-Bresson. He received the Goncourt Prize in 1947 for *La Marge* (The Margin). / **32** Renoir album: On his return to Paris in the mid-1930s, Cartier-Bresson wanted to work in film as an assistant director; he first thought of contacting Luis Buñuel, then G. W. Pabst, and finally settled on Jean Renoir. To present his work, he put together an album of 52 photographs which he had printed himself.

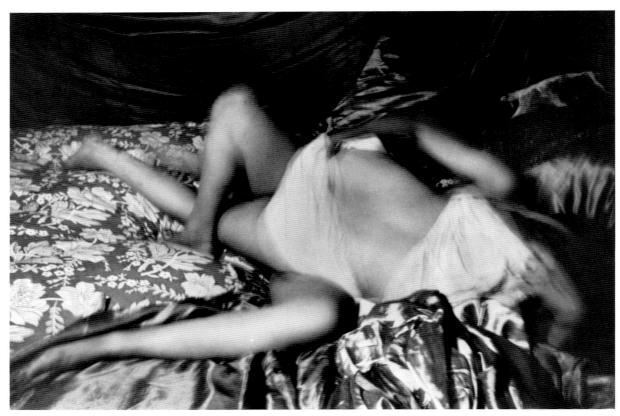

23

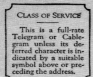

24

23 Mexico, 1934
24 Telegram from Edward Steichen to Henri Cartier-Bresson, 4 February 1947

There are also very few photos of New York from 1935 in the *Scrapbook* – six – and none on show, although we are now familiar with excellent images from that period. We have already seen that Cartier-Bresson privileged the shots from 1946 for the exhibition and truly believed, at the time, that he had stopped photographing in 1935 in order to devote himself to the study of filmmaking, notably with Paul Strand.

A more recent portion of his work is also missing: the Liberation of Paris. It is as if Cartier-Bresson had totally forgotten that he had photographed the event. Indeed, it was so far from his mind that at the time of the exhibition, journalists reported that, 'very occupied by his underground activities with the resistance, Henri Cartier-Bresson did not photograph the Liberation'[33].

Only two years had gone by when he was preparing the exhibition. Could he have felt that these were not 'real' photographs? In any case, he was to rediscover them twenty-four years later on a shelf in his parent's apartment.

Methodology

We have opted here for a strictly chronological layout, given that the few sheets still mounted indicate that the images were grouped together by 'subject' and thus chronologically rather than formally. The single photographs are reproduced full scale while the mounted pages and the cover have been reduced by 15 percent.

The short texts which introduce each part of the album are intended to offer year-by-year information, thus making this book a kind of illustrated biography. It ends in 1946 with the only 'family' photos printed for the exhibition, for, in spite of an early revolt against his bourgeois background and a marriage which was hardly conventional, Cartier-Bresson had maintained very close relations with his family. His mother and father wrote to him a great deal and never discouraged him from his decision to embark on an artistic career[34]. He travelled with his sisters on several occasions and participated actively in the Resistance, probably maintaining an intermittent connection with his brother Claude, who was in the first wave of Resistance fighters[35]. Ultimately, what might at first glance seem to be the surprising presence of these three very personal images in his selection could not be more logical.

A vital period for Cartier-Bresson

All of his pre-war travels were impregnated with the desire for discovery and an insatiable curiosity about 'what's happening elsewhere'. When he was quite young, he attended the meetings of the Surrealists at Place Blanche and this experience allowed him to establish a close friendship with René Crevel, as well as with André Breton[36]. 'I liked Breton's conception of Surrealism a great deal, the role of spontaneous expression and intuition and, above all, the attitude of revolt,' he recalled[37]. But after his initial stirrings with photography in the 1930s, he made a first break in order to explore filmmaking.

For Cartier-Bresson, the image could in fact take different forms and at that time, he wanted to 'learn' film. He first tried to gain some experience with Paul Strand in 1935 but his real knowledge came from the periods spent working as Jean Renoir's assistant (fig. 5). Convinced that he did not have the imagination it took to create a fiction film, he made three documentaries[38] during the period before the exhibition. But in the end, encouraged by the exhibit and the creation of Magnum, he was to opt for a 'way of living': the 'photo-journalism' which Capa proposed but

33 Cf. the museum press kit: 'He was so busy organizing underground photographers to record the great day of liberation that when it came he only had time to direct those men to strategic points in and around Paris, with no opportunity to take even one picture himself.' / 34 Cartier-Bresson often recalled how, when he decided to become a photographer on his return from Africa, he wanted to tell his parents and so, whether to win them over or have more weight, he asked Max Ernst, who was seventeen years his senior, to come with him. / 35 Under the pseudonym 'Vincent', Claude Cartier-Bresson (1917-2002) was a member of the Mouvements Unis de la Résistance (United Resistance Movements, MUR) in the Toulouse area. The MUR was formed in January 1943 from the grouping together of the three main movements of the southern zone. The steering committee was headed by Resistance hero Jean Moulin. Claude Cartier-Bresson was to finish the war as a colonel in the FFI. / 36 René Crevel (1900-1935), a young writer close to the Surrealists, was the author of *Détours* (Detours, 1924), *Mon corps et moi* (My Body and I, 1925) and *La mort difficile* (The Difficult Death, 1926). / 37 'HCB, Gilles Mora: Conversation', p. 117.

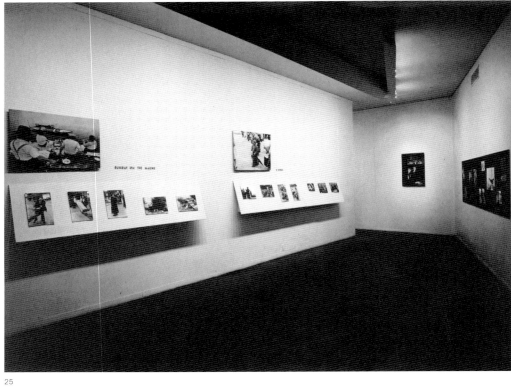

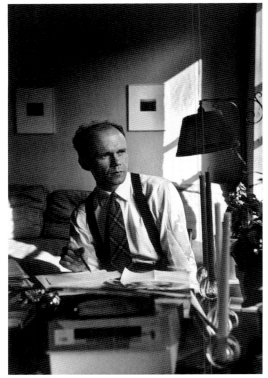

25

26

25 The Cartier-Bresson exhibition at MoMA, New York, 1947
26 Portrait of Beaumont Newhall by Henri Cartier-Bresson, 1946

which he adapted in his own way, as a kind of diary. 'When the war came,' he later recalled, 'I went through my negatives and destroyed almost everything, except what's left in *The Decisive Moment*. . . . I did it the way you cut your fingernails'[39] (Yet another example of the consummate art of understatement for which he is known.). 'But – and this is my weak point –' he continued, 'since the magazines were paying, I always thought I had to give them quantity. I never had the nerve to say, "This is what I have, four photos and no more!"'[40]

He continued this way of life until the late 1960s or early 1970s, with great productivity but also a growing desire to take up drawing again. After a conversation with the person he always considered his mentor, Tériade, and with the encouragement of Jean Renoir and Saul Steinberg, he decided to give up reportage[41]. Once again, there was a break, this time to come back to drawing[42]. Over the years, he continued to photograph faces and landscapes, but without commissions. He also published numerous books with Robert Delpire and his works were honoured by exhibitions in the world's most prestigious museums[43].

In 1947, at the age of thirty-eight, the moment had come for him to choose a direction and seize the opportunity. 'There's no such thing as chance,' he often said. Despite all the attempts to make Cartier-Bresson synonymous with the 'decisive moment' – an expression he never employed himself – he exercised his intuition, with his eye to the wind, giving free rein to his imagination, from life[44].

The youthful adventurer in Africa à la Rimbaud in 1931 and the ripe old man who still had 'so many things to learn in drawing' were one and the same person, fascinated by life and marked by his time. His approach to photography evolved, changed with maturity, and this Scrapbook clearly indicates the turning point which he expressed so well in an interview with Hervé Guibert: 'I set out in search of photography for its own sake, a bit like you make a poem. With Magnum came the need to tell stories'[45].

Agnès Sire
Director, Fondation Henri Cartier-Bresson

38 *Victoire de la vie* (Return to Life, 1937). Documentary on medical aid to Republican Spain. Director: Henri Cartier-Bresson, with Herbert Kline. Produced by the Medical Bureau. 49 min. Black and white. *L'Espagne vivra* (Spain Will Survive, 1938). Documentary on the Spanish Civil War and its aftermath. Director: Henri Cartier-Bresson. Produced by the Secours Populaire de France et des Colonies. Distributed by Films Populaires. This film has been restored by the French Ministry of Culture and the Film Archives (Centre National du Cinéma). 43 min. Black and white. *Le Retour* (The Return, 1945). Documentary on prisoners of war and deportees. Directed by Henri Cartier-Bresson, Lieutenant Richard Banks and Captain Krimsky. Production: U.S. Army Signal Corps, Office of War Information (OWI), Noma Ratner. Commentary by Claude Roy. Cameramen: Film Section of the American Army. Music: Robert Lannoy, orchestrated by Robert Desormières. 35 mm. 32 min. / **39** 'HCB, Gilles Mora: Conversation', p. 121. *The Decisive Moment* (New York: Simon & Schuster, 1952) was the American edition of *Images à la sauvette* (Images on the Run) (Paris: Verve, 1952), conceived and designed by French art publisher Tériade. See note 42 below. / **40** 'HCB, Gilles Mora: Conversation', p. 122. / **41** Artist and illustrator Saul Steinberg (1914-1999), best known for his *New Yorker* covers and drawings, was a friend of Cartier-Bresson. / **42** 'Tériade has been telling me to give up photography for 15 years: you've said what you have to say; draw and paint!' Interview with Hervé Guibert, *Le Monde*, 30 October 1980. Stratis Eleftheriades, known as Tériade (1889-1983), was an outstanding art publisher. He met Cartier-Bresson in Montparnasse on his arrival in France at the beginning of the 1930s. Art director of the Surrealist review *Minotaure*, he began publishing the magazine *Verve* in 1937, followed by books devoted to the most important artists of the 20th century, including two by Cartier-Bresson: *Images à la sauvette* (cf. note 40 above) in 1952 and *Les Européens* (*The Europeans* in the English edition, published by Simon & Schuster) in 1955. / **43** Robert Delpire, a long-time friend of Cartier-Bresson, published most of his books after Tériade and designed many of his exhibitions. / **44** In the conversation with Gilles Mora (op. cit., pp. 124-125), Cartier-Bresson recounts the origin of the expression 'the decisive moment': 'They twisted my arm to write that text. Simon [the New York publisher] asked me, "How do you make your pictures?" I was puzzled. . . I said, "I don't know, it's not important." Tériade, the good calm Greek, took me aside: "Why have you been doing that for twenty years? Come on, put that down on paper." . . . It was Dick Simon who found the title of the book, *The Decisive Moment*, for the American edition, after I excerpted the quotation from the Cardinal de Retz, which I'd simply used as an epigraph.' The phrase 'imagination, from life' (*l'imaginaire, d'après nature*) alludes to an expression used by Cartier-Bresson in a 1982 essay. See his *The Mind's Eye, Writings on Photography and Photographers*, edited by Michael L. Sand (New York: Aperture, 1999). / **45** Interview with Hervé Guibert, op. cit.

UNPREDICTABLE GLANCES:
Photography Lessons from a Scrapbook

Henri Cartier-Bresson's work, which includes a large number of individually celebrated and widely commented-upon photographs, has been unanimously hailed for several decades. Indeed, it demonstrates an extraordinarily consistent formal balance, maintains the surprise effect of the moment captured and has a universal impact through the humanity of its subjects. The vast retrospective first presented at the Bibliothèque Nationale de France in 2003 offered yet another exemplary demonstration of these qualities[1]. But this body of work, taken as a coherent whole, an aesthetic quest and process and the subjective commitment of an entire lifetime, remains to be examined[2]. HCB himself, as is well known, was always extremely reluctant with regard to a historicist approach which would situate each photograph in its professional, artistic and social context and would replace the photographer's inner necessity with a 'superego' of practice, craft and visual memory that, for the fact of being masked, would come back to the fore with insistence. Such an approach to the works would necessarily bring out at once similarities, references, and, even more, discontinuities from one period to another. And this could be interpreted as the sign of inconsistency, or infidelity, to the intuitive principles which he wanted to be exclusive, as he had laid them down in the introduction to *The Decisive Moment* (1952) and ultimately came to accept them under that title[3]. And this was so until HCB abandoned photography itself, relegating these questions to the rank of futilities and bothersome interference: he no longer had to justify himself for what did not interest him

any more. There was, however, the recognition of the first impulses stimulated by his elders, Martin Munkácsi and André Kertész for photography, André Breton and André Lhote for what HCB called 'the literary and visual baggage'; the birth of a major photographer thus seemed to have been circumscribed, without anyone knowing it, in fact, when he started to photograph 'seriously', with the intentionality attributed to this practice. And then came the acceptance of Peter Galassi's research, which benefited from HCB's own explanations and other contributions; an effort of spadework, a 'study intended to isolate the work of 1932 to 1934' in order to break up the 'undifferentiated whole' which Galassi disavowed in order to 'examine the pictures critically and within a broad pattern of culture'[4].

The 'rediscovery' of the 1946 *Scrapbook* contributed to a recognition of its own historicity, its own place within the transformations of the arts of the image. Did that rediscovery, at the end of the 1980s, follow the acknowledgement of the pertinence of the historian's work, which not only untangled the threads but attempted to reconstitute paths along them? Bolstered by this attitude, the works could then – contrary to publications which attempted to maintain their non-differentiation – be reconsidered as a fragmented aggregate of epochs and contingencies. At that time, moreover, HCB sought to preserve the 9 x 12 prints he had made for the *Scrapbook* from the disaster of the album sheets on which they were pasted, after decades of heaping opprobrium on his 'old prints' from the 1930s and

1 *Henri Cartier-Bresson: The Man, the Image and the World*, translated by Jane Brenton (London: Thames & Hudson Ltd, 2003). (Trans. note: Since Paris, the exhibition has been presented in Barcelona, Berlin, Edinburgh and Amsterdam and is scheduled to travel to Milan and Tokyo.) / **2** I would like to thank Martine Franck, president of the Fondation Henri Cartier-Bresson, for the generosity of her invitation and her warm welcome, the access to her archives and the authorisation for reproduction of unpublished photos by Henri Cartier-Bresson for scholarly purposes. My sincere gratitude also goes to Agnès Sire, director of the Fondation, and her staff (Aude Raimbault, Pauline Vermare) for their collaboration and all the documents and information placed at my disposal. And last of all, special thanks to Daniel and Mireille Raimboux, Cédric de Veigy and Mathilde Kiener. / **3** *The Decisive Moment* (New York: Simon & Schuster, 1952). / **4** Peter Galassi, *Henri Cartier-Bresson, The Early Work* (New York: The Museum of Modern Art/Thames & Hudson, 1987), pp. 9, 10. 'No artist has worked in a vacuum', adds Galassi.

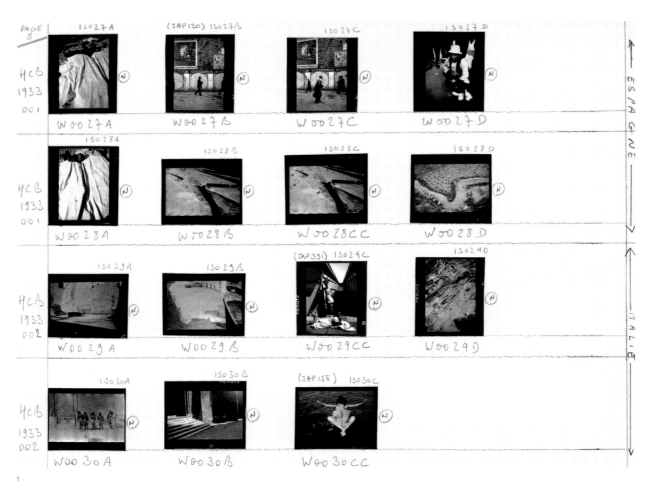

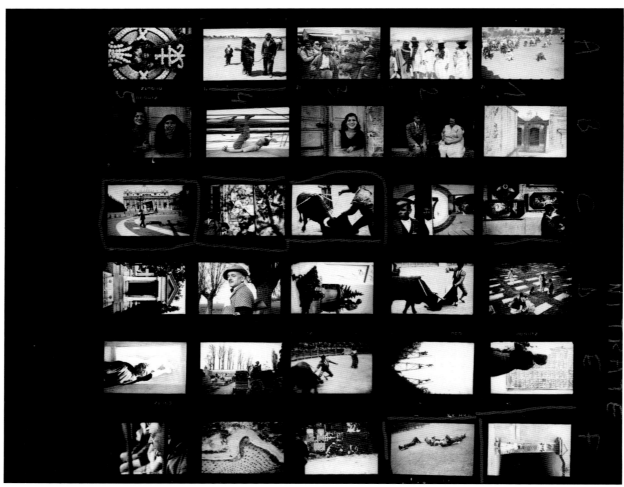

1 Henri Cartier-Bresson, n° 8 of the 'Singles' sheets
2 Henri Cartier-Bresson, n° 17 of the 'Liberation' sheets

1940s, which he considered too grey[5]. Later on, in his last retrospective (BNF, 2003), he would decide to include the prints of the 'Renoir album' (1936), albeit in a showcase where they were displayed along with family archives and not as historic originals. HCB's flagrant interest in the *Scrapbook* and the circumstances of its constitution, the Fondation Henri Cartier-Bresson's commitment to a scholarly approach and the preparation of the present exhibition have in fact brought out the key issues: by virtue of its content, the *Scrapbook* is an essential observation post for analysing the first fifteen years of his photographic work.

Assembled in 1946 in order to provide Beaumont Newhall, curator of the Department of Photography at the Museum of Modern Art (MoMA) in New York, with a large choice for the selection of the photos which would be shown in the proposed HCB retrospective (and the travelling exhibition), the *Scrapbook* has the exceptional advantage of revealing the photographer's personal evaluation of his career from the time of his beginnings (in any case, since 1931, the beginning he 'recognises'), after various ups and downs, the self-searching of the war and the period of captivity[6]. It must be understood, however, that the *Scrapbook* is limited by the aesthetic gesture of 1940: the draconian selection which HCB made among his earlier negatives just before he was taken prisoner by the Germans. These were what he called the 'singles' ('top selection' negatives stored individually). This episode shows just how much HCB was concerned with preserving what he considered the 'best' of his output from the 1930s (whereas at that point he thought he was moving definitively towards filmmaking). At the same time, and in an equally symbolic gesture, he hid his Leica by 'burying' it: faced with multiple uncertainties, HCB thought about what might survive him, and about what he did not want

to leave for posterity (the negatives which were to be destroyed)[7]. He irreversibly inaugurated the construction of the corpus to be remembered and revealed the consciousness of a coherence in the work of the 1930s. In 1946, the *Scrapbook* was at once this stocktaking of an accomplishment and a sign of return to life and rebirth as a photographer. But the self-destructive gesture of 1940 was combined with a subconsciously deliberate mistake, because hundreds of negatives, often in strips, associated with the 'singles' selected individually, reappeared in 1968: classed in the contact-sheet files labelled 'Liberation', they were rarely to be taken into account by HCB because they were rejects which had been – inadvertently – saved[8].

The *Scrapbook* thus becomes an indicator of HCB's successive levels of selection if we compare its contents (346 prints) to the two groups of negatives: the 'singles' (1,455 pieces) (fig. 1), from which the prints in the *Scrapbook* were made, and strips or individual shots cut out of the 'Liberation' contact sheets (6,624 pieces) (fig. 2) – without excluding the possibility that many other negatives had been destroyed in the spirit of 1940. These levels of archiving correspond to the levels of HCB's selective intervention (on the basis of criteria which he did not disclose); what is new here is the appearance of *complementary* views of certain series of shots already known from the 'singles'. Given the various hesitations which the *Scrapbook* reveals in the choices of 1946, the juxtaposition of these groups at least allows us, through interpolation, comparison, deduction, to undertake an initial analysis of the way the body of work has been 'constituted', piece by piece, through a process of repetition-selection-exclusion which closed the corpus in on itself. Far from disparaging the photographer's rigour, it delimits the mental components involved. For it is time to open up pragmatic alternatives to

5 HCB preferred the more high-contrast prints, on paper containing a greater quantity of silver, which was typical of the 1950s and 60s; these prints were always delegated to his friend Pierre Gassman's Pictorial labs. The vintage photo market which emerged in the 1970s, on the other hand, valued the age of the prints, the photographer's participation in the printing process, and the grey scales proper to that period. / **6** On the organisation of the MoMA exhibitions, see *Scrapbook* Stories' in this volume. / **7** [In May 1940], 'he cut out one by one those [negatives] he intended to keep, in an act of intense self-criticism devoid of even the slightest complacency. Three-quarters of those he examined were discarded . . . the chosen few were placed in a Huntley & Palmer biscuit tin and dispatched to his father, who had the good sense to store them in a safety deposit box at the bank' Pierre Assouline, *Henri Cartier-Bresson, The Biography*, translated by David Wilson (London: Thames & Hudson, 2005), p. 118. 'When the war broke out (we'd anticipated it for a good while), I took my negatives and destroyed almost all of them, except for what's left in *The Decisive Moment* . . . I did it the way you cut your nails: "Come on, off you go!"' 'HCB, Gilles Mora: Conversation', p. 121. / **8** These were probably 'second choices' which HCB entrusted to his father at the same time as the 'singles' constituting the 'top selection'. The photographer rediscovered all of them following his mother's death.

the poetic, essentialist closure of individual, spontaneous successes proposed by the major writings which have accompanied HCB's publications until now.

But the *Scrapbook* does not simply represent a privileged access to the prior work. It was to confirm a decision of involvement in photojournalism, for it was at the time of the MoMA exhibition that Magnum Photos was founded in New York by HCB, Capa and others. This commitment to photojournalism imposed a break in the craft, the intentions, the shooting method – a definitive choice between two 'labels', two functions in the eyes of others, 'little Surrealist photographer' or 'photo-journalist', as Robert Capa told him in 1947[9]. HCB tackled this orientation (single photos versus story told in photos), as did others, when he approached the illustrated media, in 1932-1933 (see below). However, the 1947 exhibition made this break coincide with the celebration of the individual and his works, a celebration which took place in the institution embodying international modernity in art and photography alike around 1950: The Museum of Modern Art. It is not without significance that the same MoMA (Peter Galassi, curator of the Department of Photography) would go back over these criteria by probing the 'early works' supposed to give more precise clues for the aesthetic assessment of the 'photographic corpus' defined by HCB through the *Scrapbook*. Especially since the preface to *Images à la sauvette* (Images on the Run, the original French title of what became, for the American edition, *The Decisive Moment*) (1952) had clouded the issue somewhat by associating in one mental stance the 'single' photos of the beginnings, the portraits (1944) presented in the *Scrapbook* and the exhibition, and the reportages on China or India (1948-1950). And this stance was soon assimilated to the single vague notion of the 'decisive moment' which a semantic misunderstanding was to place in the determi-

nant position it occupies to this day. The misunderstanding arose from the quotation of Cardinal de Retz placed in epilogue to HCB's introduction to *Images à la sauvette* ('There is nothing in this world without a decisive moment'), on which the title of the American edition was based. From these titles which he did not choose comes the 'decisive moment', in the end accepted as a major signifier of his practice, in spite of the limitations of what it actually says.

The careful examination of the *Scrapbook*, with all it reveals about the genesis of a body of work, including the shooting of the image, invites us to resituate these metaphors of the photographic process which are *à la sauvette* ('on the run, to avoid attracting attention'), the *decisive moment* ('which has a determining influence' or 'which convinces') or *in flagrante delicto* ('to "trap life" – to preserve life in the act of living', i.e. as if it were caught *in flagrante delicto*), within both the whole of the practices of a period and one individual's abilities and interests[10]. This also leads to examining Surrealism and painting as referential models – clearly advanced by HCB himself – but only according them the role of an intellectual background which was implicitly not very determinant for photography. Even under the grip of Surrealism and painting, there remains, within a creative, innovative quest, the weight of cumulative visual and emotional experiences which are not immediately conscious. We are made up of what we have seen, what we have loved, what has impressed or shocked us, what we have not dared to look at, what we want to see, what we have regretted seeing: an entire complex of *backward glances*, real and imaginary, lived and sometimes dreamed, which constitute an aggregate and a desire. It is impossible for HCB *not* to have seen a great many photographs, films and images of films, news magazines, and *many more* of them than of paintings: this is a natural hypothesis for the education of a photographer who

9 'When we founded Magnum . . . Capa told me, "Watch out for labels! They are reassuring. But they're going to stick you with one you won't get rid of: that of a little Surrealist photographer. You're going to be lost, you'll become precious and mannered." He was right. He added, "Take the label of photojournalist instead and keep the rest tucked away in your little heart."' 'HCB, Gilles Mora: Conversation', p. 122. / **10** Cartier-Bresson's introduction to *Images à la sauvette/The Decisive Moment*, which was itself untitled, has come to be republished as 'The Decisive Moment' ('L'Instant décisif' in French editions). (Trans. note: The reference to *flagrants délits* – the equivalent of *in flagrante delicto* in French – also comes from that introduction. The expression became the title of a subsequent album of HCB's photographs, published in English as *The World of Henri Cartier-Bresson* (New York: Viking Press, 1968). For a more recent edition of the essay 'The Decisive Moment' in English, see Henri Cartier-Bresson, *The Mind's Eye, Writings on Photography and Photographers*, edited by Michael L. Sand (New York: Aperture, 1999), pp. 20-34)

is above all someone who looks. Each photograph is a personal appeal to the world, with the hope of a reply, which draws its claim from the pre-existing but as yet unsuspected magma: 'Photography is an instantaneous operation both sensory and intellectual – an expression of the world in visual terms, and also a perpetual quest and interrogation,' as HCB was to write much later, at the end of his trajectory, when he had resolved the question of photography (Preface to *The World of Henri Cartier-Bresson*, 1968).

Condensation

There has been some confusion between HCB's formative years, the academic and cultural education befitting every young man from a good family – let's say from 1925 to 1929 – and the years which saw the emergence of his own originality, the manifestation of a desire, although still uncertain, to 'do photography' without really knowing what kind of practice he would adopt. Of this second period (1929-1932), he said almost nothing and left room for suppositions, while the numerous negatives (which he saved) from his travels in Poland and other East European countries in 1931 suggest that at this date he was already quite involved in the photographic experience.

Born in 1908 into a bourgeois family which owned a prosperous, well-known textile business (Cartier-Bresson), HCB attended the prestigious Lycée Condorcet, discovered painting at the age of twelve and became an assiduous reader of literature and poetry but failed the *baccalauréat* exams three times. After leaving high school in 1927, he let it be known that he would not continue in the family business, but this did not provoke a real rupture (Henri was to continue living with his parents until his marriage to Ratna Mohini in 1937). He turned unhurriedly towards the arts, with the approval (or resignation) of his father. Since 1923

he had been in contact with Jacques-Emile Blanche, a painter who was already considered rear-guard in the 1920s; nonetheless, it was through Blanche's intermediary that he met Surrealist writer René Crevel (1900-1935), and this influential friendship brought him in contact with André Breton[11]. Max Jacob and the art historian Elie Faure were among his friends. In 1927, he entered André Lhote's studio, which was one of the most popular of the period. Lhote, a post-Cubist modernist who did not belong to any of the avant-gardes typical of the late 1920s, advanced the theory of a balanced painting, constructed through forms and colour (in the continuation of Cézanne and Maurice Denis)[12]. In spite of these established references, however, there is little evidence of the influence of painting on HCB; moreover, he destroyed most of his painted works and those which survive show no relationship with his photographic practice, even in terms of the framing he was to treat with such great care. As for Surrealism, he indicated quite clearly, 'I was marked not by Surrealist painting, but by the conceptions of Breton, when I was quite young, around 1926-1927'[13]. As Galassi notes, through Surrealism, HCB adhered to a spirit of 'revolt' and a political commitment in favour of 'the revolution' (he had little enthusiasm for 'Surrealist painting'). Nor is there any reason to look to those years for a photographic aesthetic likely to be developed: the journal *La révolution surréaliste* contained practically no photographs apart from those of Man Ray and cover images borrowed from Atget, emphasised by a disturbing, discordant caption. At that time, Surrealism was a state of mind, an intellectual ambience, not a recipe and even less a pool of images.

On the other hand, in 1929, when HCB returned from a long stay in Cambridge, the situation had changed. Breton had written the Second Surrealist Manifesto and set up a new journal, *Le surréalisme au service de la révolution*.

11 Throughout his life, HCB recalled his friendship with Crevel and the regret over his suicide in 1935, which became a crucial episode within the history of Surrealism and its relationship with revolutionary ideology – through the AEAR (Association of Revolutionary Writers and Artists) group – with which Crevel, Breton, Eluard and Char were linked in 1932. / 12 Lhote published *Traité du paysage* (Treatise on Landscape) (Paris: Librairie Floury, 1939) and *Traité de la figure* (Treatise on the Figure) (Paris: Floury, 1950). The former appeared in English as *Treatise on Landscape Painting*, translated by W. J. Strachan (New York: Frederick A. Praeger, 1950). / 13 'HCB, Gilles Mora: Conversation', p. 117. In fact, this meeting would seem to have occurred slightly later. Elsewhere, HCB writes, '[As for Breton], I probably knew him from 1928 or 1929.' *André Breton, Roi soleil* (André Breton, Sun King), texts and photographs by HCB (Saint-Clément: Fata Morgana, 1995).

HCB did his military service at Le Bourget airfield but spent a great deal of time with Harry and Caresse Crosby, a rich, cultivated American couple living in Ermenonville, near Paris. Poetry and literature enthusiasts, they ran the Black Sun Press (which in 1930 published Arnold Crane's *The Bridge*, illustrated with 3 photos by Walker Evans). At their home, HCB met Max Ernst, the New York art dealer Julien Levy, with whom he was to exhibit in 1933 and 1935, and Gretchen and Peter Powel, ardent fans of photography and jazz[14]. Above all, the situation and role of photography had changed in the 1928-1929 period: the major exhibition 'Film und Foto' in Stuttgart (1929) had mobilised the entire international avant-garde under the leadership of Moholy-Nagy. These two years saw the rise of the 'new photography' in all the 'advanced', 'modern' circles, which were not necessarily avant-garde or Surrealist but offered new possibilities and support to the applied or decorative arts of advertising, graphic design and furniture design. Photography constituted at once the means of their distribution, the most flexible, rapid and instantaneous medium and a locus of experimentation without material stakes: if a photo was not accepted by the appropriate media, it might please later on, and if not, there were others to be taken the next day. At that time, three 'new' photographers distinguished themselves by the singularity of their approaches, their aesthetic ties and their nearly simultaneous presence, as if they formed a trio: André Kertész, Germaine Krull and Eli Lotar. Foreigners (Hungarian, German, Romanian) like most of those who were to constitute French photography in the 1930s, they were all the more impatient to be done with academic and professional photography (the Parisian studios, the neo-Pictorialists, the enthusiasts of the Société Française de Photographie) because they did not come from its ranks, had no stable employment and felt the pressing need to live from their art on a day-to-day basis. The magazine

VU, created in March 1928, immediately opened its pages to this threesome (and symptomatically, to Man Ray as well) and soon asked them for 'reportages' as well as unusual photographs without particular connotations, which served as perfect illustrations, 'neutral in their meaning' but poetic and offbeat. Their photos could also be seen in magazines more oriented towards modern art, literature or poetry, in a vein which did not owe a great deal to Surrealism but touched on all the modernist and internationalist currents. And we can wager that in 1929, the young HCB, although he never breathed a word about it, saw these magazines in his friends' homes, if he did not buy them himself. As for what he had to say about his acknowledged elders, he venerated Kertész, without specifying the circumstances in which he had seen his photos[15]. The other photographer HCB often spoke of is Lotar, who was a friend and whose photographs clearly followed the same lines, if not on occasion the same formula. What set Lotar apart – accounting for his place among HCB's forerunners and making him stand out in Henri's memory – was his combined involvement in photography and film (which took concrete form in his collaborations with Joris Ivens and Luis Buñuel)[16]. Upon examination, Lotar emerges as a 'Cartier-Bresson before Cartier-Bresson' and HCB paid close atten- tion to what he was doing in the 1930s. Despite the fact that Lotar is less well known today, it is not insignificant that he turns up in all the magazines, like Kertész or Krull.

Modern photography in that period, at least the kind which interested and stimulated HCB, in contrast to press or art photography, might be defined as one of free expression, of aimless wandering ('accelerated' drawing in his words): it consisted of strolling around the city and identifying situations, figure compositions, details, incongruous associations which, isolated within the frame of the photograph and cut off from the context

14 In 1931 the Black Sun Press published *Mr Knife Miss Fork*, a text by René Crevel, illustrated with 19 photograms made in Man Ray's studio from frottages by Max Ernst. / 15 According to P. Assouline, op. cit., p. 60, prints 'of Eugène Atget's work had made a big impression on him, as had others by André Kertész, whom he always regarded as a poetic inspiration.' It does not seem that HCB and Kertész met each other at that time. Kertész spoke very little French and remained within the community of foreign artists at Montparnasse. / 16 *Eli Lotar* (Paris: Éditions du Centre Pompidou, 1993), published following a donation of his negatives to the Musée National d'Art Moderne, Centre Georges Pompidou, is the only available source for this unjustly neglected photographer.

and what was off-camera, made a banal reality suddenly transform itself into enigmatic suspense. 'Something' seems to be happening in the image but it is the viewer's imagination which starts to float, to hesitate, while capturing reminiscences, undefined echoes. In general, there is no Surrealist affiliation in these images, especially since protagonists like Kertész or Lotar had no contact with that literary movement. On the other hand – with or without Surrealism – a budding photographer was perfectly able to grasp the totally new lesson of attentive roaming and the hunt for self-contained images bearing their own autonomous meaning, disconnected from the micro-events or objective situations which had shaped them. As HCB later recognised in speaking of his discovery of the Leica and his earlier references, 'I went nosing around, there's no other word for it, I was sniffing out with the camera. But in addition, I had a whole literary and visual baggage.'[17]

We can characterise this formula of a significant shot with a term which Henri himself proposed: *condensation* (when he insisted, relative to the photo-reportage, that he was 'looking instead for the unique photo, in other words: condensation'[18]. This single photo, which sums up, synthesises, closes, was something HCB dreamed of as unique, fantasised as condensed uniqueness (through the *decisive moment*) to such a degree that he would forget it was only unique among others which were almost identical shots (several negatives). 'I prowled the streets all day, feeling very strung-up and ready to pounce, determined to "trap life" – to preserve life in the act of living. Above all, I craved to seize, in the confines of one single photograph, the whole essence of some situation that was in the process of unfolding itself before my eyes'[19]. That 'essence', as we shall see, is immediately recognisable in a geometry of rhythms. HCB also suggests the idea of a 'simultaneous coalition': 'Photography implies the recognition of a rhythm in the world of real things. . . In a photograph, composition is the result of a simultaneous coalition, the organic coordination of elements seen by the eye'[20].

Is it not possible that the condensation practised by Kertész or Lotar might lie behind what HCB wanted to try? In 1929 he was already doing photography, as demonstrated by the 1929-1931 images which appear for the first time in *Henri Cartier-Bresson: Photographer* (1979), in Galassi's *Early Years* and in the 2003 retrospective (but had been exhibited at Julien Levy's gallery in 1933 and 1935)[21]. The question, then, is what kind of 'visual baggage' a young man of twenty years might draw on to build his autonomy.

L'Art vivant (Lively Arts) was the most accessible magazine[22]. It turned to photographers for documents on the 'modern arts' in general but above all, as of January 1929, it undertook a series of articles by Jean Gallotti on art photographers. Presented as a double-page spread in the middle of the magazine (well printed in heliogravure), these had the tone of a manifesto: Atget, Laure Albin-Guillot, Kertész, Krull, Lotar, Emmanuel Sougez. Among the other magazines, more limited in their audiences but well received in literary and artistic circles, were *Jazz, Variétés, Documents* and *Bifur. Jazz*, founded by the adventurer-journalist known as Titaÿna (Elisabeth Sauvy) and edited by Carlo Rim (subsequently editor of *VU*), was typically the magazine of the strange illustration deliberately out of phase with the 'subject' treated; it was a (successful) attempt at evocative balance between essays and photographs[23]. Lotar was the most frequently represented: the *Amsterdam* page, composed of two photographs (fig. 3) showing, respectively, two nuns and two cyclists with their shadows (no. 12, 15 December 1929); the page from an article on Toulon (no. 8, 1929) with a high-angle shot of a street and passers-by, which evokes both Kertész and HCB; the group 'à la HCB' from the reportage on pearl fishers (*Jazz* no. 9, September 1929) (fig. 4); the double page 'Ici on

17 'HCB, Gilles Mora: Conversation', p. 119. / 18 'HCB, Gilles Mora: Conversation', p. 121. / 19 'The Decisive Moment,' in *The Mind's Eye*, p. 22. / 20 Ibid, p. 32. / 21 See *Henri Cartier-Bresson Photographer* (New York: Robert Delpire for the International Center of Photography, 1979), no. 149, *Dieppe*, 1926, HCB's oldest photograph; no. 129, *La Villette*, 1929; no. 97, *Hungary*, 1931; Galassi, *Early Work*, p. 53, Untitled, 1931; 54, *Rouen*, 1929 (black model); 55, *Budapest*, 1931; 56, Untitled, 1929; 60, *Warsaw*, 1931; 61, *Budapest*, 1931; *Henri Cartier-Bresson: The Man, the Image and the World*, no. 6, *Poland* 1931; no. 8, *Warsaw*, 1931; no. 16, *Berlin* 1931; nos. 38, 39, 40, 41 *Ivory Coast*, 1931. / 22 1925-1939, edited by Florent Fels, who subsequently became editor of *Voilà* in 1931. / 23 *Jazz, l'actualité intellectuelle*, nos. 1-15, December 1928-March 1930.

Amsterdam

par Éli Lotar

— 533 —

3

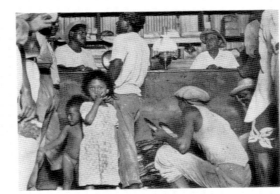

LE PLONGEUR CÉDERA SA CUEILLETTE DE NACRE A BAS PRIX

plongeurs de nacre... pêcheurs de perles

Lentement notre goélette avance dans la nuit, toutes voiles amenées, moteur au ralenti. Je suis de quart...

Devant la possibilité de faire une longue croisière aux îles Tuamotus et d'y suivre une saison de plonge, j'ai embarqué comme maître d'équipage sur *La Mouette*, goélette du gouvernement à Tahiti. Mes appointements : 45 francs par mois, exactement de quoi payer 3 litres d'infâme vin blanc chimique chez un Chinois des îles. Mais, bah ! L'aubaine était trop belle, l'aventure trop tentante et le capitaine Brisson, commandant du bateau, trop bon ami pour ne pas partir.

Adieu Papeete, ses bars, ses dancings et les beuveries de pippermint, les nuits de lune au son des guitares. *La Mouette* n'est pas vieille, un peu pourrie cependant; elle vibre, geint, fait eau et roulbord sur bord, ventre vide. L'équipage, capitaine et maître à part, est recruté parmi les prisonniers de droit commun d'Océanie.

Crise du personnel ? Non, économie pour le budget de la colonie. Ces hommes ne sont pas payés mais comme ils préfèrent la liberté de la navigation aux corvées de la prison à Papeete, on en obtient ce que l'on veut. Au demeurant, aucun criminel; il n'en existe pas à Tahiti, seule la sévérité peut-être exagérée de leurs juges a privé ces grands enfants de leur liberté pour de longs mois.

D'une île à l'autre, nous allons dans cet immense archipel, ici recevant l'impôt, la rendant justice, plus loin écoutant des doléances.

Il y a deux jours que nous avons quitté Takaroa, île très au nord. De jour, la navigation à travers toutes ces îles à fleur d'eau est aisée, mais la nuit il faut aller très lentement, la présence des îlots n'étant signalée que par le grondement des vagues qui s'y brisent et par la barre d'écume qu'on y distingue quelquefois trop tard. Pas de feu, pas de phare sur ces routes de mer en dehors de tous passages.

Je sais que vers deux heures du matin nous devons être en vue de Takume, but de ce voyage. Nous mettrons à la cape où nous croiserons devant l'île et attendrons le jour pour approcher et débarquer.

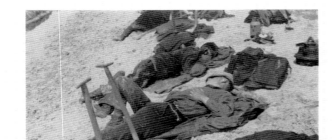

LA TOOFA HAMIA COULANT LE LONG DU QUAI DE PAPEETE

Tout doit à bord, hormis l'homme de barre et moi.

Vers l'heure prévue, une légère ligne blanche à l'horizon, le récif.

Nous stoppons. Ce doit être Takume, à moins que, poussés par la dérive, nous ne nous trouvions devant une autre île : on navigue ici à l'estime ; anneaux plats, insombrables jumeaux, les îles Tuamotus se ressemblent tellement que le jour seul nous fixe : c'est bien là Takume.

Anormalement, cette île n'a pas de passe qui fasse communiquer avec le lagon intérieur. La baleinière du bord nous conduira à terre. Un premier voyage et transporte nos bagages.

Bien nous en a pris, en franchissant la barre, près du récif,

— 427 —

4

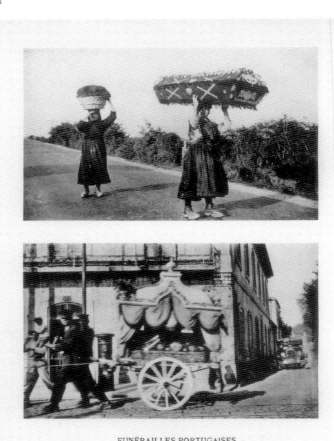

ici, on ne s'amuse pas

Nous sommes quelque part, très loin, dans une contrée qui ne ressemble à aucune autre, et à laquelle on n'a pas envie de donner un nom. Je sais bien qu'Amsterdam est à quelques heures d'ici et qu'Amsterdam est en Hollande mais il est si difficile de faire un effort d'imagination après une semaine passée dans ce pays. Ce pays qui n'en est pas encore un, à vrai dire, mais qui aura pris figure lorsque sur cette mer on pourra marcher en sabots. Nous sommes sur le golfe du Zuyderzée où l'on travaille péniblement à l'assèchement de la mer. Une métamorphose qui durera peut-être cinquante ans, au bout de quoi ce peuple de pêcheurs se sera mis à la terre et moissonnera un océan sans tempêtes — aux vagues de blé.

Les quelques hommes audacieux qui ont pris l'initiative de ce gigantesque labeur sont là, qui veillent à la lente métamorphose.

Aujourd'hui cela ressemble à un lieu de déportation. La vie y est réduite à un épuisant travail. Plus de deux cents ouvriers dans ce coin, qui triment comme des bagnards, résignés aussi comme des bagnards.

Ce n'est pas dans deux ans, ni dans cinq, ni dans dix ans que « cela » sera fait, mais dans cinquante ans. Ils le savent et pourtant songent à la fin. Les travaux forcés à perpétuité.

Il y a ici deux races d'ouvriers. Ceux de la digue, ceux des écluses. Une petite étendue d'eau, une baie étroite les sépare. D'ici, vous pouvez faire signe. On vous voit de l'autre rive et l'on vous envoie le bateau à moteur.

J'ai visité les écluses, je suis allé sur la digue. Ce sont bien deux pays différents, aux mœurs différentes.

Sur la digue, une rangée de baraquements qui évoque un train abandonné. Le matin, à six heures, les ouvriers quittent ces tristes logis, une paire de bottes imperméables sur le dos, des bottes d'égoutier ou de mousquetaire. Ils n'y reviendront que dans dix heures, harassés et les yeux déjà fermés par le sommeil.

Ils vont se disperser sur la digue et reprendre chacun son travail au point où il l'a laissé la veille. Ils nivelleront cette boue grise. Ils étendront là leurs tresses de paille ou bien ils feront de ces blocs de granit un puzzle

— 482 —

FUNÉRAILLES PORTUGAISES

5 6

3 'Amsterdam' by Eli Lotar, *Jazz*, n°12, December 1929, p. 533
4 'Shell divers...pearl fishermen', *Jazz*, n°9, September 1929, p. 427
5 'We don't play around here', by Eli Lotar (on *Zuyderzee* by Joris Ivens), *Jazz*, n°11, November 1929, p. 482
6 'Portuguese funerals', *Bifur*, n°5, April 1930

38

ne s'amuse pas' (We don't play around here) (no. 11, 15 November 1929) (fig. 5), which recounts the making of the film *Zuiderzee* by Joris Ivens (who was Krull's husband before she met Lotar), partly shot by Lotar: the view of the figures lying on the ground turns up again several times in HCB's photos, as with the sleeper or the tramp lying down or crouching (but which are also quite frequent in the work of Krull and Kertész).

Bifur, with its separate plates of photos, provides the best repertory of these photographic condensations, taken here in the sense of a verbal condensation (the title) superimposed on the visual one[24]. Among many examples, we may cite: Kertész's two hearses with the title 'Garage'; the double page (by Kertész) of 'Sources' (wine barrels) and 'Refuge' and 'Tramp'; the page combining 'Storefront' (nude mannequins in a shop window) and 'The kiss which kills' (a poster of the same title); the double page associating 'Rocking horses' and two views of empty streets in Marseilles and Amsterdam (all from *Bifur* no. 1, May 1929); the page 'Portuguese funeral ceremonies' playing on the repeated figures dear to Kertész, Lotar and HCB (*Bifur* no. 6) (fig. 6). If *Bifur* could be situated in a Surrealist current, this was not the case for the photographers' approaches; the systematisation of the dislocation lay in the choice of the images and often in the (false) caption accompanying them, which was intended to mislead the eye, to separate the poetic interpretation from a banal identification of the subject.

Documents, edited by Georges Bataille and closest to the anti-authoritarian spirit of Surrealism but quite critical of it, pursued a totally different approach to the use of artistic documentary photography (a genre in itself for this publication)[25]. It was nonetheless a possible influence for several reasons: the presence of Lotar's singularly impressive photographs of the slaughterhouses at La Villette in the north of Paris (no. 6, November 1929), a subject on which HCB would shamelessly 'rebound' in 1932 with an obvious stylistic proximity (one of his photos appears in the *Scrapbook* but has little of the Cartier-Bresson look; there are two other unprinted negatives); the interest in African ethnology – HCB would soon set out for the Cameroon and the Ivory Coast (article by Michel Leiris, illustrated by photographs in *Documents*); the photographic references to film, in particular two pages of frames from *The General Line* (see below). In addition to the slaughterhouses, another of HCB's photographs, unpublished prior to Galassi's *Early Years* (p. 57, deformed face covered by a silk stocking, 1931) is very close to three photos by Jacques-André Boiffard showing faces wearing leather masks (no. 8, 1930).

A young disciple of modern art who was attentive to the new photographic options, if he was affable, sociable and moving in cultivated Parisian circles, would have had numerous occasions, while 'poking around and sniffing out', to peruse, in bookstores or friends' homes – or to purchase himself – the books, reviews and magazines in which, if only nonchalantly and without thinking about it, he would 'have a look' at these photographs of a new genre and style. If, in addition, he was in Lhote's studio, he could have also seen the magazine *L'Esprit Nouveau* (The New Spirit, 1920-1925) edited by Dermée (one of Kertész's supporters), Ozenfant and Jeanneret, which was the first to distinguish itself for its illustrations of documentary and industrial photography. And it would have been impossible for him to overlook Ozenfant's book *Art* (1928). HCB was not far removed from this painter, who co-founded Purism with Le Corbusier, and two of his 1928 paintings are even closer to Purism than to Lhote[26]. *Art* contains several photographs in the Cartier-Bresson spirit: the group in front of the cigar store sign (fig. 7) (already signalled by Galassi), a group of Africans using a mirror (fig. 8) and a reproduction of Seurat's *A Sunday on La Grande Jatte*, a model of geometric balance in the framing of the figures, and the most striking photograph from André Gide's *Voyage au Congo* (natives holding an enormous ball at arm's length). It is

24 Nos. 1 to 8, May 1929 to June 1931, Éditions du Carrefour, editor in chief Georges Ribemont-Dessaignes, published Henri Michaux, Philippe Soupault, Tristan Tzara, Francis Picabia, Michel Leiris, Robert Desnos, James Joyce, Ernest Hemingway, etc. The press run reached 3,000 numbered copies. / **25** Two years, 1929 and 1930, then 1933-1934. / **26** This point is made by Galassi, who presents the paintings as figs. 3 and 4 in *Early Work*. *Art* was published in English as *The Foundations of Modern Art* (1931).

Vendeuse de cigares à Cuba

7

négresse se regardant pour la première fois dans un bon miroir

8

9

10

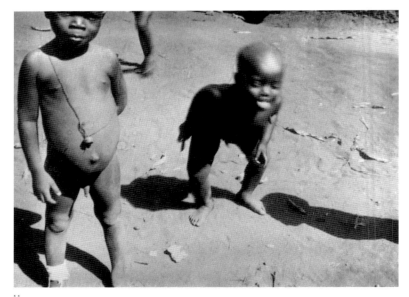

11

7 'Cigar-seller in Cuba', in *Art* by Ozenfant, Paris, 1928, p. 101

8 'Negro woman seeing herself in a good mirror for the first time', in *Art* by Ozenfant, Paris, 1928, p. 263

9 Photograph by Marc Allégret, in André Gide, *Voyage au Congo*, followed by *Retour du Tchad*, Gallimard, 1929

10 Photograph by Marc Allégret, in André Gide, *Voyage au Congo*, followed by *Retour du Tchad*, Gallimard, 1929

11 Henri Cartier-Bresson, *Ivory Coast*, Africa, 1931

plausible that HCB had even admired the sixty-four photographs in this book (meticulously reproduced in heliogravure); taken by Marc Allégret (figs. 9 and 10), they were amateur photos devoid of artistic standards but all the more effective, and HCB would soon have the occasion to recall them when he was himself in Africa (fig. 11)[27].

Geometry: topology, punctuations, echo

In 1930-1931, HCB had not yet found his method, but he was actively looking for it, on the sly as it were, without claiming to be a photographer. The many negatives found among the 'singles', from the 1931 trip to Eastern Europe (Poland, Czechoslovakia, Budapest, Berlin) (figs. 12, 13, 14), none of which is included in the *Scrapbook*, attest to an attraction to features which were already pronounced: faces seen in medium close-up, backgrounds of shop signs, complex figure groups. An event in his personal itinerary was to take him away from this goal but abruptly brought him back to it: his 1931 departure, which was instigated by Paul Morand and motivated by the spirit of adventure and the desire to break with a routine which had already been opportunely disrupted by the journey in Eastern Europe. The 'Rimbaldian' choice of Africa thus gave rise to the stay in the Cameroon and the Ivory Coast, hunting for game in the bush, photographs made with a Krauss camera, some of which were lost because of the climate, bilharziasis, the brush with death and the moribund return. And at the end of this very full year, a revitalisation through photography: in 1932, HCB bought a Leica in Marseilles.

He always said so: it was with the Leica that he became the photographer Cartier-Bresson, the one who made images on the run, who shot photos like arrows, because the Leica was the only camera which permitted such a posture: loaded with 35 mm movie film, it was meant to be very easy to handle, quick to use, without having the settings get the edge on the sighting. Its most distinctive feature was the viewfinder which, placed in front of the

eye, showed the exact field covered by the lens: the space aimed at corresponded to what would appear on the 24 x 36 mm negative. The novelty lay in the precision, the clarity of what was seen, and the reliability of the frame the photographer defined at the moment the camera was aimed – which earlier hand-held cameras did not permit with the same accuracy. The Leica reached the market around 1928 (the date when Kertész bought one) but many followers of the 'new photography' who used it did not do so exclusively, depending on the kind of work involved: the negative was very small and not always suitable for the 13 x 18 cm or 18 x 24 cm prints intended for the press. Equipped with a standard 50 mm lens, with the possibility of 35 mm, it gave HCB the possibility of two positions, distant or close[28]. And, unlike other cameras, the Leica was not intimidating for the person being photographed. It did not give the impression of capturing something or intruding, perhaps because it hid the photographer's eye and replaced it with an artificial eye of glass which did not 'really' see. When the photographer came closer, what he lost in terms of anonymity (because he was now identified) was gained in complicity with the subjects, who became partners in the photograph: they knew they were being photographed and played on it, especially if their interlocutor won their trust: 'This profession depends so much upon the relations the photographer establishes with the people he's photographing, that a false relationship, a wrong word or attitude, can ruin everything'[29].

With the Leica, HCB discovered above all the possibility of constructing the geometry of the image, enclosed within the 'perfect' proportion (2:3) of the frame. Photography, after all, is only the effect of a geometric projection on the film stock, and the Leica, in HCB's view, permitted this to be controlled with the greatest efficiency, while remaining very mobile. His taste for construction through a system of lines and proportions probably came from Lhote and Purism.[30] The golden section was in the fore of the 'return to order' of the 1920s, the Neoclassicism à la Puvis de Cha-

27 The documentary film of the same title, *Voyage au Congo*, which was Marc Allégret's first feature-length work, was made in 1927 and released in 1928. / **28** The Leica Ia (March 1930) had three interchangeable Elmar lenses of 35, 50 and 135 mm. The 90 mm appeared in 1931.. / **29** 'The Decisive Moment' in *The Mind's Eye*, p. 28.

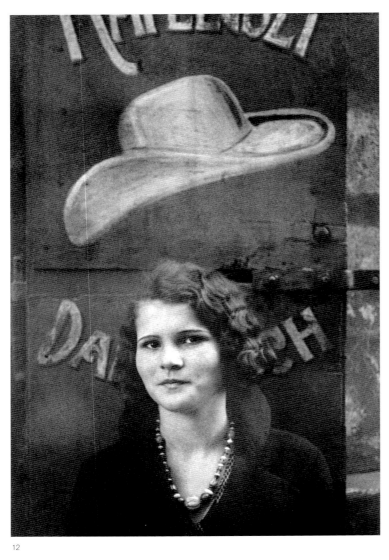

12

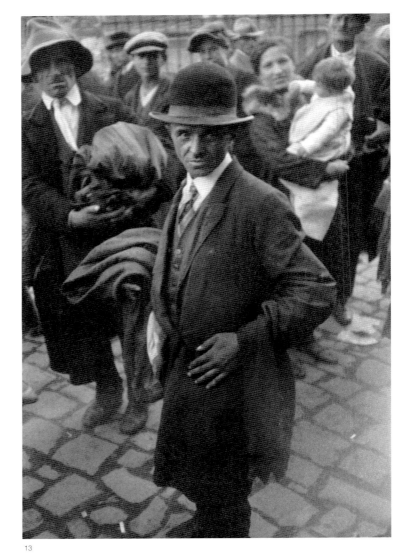

13

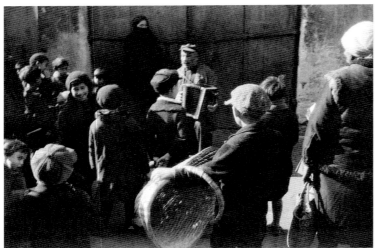

14

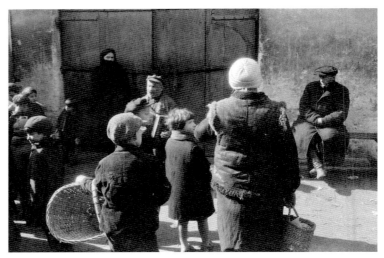

12 Henri Cartier-Bresson, *Krakow, Poland,* 1931
13 Henri Cartier-Bresson, *Krakow, Poland,* 1931
14 Henri Cartier-Bresson, *Poland,* 1931

vanne or Maurice Denis bolstered by a widely distributed book justifying Pythagorean construction, *Le Nombre d'or* (The Golden Section) by Matila Ghyka[31]. But in photography, geometry is not a property of the space itself but the result of the viewpoint chosen (the centre of the lens) to take into account a three-dimensional space and the delimitation of the frame by the photographer's body movement. In a far shot, the geometry is that of the architectural lines, the shadows, the linear perspectives of empty public spaces seen in the high-angle shots dear to HCB, and closer to the foreground, sidewalks and street lamps, shop signs, a cast-iron gate. But in this geometry, there has to be an event which makes it come alive, which gives it a tonality, like an accent on a syllable: one or several passers-by (fig. 15), a cyclist, children playing.

The examination of the photographs in the *Scrapbook*, and especially the comparison with the surviving negatives ('singles' and 'Liberation'), bring out what was in fact HCB's determining stance as the surveyor who was able to define a fixed, invariable frame and wait for the successive events which would fill in this geometry: here, the passers-by making their way along the sidewalk of a curved parapet in perspective, overhanging a slope where we can see the photographer's shadow. For one of the photos preserved by HCB in the *Scrapbook*, we have four very similar negatives, where the only variation is that of the passers-by (SB 92 - fig. 18). Random intrusions in a commanding structure: HCB is a lookout who has set his trap and just has to wait for the insect to get caught in the wires. The public squares in Italy or Spain, with their harsh shadows and their rare strollers lent themselves quite well to this exercise (SB 94); like the high-angle shot of a staircase, which comes alive with a cyclist below (SB 10), or the devastated urban space in which a scrawny pedestrian turns up (two existing shots with the same composition) (SB 17), the buildings in ruins and the priest with his cane (SB 340), the

donkeys seen from above on a mountain path (SB 71), the woman followed by a dog on a ground striped with dark lines (SB 49), the child standing in front of a cart on the edge of a vast geometrical patch of shadow (SB 35).

But the geometry of the image is only the projection of the spatial topology onto the sensitive surface, the topology of the photographic 'arrow' shot into a field whose two-dimensional centre is the position of the photographer's eye, and whose projected two-dimensional image (i.e. a *project* for an image) would be the target: 'And above all, that mysterious thing in photography: composition, geometry. If I move one millimetre, how does that make for a better composition? That's why I told myself, "You can't crop."'[32] The figures placed at different depths are like echoes of one another, and this double punctuation is also an HCB trademark: two men in white underwear getting dressed, with the same bending gesture, on beams piled up along a wall (SB 84 and 85); the swimmers on the banks of the Marne River echoing the couple intertwined on a blanket in the foreground (SB 159, 160, 161); the two fishermen corresponding to another couple under a tent (SB 157, 158); the husky backs of four picnickers lined up along the slope all the way to the small boat which materialises the geometry of the current (SB 201); the children seemingly arranged within the composition of the anchors and rigging on the beach (SB 73, 74).

The geometry creates the topology of the reverberations, punctuations, echoes in 'metaphysical' empty spaces with harsh shadows, which are also frequent in the work of Kertész and Lotar[33]. HCB's recognised model for the geometry of the bodies echoing each other was Martin Munkácsi's photograph of African children reproduced in the special 'Photographie 1931' issue of *Arts et métiers graphiques* (Graphic Arts and Design), which he probably saw on his return from Africa, when he had just purchased his Leica. In a letter to Munkácsi's daughter, he writes: 'Prob-

30 'I learned a lot from André Lhote, in terms of painting and the visual in general.' 'HCB, Gilles Mora: Conversation', p. 118. / **31** Mathila (sic) Ghyka, *Le nombre d'or* (Paris: NRF Gallimard, 1931). Subtitled 'Pythagorean rites and rhythms in the development of Western civilisation,' the work was prefaced with a letter from Paul Valéry. Another book by the same author was entitled *L'esthétique des proportions dans la nature et dans les arts* (The Aesthetics of Proportions in Nature and the Arts) (Paris: Gallimard, 1927). In English, see Matila Ghyka, *The Geometry of Art and Life* (Mineola, New York: Dover Publications, 1946). / **32** 'HCB, Gilles Mora: Conversation', p. 120. **33** In 'Les choix d'Henri Cartier-Bresson', the Fondation Henri Cartier-Bresson's inaugural exhibition (2003), Henri chose to represent Kertész (whom he hailed as his model) with the photo *Dubo, Dubon, Dubonnet* (Paris, 1934), which functions through echoes on different levels (formal, semantic, vocal).

15

ably in 1931 or 1932 I saw a photograph by your father showing three black children running into the sea, and I must say that it is precisely that very photograph which was for me the spark that set fire to the fireworks . . . and made me suddenly realise that photography could reach eternity in a moment. It is the only photo that influenced me. There is in that image such intensity, spontaneity, such joy of life, such a prodigy, that I am still dazzled by it even today.'[34] The geometry lies in the layering of the bodies in space, the perpendicular equilibrium of the limbs, the alternating path along which the eye is guided towards the water.

Spain, 1933 (SB 58, 59, 60) shows the most fluid interaction between a topological geometry and the random, unpredictable punctuation of the bodies (fig. 16). The site provides a view of white walls, a kind of corridor of light and rubble; a gaping hole, seen head-on, serves as a second, shapeless frame for the 'view', as if it were tearing open the surface of the photograph to see behind it; a dozen or so children dressed in black or white, one of whom is on crutches, bustle about and jostle each other, but offer the photographer a spectacle. HCB is the master of topography: 'A photographer can bring coincidence of line simply by moving his head a fraction of a millimetre. He can modify perspectives by a slight bending of the knee'[35]. He can move forward, backward, orient the camera horizontally or vertically. But he is not the organiser of the positions or punctuations or echoes of bodies which will 'make' the photo, an objective mathematical rigour which the children's independence has nothing to do with. HCB was to select three of the photos from this series for the *Scrapbook*, along with ten 'single' negatives and three others in the 'Liberation' contact sheets. Fourteen shots (and probably more) for a lesson in attention to the productive unpredictability of gestures, instances, positions echoing each other within a pre-established three-dimensional space.

A subjective geometry: gazes

HCB would certainly not want to be locked into a formula which would leave him on the outside, waiting, without the possibility of intervening, cut off from the protagonists. In the early 1930s, he clearly introduced the medium close-up of individuals and groups which, among modernist photographers, was hardly common at that time: the medium-format cameras used for the press were not suitable but the Leica lent itself to such a strategy, as Capa would also understand in Spain in 1936. Perhaps HCB had a 35 mm lens, which widened the field[36]. In short, from close up, the figures override the geometry of the surroundings, which is effaced. The figures then become the geometry of the image because they take up its entire surface. But figures of subjects who are thinking, suffering, seeing, constitute a whole other structure, a second geometry full of meaning and emotion: the interlace of gazes, their directions, their paths. Each gaze indicates more or less what drives it, what it bears on, within the image or outside of it, or towards the photographer. The 'looking subjects' (which we are at every moment, and everywhere around us) base their system of relationships, their behaviour and their intelligence of the world and others on these mediating signals which are sent, received, exchanged, captured on the move, and which we willingly assimilate to light rays, the very ones which act upon sensitive surfaces. After all, isn't our retina, the organ of this reception, photosensitive? And the gaze, the visual manifestation of sensitivity? We instinctively transfer this understanding of gazes onto our

34 Letter dated 25 May 1977 (with thanks to Agnès Sire for this information). HCB also speaks of his amazement when he saw this photo ('the one which was determinant for me', 'this is the photo which marked me') in 'HCB, Gilles Mora: Conversation', p. 118. / **35** 'The Decisive Moment' in *The Mind's Eye*, p. 33. / **36** Given HCB's praise for the 'naturalness' of the 50 mm lens, standard for the Leica, because of its correspondence to human vision, it has sometimes been assumed that he only had one and the same Leica, and that the invariable setup would thus guarantee the consistency of the method. It is known, however, that over his years as a photographer he had several kinds of Leicas – which did not all offer the same possibilities: 'The tools for the job were one or two Leicas M4 or 3G . . . usually fitted with a 50 mm Elmar. . . . In his bag, although they were rarely used, were a 90 mm lens to capture the foreground of landscapes, and a wide-angle 35 mm lens. He generally avoided using the former because it distanced him too much from the subject, and the latter because it could jeopardise the balance between forms. . . . his speed was 1/125th.' (P. Assouline p. 245). We also have the account of American writer Truman Capote, who accompanied HCB in Louisiana in 1946 and reported, perhaps with a certain exaggeration, that he had 'three Leicas swinging from straps around his neck' (cf. Agnès Sire's essay in the present volume).

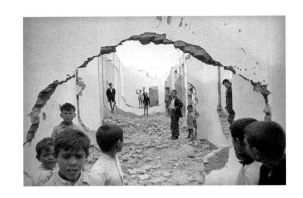
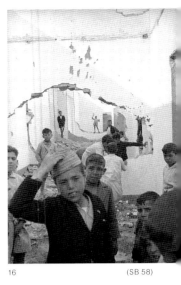

(SB 59)

16

(SB 58)

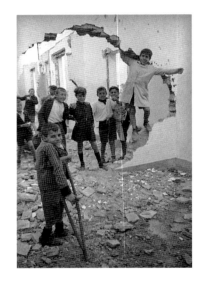
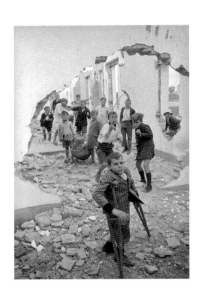
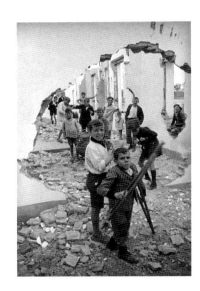
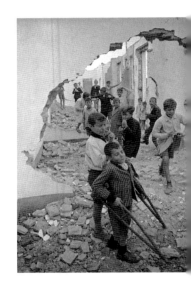

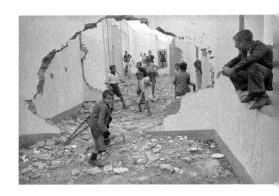

16 Henri Cartier-Bresson, *Seville, Spain*, 1933

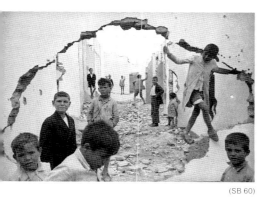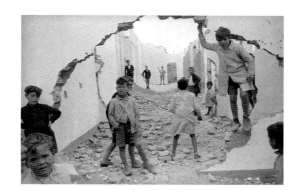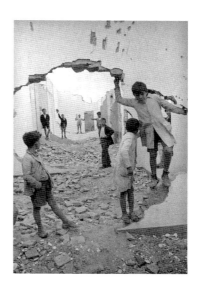

(SB 60)

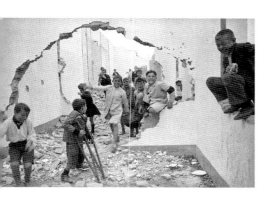

17

18

(SB 92)

17 Henri Cartier-Bresson, *Paris, France*, 1933. Cover of the magazine *Crapouillot*, April 1933
18 Henri Cartier-Bresson, *Spain*, 1933

perception of images, and so much so that photos have perhaps taught us to analyse the functions of the gaze.

The geometry of invisible, imaginary lines is something we imagine quite well because, as unrepentant lookers, we are always party to them, and these lines which we instinctively reconstitute give meaning to the image, give new life to the scene as if we were participating in it. We trace lines between those who are looking within the images, and between them and us, putting ourselves in the place formerly occupied by the photographer, so that the people in the photo are now looking at us. Our presence is mental but it makes us into decoders of the intentions and projections of the others, of the emotions they feel towards – or against – what they are looking at. Cartier-Bresson the photographer had discovered that he could be the instantaneous co-ordinator of that geometry, the organiser – if he believes it, we believe it – and that certain configurations of the subjective geometries of gazes were more meaningful than others.

But is it possible to seek out the unpredictability of the photo to come – what is *not visible beforehand* – and to be its organiser? 'Since these mysteries are beyond me, let's pretend to be their organiser,' Cocteau would have said. That modest 'pretending', however, might well have provided the basis for a poetics of photography. The photo seeks to capture those 'explosive glances' at the moment they will offer the greatest number of meaningful impacts.

The image most often cited in terms of the gaze (*Brussels, 1932* – SB 16) is that of the two would-be gatecrashers standing in front of a cloth which blocks their view of a show: they echo each other against the diagonal of the cloth, with their suits, their hats, their shadows, but that is not enough to make 'a photo'. It is clear from the outset that the real subject is the two divergent gazes of these men, and the frustrations they imply: the one in the middle ground indicates something desirable, appealing, which is invisible to us; the one in the foreground, large eye gleaming attentively, makes us witness its distraction, as if to say that the pleasure may lie elsewhere.

In *Barrio Chino, Barcelona, Spain, 1933* (SB 87), the face drawn in chalk, a profile with a cap and a big eye, echoes the sleeping man seen in profile in the foreground, whose eye would in any case be hidden by the shadow. The drawing makes the sleeping man even more human by accentuating the interplay of opposites: open/closed, attentive/absent. With the shop sign for the corset (*Cordoba, Spain, 1933* – SB 75), the woman in black is a replica in reverse of the painted figure of the young woman, through the same echoing of forms – the mannered hand gestures, the wavy hairstyle, the symmetrical bearing of the heads – but above all the contrast of the two gazes addressed to us: that of the painting, hidden by an oval label which reappears on her hip, but which is directed at the viewer (or at least we perceive it that way), and that of the woman, reduced to a minimum but sufficiently readable to express a certain awkwardness. In fact, HCB made seven shots of this scene (5 vertical, 2 horizontal), moving very little himself, until the points of view became part of the underlying geometry. Without the positioning of the gazes, there would be no denouement, no significant outcome to what would remain an anecdote.

Cartier-Bresson's strategy makes the eye the subjective pivot of the interaction between protagonists, a photographer, future viewers; this approach (which is deliberate because it is repetitive) implies that each photograph is an object entailing – and thus expressing – this kind of human relations, and thus to be viewed as such. But on the spot, he could not anticipate reactions which were by their very nature *unpredictable* and could only count on chance or complicity (fig. 17). His awareness of this phenomenon is clear in the five *Scrapbook* photos of a Spanish family (*Spain, 1933* – SB 65 to 69), father, mother, child, in a window, behind the cast-iron bars which establishes the geometry of the composition. Two shots, with the mother, are vertical, three, without her, are horizontal. This is the largest number of similar views in the *Scrapbook*, which is an indication that HCB found all five of them interesting and had put off the final decision. There are also three unprinted negatives in the selection of 'Singles' which correspond to the same formats (two vertical with the mother, slightly farther away, and one horizontal) (fig. 19). We can

19

(SB 69)

(SB 68)

(SB 67)

(SB 65)

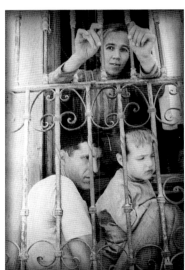
(SB 66)

19 Henri Cartier-Bresson, *Valencia, Spain*, 1933

easily reconstruct the situation (through the numbering on the film)[37]. HCB notices the figures behind the window gate, just a bit above him. He is quite close, the father pretends not to see him, goes along without any sign of approval in his gaze (a direct gaze would signify agreement). The child (always the expressive centre of a photo) does not really know what to think; he looks 'sideways' at the photographer, or elsewhere; he is in his parent's care and he knows it. HCB does not change places, the camera hardly moves. The mother arrives, HCB positions the camera vertically to include her. The gate, which is quite high, continues to play the same compositional role. The mother stands back but is intrigued; she comes closer, leans forward and grasps the bars. Is she going to say something? The moment of unpredictability is over. Once again, the photographer is on the lookout, waiting for glances or postures which induce meaning, additional sensitivity, the greatest possible number of trajectories over the surface of the image and towards the viewer (who is, for the time being, the photographer). This 'something extra' may not arrive, Henri will see that later on the contact sheets. In each of the eight photographs, the slight variations in the positions of the faces, the orientation of the gazes, the opening of the eyelids, the direct address to the photographer (acceptance of his presence), provoke different associations – anxiety, sadness, boredom, resignation, annoyance – which are superimposed on the respective poses. The only photo which was published (in *VU*, no. 296 – SB 65), and which undoubtedly corresponds to the final choice, is the one which creates the most 'visual' links from eye to eye: the child and the mother look at the photographer, the father gives a sidelong glance without turning his head[38].

The only way to penetrate an image is to include oneself in the paths of the gazes going back and forth with the surface, and to accept, within this same movement, the networks created among the protagonists, or sometimes between them and what is outside the frame. Of the 150 *Scrapbook* photos from before 1936, more than a third are based on this strategy of the gaze which emanates from each face and includes the photographer in a web which is invisible but perceptible to everyone, the very foundation of sensory communication among human beings.

The logic of this strategy is perfectly obvious: the more 'transmitter' faces there are in a photograph, the more imaginary rays (and meaningful rays) there are going from these eyes to their identified or presumed target and coming together by taking the photographer, and thus the person looking at the image, as a witness (and taking them aside as well). When we are in front of a photograph, we participate in the exchanges of gazes. Each person brings their personal experience to it, according to their perceptual capacities and their own emotional penchants for solicitude, confrontation or evasion.

More examples: Three people who become six through the play of a sidelong mirror (SB 56), which multiplies the positions, angles and axes and makes them into a complex image of suspended questioning. Guys wearing caps, out of work or on strike (SB 5), who surround a policemen, seen from behind: he is under attack, caught in the trap of uncomfortable convergences. HCB enjoyed these constructions of tangled lines (bodies, faces, gazes), at least one of which was directed at him. *Cardinal Pacelli in Montmartre, Paris,* 1938 (SB 210)*,* and *Gold Sale in the Last Days of the Kuomintang, China,* 1949, are the high points.

And once again children, in the gaping hole of *Seville,* 1933 (SB 58, 59, 60), which, functioning as both oculus and peephole, maintains the viewer's eye within its ellipse. The dizzying architecture, the positions of the bodies would be enough, but there are also those questioning or knowing glances, which reorganise all the mystery by clouding the issues. Children are the ones who conceal

37 For our purposes here, we have reconstituted the order in which the shots were taken (numbers 17 to 24), which is not the order in which the contacts are placed on the 'single' sheets. The film, with numbering, was manufactured by Perutz (the other brand used by HCB was Agfa, without numbering). Perutz was the first to market orthochromatic film in 36-exposure cassettes. In 1930, Kodak, Agfa and Pathé also came out with 36-exposure cartridges and this is when Perutz started putting the numbers 1 to 36 on the film. See 'Le système Leica. Les années 30' (The Leica system. The 1930s), *Prestige de la photographie* no. 2, September 1977, p. 120. / **38** Shot no. 23 on the film. Galassi, with HCB's permission, reproduces one of the three unpublished singles, no. 20, which does not appear in the *Scrapbook* (*Early Work*, p. 125).

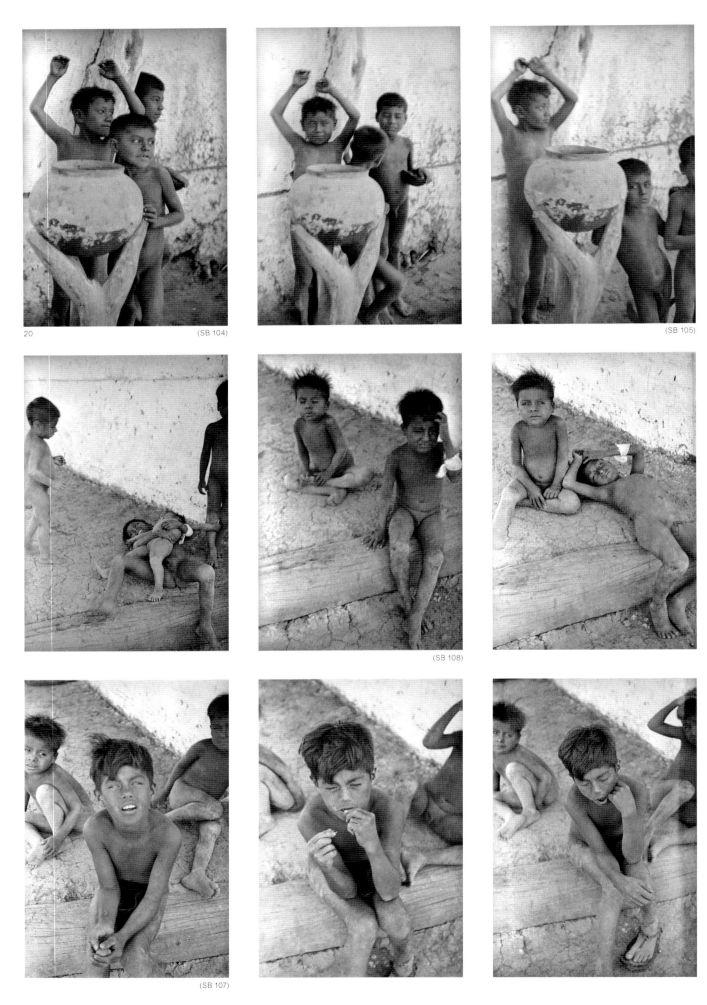

20 (SB 104)

(SB 105)

(SB 108)

(SB 107)

20 Henri Cartier-Bresson, *Mexico*, 1934

things the least. A shapeless group (SB 120): the armature which holds the amalgam of bodies together and props them up on all sides, punctuated by an uneasy woman in the background, is that of the directions which the eyes make us follow.

The gaze is what structures the field of intentions, emotions, subjectivities, which is nothing other than the surface plane of the photograph: it is there alone that we give it visibility. Four photographs (in the *Scrapbook*) of naked children (*Mexico,* 1934), plus five other negatives, invite a random construction through the flexible geometry of the bodies, animated by lively, shifting glances (fig. 20). But a given gaze is never just an interpretation of our own making: the one we think we perceive on an image is only a projection; we attribute life and intention to it, while it is only the sign of the position of two eyes. And what is unpredictable in a photographic scene, the unforeseen ability of a coincidence, can only confer a presumed meaning. One of HCB's most famous photographs (*Valencia, Spain,* 1933) (SB 86) shows a young boy looking into the void, along a peeling wall which is not without influence on the interpretation. But this leads to a misunderstanding (what is mis-understood) of his swaying posture, like a blind person with an impossible gaze. In fact, his eyes, squinting from the light, are searching for his ball, which is in the air.

Filmic situations

HCB's photographs, those of the 1930s, are distinguished by the ability to grasp and condense geometries and subjective trajectories. This was to remain a driving force throughout his career: in one of the most famous photographs, four women in long hooded capes, seen from behind, side by side, in Srinagar (*Kashmir,* 1948), designate through their position, and the outstretched hands of one of them, the vast horizon bounded by the mountain, which gives off a diffuse light. The gazes are not seen, but a crouching woman plays the role of intercessor by turning towards her companions, conferring a gaze on them in our

place; she gives them sight, on our behalf. Once again, a double geometry, spatial and subjective, of designations.

If we compare the photographs of Kertész and those of HCB from the 1930s, the former seem closed into their structure (fig. 21), locked into the reading of their enigma; their framing restricts the meaning, we stop at that limit of the image (splits, echoes as with HCB), there is nothing which invokes the outside. But the latter, on the contrary, are open to what is outside the frame; we understand that they are only a fragment of a continuity, one instant of a little adventure between people who do not know what will come next. They are not metaphors of the chance encounter, within the frame, between unexpected elements; they participate in a relationship between people, between these people and the particular geometric features of the space, where the photographer has introduced himself. His subjects themselves often indicate his presence, include him in their interplay.

We are entitled to ask ourselves how these threads could have been manipulated by HCB, or where, in any case, he could have perceived their potentialities. In fact, the important model looming over photography around 1928-1935 – but which in no way provided it with a direct example – was *film*: after all, the great exhibition held in Stuttgart in 1929 was entitled 'Film und Foto' in order to take into account the two modern (avant-garde) paths of the image whose common basis was 'photo-graphy'. But film was so much defined by an unprecedented economy of the production of stories, by movement and editing, that the proximity to photography was at once something obvious and a blind spot: something which went unnoticed. And yet, all the photographers went to the movies, beginning with HCB, since his youth (and the 'photographic' innovations of film are more visible for someone who is a photographer). The various references he has indicated himself show the intensity of his interest. Indeed, the second paragraph of his introduction to *The Decisive Moment* (after an opening paragraph offering references to painting) is the following: 'And then there were the movies. . . *Mysteries of New York,* with Pearl White [1915]; the great

CHEVAUX de BOIS

Photo André Kertész

21

films of D. W. Griffith – *Broken Blossoms* [1919]; the first films of Stroheim, *Greed* [1924]; Eisenstein's *Potemkin* [1926]; and Dreyer's *Joan of Arc* [1928] – these were some of the things that impressed me deeply.'[39] Indeed, such a declaration, at the beginning of the essay which established the legitimacy of his career as a photographer, would seem to be more revealing than the 'decisive moment' of the epigraph. HCB would also express his great admiration for Jean Vigo (*A propos de Nice*, 1930; *Taris*, 1931; *Zero for Conduct*, 1933; *L'Atalante*, 1934), but he had in fact seen and appreciated many films without feeling the need to talk about them. If it is difficult for the time being to define his early ties with film, the role of film historian Georges Sadoul (whom he knew before 1934 and who subsequently became his brother-in-law) might nonetheless be advanced. We do not know when and how he met Buñuel (perhaps through Crevel), which would lead to his encounter with Lotar as well (see below)[40]. For HCB, film was much more than a cultural reference, or a medium closely related to photography: he wanted to become a filmmaker. In 1935, during his stay in New York, he went to study with Paul Strand (who was also a photographer): 'I stopped photographing in 1935, when I was in New York. . . I've abandoned photography like that several times in my life. Let me tell you again: photography isn't essential for me. So I started learning filmmaking from Paul Strand, with other people'[41]. On his return to Paris, he sought to meet film directors: 'He approached Luis Buñuel, who said no. He had chosen Buñuel because he knew him'[42]. On the advice of Paul Morand, 'He approached Georg Wilhelm Pabst . . and he too said no'[43]. He then besieged Jean Renoir, showing him the album of forty photographs he had prepared to convince the master of his abilities – in film. This effort led to his participation in *Une partie de campagne* (A Day in the Country) as second assistant, without great enthusiasm. The years which followed were mainly occupied by film: in 1937, HCB became actively involved in the Spanish Civil War but did not take a single photo: he made a film (*Return to Life*). And he was always to regret it, because he understood that it was in Spain that Capa and Chim had created new issues and languages for photojournalism.

That said, for a photographer, there were other possible contacts: films were not just visible in a movie theatre, they could be seen in the form of *photographs*. At the end of the 1920s, the film magazines appeared (notably *Pour Vous* [For You], November 1928); every film production had a stills photographer whose images made on the set fed the magazines. The films themselves were accompanied by publicity booklets which were sometimes quite luxurious, and the 'preview photos', which could be either production stills or shots from the film, were tacked up at the entrance to the theatres and made available to the press. All the art magazines had a film section (beginning with *VU*, in 1928, under the direction of Edouard Gréville): there were not simply reviews but pages illustrated with photos specifically chosen to correspond to the editorial style. One magazine dealt with film on an intellectual, theoretical and artistic level equivalent to that of *Documents:* the monthly *La Revue du cinema* (1928-1931), which contained dozens of film stills in each issue: Victor Schertzinger's *The Showdown*, King Vidor's *Hallelujah!*, *The General Line* by Eisenstein and Aleksandrov, Clarence Brown's *The Trail of '98*, Dovjenko's *Earth*, Pudovkin's *Mother*, Pabst's *Westfront 1918*, José Leitão de Barros's *Maria do Mar*, Lewis Milestone's *All Quiet on the Western Front*, *Anna Christie* (Garbo's first talkie), Ivens's (and Lotar's) *Zuiderzee*, Murnau's *Tabu* and others.

The filmic gaze

Once we turn our attention, without preconceptions, to this world of photos which are not really photos, the singularity of this 'filmic photography' becomes obvious: we

39 'The Decisive Moment' in *The Mind's Eye*, p. 20. / **40** Buñuel had created a Surrealist group, the Order of Toledo (1923-1926), whose members included Dali, Lotar, Crevel and Sadoul. See the catalogue *Tierra sin pan. Luis Buñuel y los nuevos caminos de las vanguardias* (Valencia: Ivam, 1999). / **41** 'HCB, Gilles Mora: Conversation', p. 120. / **42** P. Assouline, p. 135. / **43** Idem, p. 136.

A l'Ouest rien de nouveau. — Première révolte contre les galons.

UNIVERSAL.

22

MARIE DRESSLER dans le personnage de Marthy, la vieille soûlotte d'*Anna Christie*.

M. G. M.

23

FILMS SUR LA GUERRE

Westfront 1918 par G. W. PABST.

NERO.

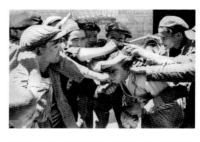

La bagarre qui ouvre **Contre-Enquête**, film policier parlant français tourné à Hollywood.

FIRST NATIONAL.

25

A l'Ouest Rien de Nouveau, par Lewis MILESTONE. Nous parlerons en détail de ces deux films d'une importance considérable dans notre prochain numéro.

UNIVERSAL.

51

24

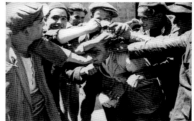

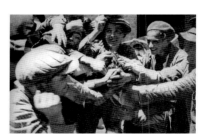

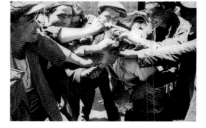

26

22 *All Quiet on the Western Front*, by Lewis Milestone, 1930, in *La Revue du cinéma*, n°22, May 1931
23 Marie Dressler in *Anna Christie*, by Clarence Brown, 1930, in *La Revue du cinéma*, n°23, June 1931
24 'War films', *Westfront 1918* [*Comrades of 1918*], by G. W. Pabst, and *All Quiet on the Western Front*, by Lewis Milestone, 1930, in *La Revue du cinéma*, n°16, November 1930
25 'The opening fight scene from *Contre-Enquête*' [by Jean Daumery], 1930, in *La Revue du cinéma*, n°17, December 1930
26 Henri Cartier-Bresson, *Spain*, 1933

know that we are seeing film images, and not just because they appear in a specialised publication. We would have the same reaction if they were isolated from the film context. For one thing, the situations are clearly not those which we might encounter in daily life, regardless of the circles we move in. But above all, the reciprocal behaviours of the protagonists are 'arranged', organised in view of defined meanings; they are in a certain way programmed to be what they appear to be, they are 'predicted' and not 'unpredictable'. On a film set, the unpredictable actor would be dismissed, or made to start over again to align himself with what has been planned. And that comes out in the gestures, the individual postures, the geometric arrangements of the groups and essentially, the network of internal gazes which, exceptionally, will be addressed to the camera (and the director-cameraman knows very well that this designation implies emphatic meaning, emotion, testimony). The 'filmic' gaze is much more predictable that the 'photographic' gaze, which is practically unpredictable.

The groups have a coherence, they know their *raison d'être*, which is the story they are part of (Lewis Milestone's *All Quiet on the Western Front*, 1930, in *La Revue du cinéma* no. 22, May 1931) (fig. 22). They are organised through individual postures, with each person in a specific role in order to form connections, through scattered glances which are fully aware of the presence of the camera (their nerve centre). Sometimes a single gaze shapes the entire scene, addressing something off-camera which the film viewer understands but which the person looking at the photo has to interpret as an enigma in itself (Marie Dressler in *Anna Christie*, 1930) (fig. 23). This is what makes all the difference: this film photo could be as much a photographer's photo as an excerpt from the film.[44] The staged group of Pabst's *Westfront 1918* (1930, *La Revue du cinéma* no. 16, November 1930) (fig. 24) is much more convincing than any scene from a reportage. And the interval between the two is doubtless where HCB wanted to situate himself.

The group of men fighting in Jean Daumery's *Contre-enquête* (Counter-Inquiry, 1930) (fig. 25) (*La Revue du cinéma* no. 17, December 1930) is not far from the street-fighters whose 'unscripted scene' HCB wound up provoking by his simple presence as a photographer (*Valencia, 1933*) (fig. 26): in short, practicing photography 'as if' it were film, but sometimes 'just for laughs'. Here and there, we can see what might be anticipations of HCB's later photographs, a view from the mind's eye or the unconscious of the gaze to come: the compassionate distribution of bodies and glances in Murnau's *Tabu* (fig. 29), José Leitão de Barros's *Maria do Mar* (fig. 30)[45].

During those years, film might well have been photography's unconscious, producing a profound renewal of photo-like situations and images in black and white. The presentation of a reportage by Carlo Rim on 'The Street' in the form of a three-shot film strip (*Jazz*, June 1929) makes it read like a short story; the outdoor urinal with the movements of its users was to be particularly appreciated by contemporaries, including HCB (fig. 27). *Film-Photos wie noch nie* (Film-Photos Like Never Before), published in 1929, classifies, in some 190 pages, the aesthetic innovations of film – in the form of photographs (1,200 reproduced)[46]. Film stills showed feelings, situations, intentions which had never been seen before in image form (fig. 28).

HCB could not have been unaware of all that, especially since his Leica used 35 mm *film* stock[47]. In his photographic practice, when he kept moving in front of his subject to frame it, he was not a filmmaker, but was he not trying to be one? The camera was sometimes riveted to his eye as if it were permanently on the move, which explains why the person photographed did not know exactly when the shot was taken. All those who use a Leica say the same thing: the shooting process yields strips of film (about 36 images) from which one or two frames will be selected[48]. The

44 *Anna Christie*, dir. Clarence Brown, 1930, MGM, with Greta Garbo. Photo reproduced in *La Revue du cinéma* no. 23, 1 June 1931, p. 29. / 45 *Tabu* (1931) in *La Revue du cinéma* no. 25, August 1931; *Maria do Mar* (1930) in *La Revue du cinéma* no. 17, December 1930. . / 46 *Film-Photos wie noch nie* (Giessen: Kindt und Bucher Verlag, 1929). The publicity strip on the cover announces '1,200 photos from the best films of all countries'. / 47 HCB: '[the photo-reporting trade came to maturity] due to the development of . . . fast fine-grain films produced for the movie industry.' 'The Decisive Moment' in *The Mind's Eye*, p. 38. / 48 The use of two Leicas, in HCB's case among others, is justified by the increased number of shots of the same subject and the desire to avoid wasting time to change rolls of film by switching over to the second camera which is already loaded.

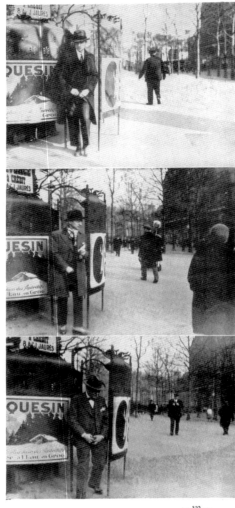

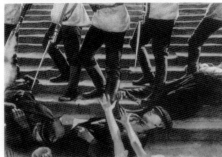

parce que rien ne ressemble plus à un arbre qu'un autre arbre et que le ciel est bleu partout et que les prairies sont toujours désespérément vertes.

Je sais dire : « préparez-moi un bain », ou « n'avez-vous point trouvé un portefeuille sur la cheminée ? » en dix-neuf langues et dialectes. Je sais que les meilleurs sommiers sont allemands ; que les punaises les plus rageuses sont italiennes ; que le miel le plus doux est suisse ; que les femmes de chambre les plus charmantes sont viennoises ; que les robinets les plus pratiques sont français ; que le whisky se boit à Bombay ; le véritable porto d'origine à Paris et le champagne à New-York. Je ne connais ni les pyramides du Caire, ni la Maison-Carrée de Nîmes, ni le pont de Brooklyn, ni le temple d'Angkor, parce que je n'ouvre pas mes fenêtres quand il pleut, et l'on peut toujours me poser des colles sur l'art égyptien ou gallo-romain ou khmer !

Hier encore, je fumais ma pipe sur l'étroit balcon du *California* et je ne connais de votre Paris, que ce que l'on en peut voir de cet observatoire : un arbre dans sa petite cage ; une terrasse familière où des gens boivent à petites gorgées en souriant à leurs voisins ; un bout de trottoir où défilent les plus grosses moustaches, les seins les plus pointus du monde et où une dame unijambiste attend sans impatience l'arrivée improbable d'un Prince Charmant manchot — et enfin, deux kiosques de fer, monstrueux, puants, obscènes, où des hommes entrent, font un petit tour et puis s'en vont, la main à la braguette, l'œil ingénu...

Wilbur Trott sourit. « Paris, pour le plus grand nombre d'entre nous, c'est le café sur le trottoir, l'arbre dans la cage, la prostituée à béquilles, la vespasienne ventrue et crachotante. Vous êtes le peuple le plus spirituel de la Terre, mais vous pissez comme des cochons... La Joconde, la Tour Eiffel, la perspective des Champs-Elysées et la crypte du Panthéon ne nous feront jamais oublier cela...

Prendre au lasso, pour les coller tout vifs dans un album de famille, les mendiants de Stamboul, les pigeons de Venise et les faunes de Versailles, non merci ! Mais un photographe malicieux aurait mieux à faire, au cours de ses voyages...

■

Wilbur Trott consulta sa montre, se leva d'un bond et me tendit la main.

— Je voyagerai encore quelques années, dit-il ; et puis, un soir, je mourrai au fond de quelque Terminus, dans le tumulte aigu des départs. Mon linceul s'ornera sans doute d'une locomotive brodée et un porteur à blouse bleue et à ceinture de pompier descendra mon cercueil, sur ses épaules, comme une malle...

CARLO RIM.

Photos Latour

— 322 —

206 POTEMKIN

28

27

MARIA DO MAR

Comme l'image de notre couverture, cette scène étonnante est extraite de *Maria do Mar*, film portugais de Leitão de BARROS. *Maria do Mar* est un documentaire romancé sur les pêcheurs de Nazaré, descendants de colonisateurs phéniciens. Leitão de BARROS, qui a sans doute été influencé par le film russe, a si étonnamment fait passer dans les images de ses films les caractères originaux de son pays. La brutale simplicité des photographies que nous publions le montre. *Maria do Mar* est le cinquième film de Leitão de BARROS qui a déjà réalisé *Malmequer* (1918), *Mal de Espanha* (1919), *Nazaré, plage de Pêcheurs* (1928), *Lisboa* (1929). *Maria do Mar* a été fait également en 1929. Il travaille actuellement, sous la supervision de J. Bernard BRUNIUS, à un film parlant, *A Severa*.

29 30

27 'The street', by Carlo Rim, photos by Latour, in *Jazz*, n° 7, June 1929, p. 322
28 'Potemkin', in *Film-Photos wie noch nie*, 1929, pp. 206-207
29 *Tabou* by F.W. Murnau, 1931, in *La Revue du cinéma*, n°25, August 1931
30 *Maria do Mar* by José Leitao de Barros, 1930, in *La Revue du cinéma*, n°17, December 1930

method falls between the practically unique shot to which glass plate cameras were limited (large format or hand held) and the film shot. The coexistence of 'photographer's' photos and 'film' photos in many magazines could only blur the boundaries, especially when these were artificial, and this was all the more true for someone (HCB) who expressed his profound desire for both professions in the form of permanent hesitation.

HCB had an equal in this respect, moreover: Eli Lotar, who, like him (but also earlier than him), was involved with photography and avant-garde film, and in equal measure. In 1927 he shot the production stills for L'Herbier's *L'Argent* (Money, 1928), went on to make a documentary with J. B. Brunius, *Un voyage aux Cyclades* (A Voyage to the Cyclades, 1931), published photographs and frames from the films of Jean Painlevé (he was Painlevé's cameraman) in *Documents*, shot part of Joris Ivens's *Zuiderzee* (1929) (cf. *Jazz*), worked with *La Revue du Cinéma* (see above), participated in poet Jacques Prévert's October Group, was Buñuel's cameraman on *Las Hurdes* (Land Without Bread), shot in 1933 – while abundantly publishing his photo-reportages (from 1928 to 1931, some 20 of them appeared in *VU*)[49]. Lotar's photographs were widely distributed and always noticed because they simultaneously belonged to the systems of photography and film. It so happens that HCB appreciated Lotar a great deal and that he liked Lotar/Buñuel's *Land Without Bread*, which was not shown until 1937 but from which he might have seen photographs earlier on[50].

We might thus advance an initial hypothesis, subject to further analysis, that, both by going 'to the movies' and by looking at 'film photography', HCB could have encountered those strange situations, those insistent poses, those intense gazes[51], those 'mute' but talkative expressions, those direct addresses to the camera[52].

The 'Renoir album', which HCB put together in 1936 to provide the filmmaker with his best photos, obviously contains all the images of 'gazes' cited here (the three versions of the prostitutes in Alicante, the children in Seville, the Valencia arena, the 'blinded' child in front of the wall, etc.), as well as the two versions of the Valencia street-fighters. One 'Renoir album' selection in particular brings out this filmic gaze: the variant of a shot of a goatskin which is not the usual version (SB 103) and which clearly shows three faces – or rather, three gazes – peering through the enclosure (we know that these are friends placed there by HCB) (fig. 32)[53]. The shadows indicate, moreover, that the two photos were taken at two different times and that they correspond to two different intentions (one of the three jars with their eyelike openings – other gazes – has been moved).

For a photographer like Kertész, for example, a photograph existed in and of itself, alone, and this is what made it interesting. For HCB, it was an *episode* from an action, with a before and an after, a break intervening at just the right moment in a stretch of time. It had to appear as such in order to be justified. In spite of its instantaneousness, it referred to a time of prolonged action. And this is what he was looking for in filmmaking, the telling of a story, the part of a whole. But he realised he would not make the leap to invention, the script, the painstaking preparation of the details: 'I knew that I wouldn't do fiction, probably documentaries, because I don't have literary imagination,' he remarked in speaking of his experience with Paul Strand in 1935[54]. The only reportage photo which HCB admitted being impressed by in his early years is surprising: 'Some [images] made their mark through expressive force, such as the very recent one [6 May 1932] of President Doumer, secretly photographed on the steps of the Hotel Berryer moments after his assassination . . . '[55]. Here was a real-life tragedy, unpredictable at that moment but with a course of

49 For Lotar's work on *Land Without Bread*, see *Terra sin pan*, op. cit. / 50 I am grateful to Martine Franck for these details. / 51 HCB on 'mute' images: 'For me, images should be mute. They should speak to the heart and the eyes' (interview with Michel Guerrin, cited in *Le Monde*, 6 August 2004). / 52 As an extra in Renoir's *Sunday in the Country*, HCB appears in a group of seminarians (alongside Georges Bataille), where he is supposed to be looking with disapproval at the sexual frolics of the heroine (Sylvia Bataille), obviously off-screen at that moment. On the production still of this scene, by Eli Lotar (once again!), HCB stares directly into the camera. See *Henri Cartier-Bresson: The Man, the Image and the World*, p. 349. / 53 Reproduced in Galassi, *Early Work*, p. 140. One of the jars was also displaced from one version to another. 54 'HCB, Gilles Mora: Conversation', p. 120. / 55 P. Assouline, p. 60. Photo published anonymously in *VU* no. 217, 11 May 1932, pp. 678-679.

L'ASSASSINAT
DU
PRÉSIDENT
DE LA
RÉPUBLIQUE

PAR ROBERT HUUCARD

L'ATTENTAT. Arrière... arrière... pas les photographes. (Au premier plan le capitaine de vaisseau)

Nº 217 VU P. IV

Le Bigot, de la maison militaire de Paul Doumer.

Nº 217 VU P. 679

31

32 (SB 103)

31 'Back... back... no photographers', (Paul Doumer's assassination), in *VU*, nº217, 11 May 1932, pp. 678-679
32 Henri Cartier-Bresson, *Mexico*, 1934

events whose consequences were eminently scriptable. The body was taken away, the bystanders were visibly appalled and the authorities sought to keep the photographers present from shooting (fig. 31). HCB's approval is revealing of what he was looking for: this could be a shot from a film, duly calculated and staged, but it is a successful photograph, where everything comes together in no time at all: 'For me, photography is the simultaneous recognition, in a fraction of a second, of the significance of an event as well as of the precise organization of forms which give that event its proper expression'[56]. In other words, behaving like a cameraman but only giving himself a hundredth of a second to tell the story.

From the unknown, from random circumstances, photography manufactures the appearance of fact. And from this unpredictability, HCB sought to make a dramatic distillation. The poet Yvan Goll, who wrote the best review of the 1947 MoMA exhibition, was the only person aware of this: 'We have to say that the prints exhibited exercise a poignant attraction over us. The viewer is struck as if he were before the presentation of a drama. An aspect of the tragic world is revealed to him, in this series of chance snapshots, which vividly engrave themselves in the memory, like the reverberations of a few profound verses or the appearance of a masterpiece in an old museum. As he travels the world with his Leica, Henri Cartier-Bresson continuously shows us its tragic, fateful face'[57].

Decisive but undecided

Before the founding of Magnum in 1947, which marked HCB's opting for photojournalism, he had hardly thought about what he might do with his photographs. In fact, he had only taken them periodically, essentially during his travels, when photography was a way of noting the main features of the country visited, somewhat like a poetic ethnography (*Mexico, 1934*). His experience as a reporter for *Ce soir* had been a stop-gap measure which allowed him to live but it had no aesthetic dimension. After his 1935 show, he had left a few prints in the United States with friends who were sufficiently cultured to appreciate them but in an insufficient number to make an exhibition, as Beaumont and Nancy Newhall were to realise at the time they were planning the 'posthumous' exhibition which subsequently motivated the constitution of the *Scrapbook*. The MoMA exhibit probably made him understand that over the past fifteen years, a body of work had been constituted, that it had its own coherence, style and method. After 1947, HCB would devote himself to determining the distribution of his works with rigour; he would limit himself to a strict selection of his earlier output, assert it though the publication of *The Decisive Moment* in 1952 (the layout itself sought to privilege neither period nor subject) and confirm its severity through the terms of the shot itself. While others spoke of contact sheets and editing, HCB was still a photo-journalist, dreaming of the single photo which sums everything up, relying on the instant which makes the decision: 'What actually *is* a photographic reportage, a picture story? Sometimes there is one unique picture whose composition possesses such vigour and richness, and whose content so radiates outwards from it, that the single picture is a whole story in itself'[58]

The *Scrapbook*, meanwhile, is full of an amazing number of proofs of indecision, seemingly at the opposite extreme from all the assertions which were to follow. When the photographer – who had not really opted for a photographic career in 1946 (he had just filmed *Le Retour* [The Return] on the prisoners of war) – was called upon to take stock of his photographic works, to look behind him and refine his choices in function of the presumed expectations of his American sponsors, when he was preparing to

56 'The Decisive Moment' in *The Mind's Eye*, p. 42. / **57** *France-Amérique* no. 40, Sunday 16 February 1947 (press clipping from the Fondation Henri Cartier-Bresson archives). **58** 'The Decisive Moment' in *The Mind's Eye*, p. 23. / **59** [H = horizontal, V = vertical] Doubles: 2H SB 2/3, VH SB 6/7, 2H SB 33/34, VH SB 38/39, VH SB 73/74, 2H SB 76/77, 2V SB 84/85, 2V SB 100/101, 2V SB 104/105, 2V SB 107/108, 2V SB 110/111, VH SB 112/113, VH SB 116/117, 2H SB 121/122, 2H SB 127/128, 2H SB 144/145, VH SB 152/153, 2V SB 155/156, 2H SB 157/158, 2V SB 329/330. triples: 3H SB 43/44/45, 2H1V SB 58/59/60, 2H1V SB 78/79/80, 1H2V SB 81/82/83, 3H SB 88/89/90, 2V1H SB 97/98/99, 3H SB 159/160/161, quintuple: 2V3H SB 65/66/67/68/69 /

33 (SB 76) (SB 77)

33 Henri Cartier-Bresson, *Valencia, Spain*, 1933

make his entry into the most prestigious of institutions, he was *undecided* at the time he had to prepare the content of the *Scrapbook*. The selection was intended to offer suggestions to Beaumont Newhall while politely leaving him a margin of choice, but the more than three hundred single prints would have sufficed. Instead of which, HCB agreed to show his indecision: twenty doubles, seven triples, one quintuple (i.e. the successive shots of a series executed from the same viewpoint, practically without any movement of the lens, and which, in the photographer's eyes, were so equivalent that he did not decide for the time being)[59]. And for six of these doubles and four triples, the criterion of indecision is the horizontality or verticality of the shot, which determines the geometry of the positioning within the frame[60]. For those who would like to imagine HCB in the horizontal mode alone, the apparent equivalence, in his eyes, of these two opposing formats is one of the lessons of the *Scrapbook*. With hindsight, when we know the final choices he later made between these two possibilities for the doubles, the initial hesitation is surprising by virtue of a simple teleological effect (we know the subsequent outcome). These cases of indecisiveness allow us first of all to appreciate the excellence of the multiple shots (which are no longer limited to a non-repeatable 'decisive moment' photo). Two photos which are similar but of different moments and framing are equivalent, even if temporarily. Each view has its legitimacy, in spite of the closeness to the other one. And in addition, these doubles allow us to understand the criteria which distinguish the shot finally selected. The fact that the variations can be minuscule explains a perplexity which 'recognises' the appropriateness desired but does not find a reason for eliminating one or the other.

In this way, we can see that the final choices are determined *both* by the effect of the geometry of the settings and figures *and* by the subjective effects of the gazes, an essential determinant of the Cartier-Bresson aesthetic: the three prostitutes who all look into the camera, the positions of the bodies and arms echoing the laterality of the gazes (SB 78, 79, 80); the smokers mentioned earlier (SB 88, 89, 90). Beyond the *Scrapbook*, all the 'single' negatives, made up of HCB's 'top selection' of 1940, offer even more examples of this indecision (and what's more, keeping the negatives meant giving himself the possibility of regrets and second thoughts: doubles corresponding to a single photo in the *Scrapbook*, complementary views of *Scrapbook* doubles).

The arena in *Valencia, Spain, 1933*, is a parable of the photographic 'lookout' in seven (known) shots (fig. 33). The photographer's position does not vary, the framing is almost fixed: one of the double doors leading to the arena is slightly open, creating a break in the kind of circular target bearing the number 7; a spyhole is open in each side of the door, people are coming and going in the doorway, others are seen in the spyhole on the left side while a man with glasses and a cap is on the lookout. More attentive than the others, and older as well – a petty tyrant – he echoes the photographer's own stance as a lookout. A single eye visible, the other, white, enormous and round like an opaque monocle, is the reflection of the light on the lenses of his glasses, alternately the right and the left; the photographer, meanwhile, has one eye behind the viewfinder, while the other is closed. Seven negatives are preserved (including 6 'singles'); for the *Scrapbook*, HCB printed two of them, and vacillated between them for a few more years. In the end, the photo which 'holds up' is the most enigmatic geometrically (we have lost half of the target, only one side of the door is left, we do not imagine a doorway any more) and the most metaphorical of the polarity of the gazes (the monocle-circle mirrors the photographer's eye, a child in the background echoes the Cyclops-like singularity of the lookout-leader).

In *The Decisive Moment*, HCB, who is supposed to be defining the determinist aesthetic of the unique, decisive image (or is that just the way it has been read?), in fact observes his practice like some strange object whose meaning sometimes escapes him. And here, he recognises

60 Out of the 346 views in the *Scrapbook*, 202 are horizontal.

L'ESPAGNE PARLE

34

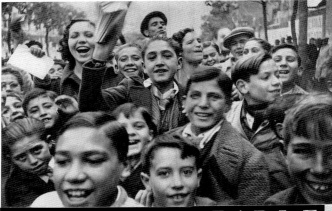

L'ESPAGNE PARLE

III. AU SEUIL DE L'AVENIR

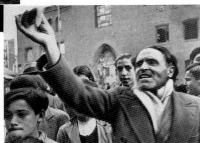

35

the two phases of indecision, at the time the shot is taken and during the selection of the one final image: 'For photographers, there are two kinds of selection to be made, and either of them can lead to eventual regrets. There is the selection we make when we look through the viewfinder at the subject; and there is the one we make after the films have been developed and printed. After developing and printing, you must go about separating the pictures which, although they are all right, aren't the strongest'[61]. Between 1946 (the *Scrapbook*, with its indecisions) and 1952 (*The Decisive Moment*, with its consecration of the unique image), he had probably learned not to regret any more.

Stories in photography: gazes once again

In 1935, HCB was in New York for his exhibit with Manuel Alvarez Bravo and Walker Evans at the Julien Levy Gallery; of the many photos he made there, none appears in the *Scrapbook*. In fact, he profited from his time in New York to accept his hesitations between photo and film: he became Paul Strand's student. In very rough terms, film differs from photography in that it tells a story and this is what now motivated HCB. But for several years, through his contacts with other photographers and the press, he had known that this was also the aim of a widespread photographic practice, the reportage, or photojournalism, which had not really tempted him because he preferred telling 'the whole essence of some situation' in 'one single photograph.' By contrast, the reportage was characterised by a series of coherent views on a 'subject', generally proposed by a magazine, or possibly conceived – at his own risk – by the photographer, who then 'placed' it. Kertész, Krull and Lotar, who were also enthusiasts of the 'new photography' with its single images, published many of these stories in *VU* (the best photography publication of the period) because it allowed them to earn a living[62].

In spite of his reluctances, HCB had already given *VU* a 'story' published in three successive issues under the general title 'L'Espagne parle' (Spain Speaks) on the occasion of the Republic's parliamentary elections (figs. 34, 35)[63]. It does not give the impression of a homogeneous reportage, however, because there is no real subject. But this conception of the reportage (a visual arrangement of 'illustrations' coming mainly from one photographer) is the one which had recently been introduced and which prevailed around 1930[64]. In the first issue, the illustrations selected are not specific: the father-mother-child behind a window gate (SB 65) is soberly entitled 'Andalusian family'. In the second issue, the subtitle 'Elections' covers photos of women in black against a background of posters, priests in 'consultation', a poster truck, a small group of young people talking. In the third ('Au seuil de l'avenir' [On the Threshold of the Future]), the theme to be illustrated is even vaguer and the ambiguity is not resolved by the cryptic captions: 'youthful politics', 'the Guardia Civil (police) in operation', 'words which make you dream'. It is obvious here that the captions are the work of the magazine's editors but perhaps the photographer had not supplied more explicit ones. In his career as a photojournalist, HCB would complain about the modifications of his own captions. The last double page (no. 298) is the one which best brings out the particular nature of his photographs: the gestures, the faces in close-up, the gazes (the group of children in the centre)[65].

This was not his first magazine publication, however: the 29 October 1932 issue of *Voilà* (recently rediscovered) shows a full-page 'reportage' (fig. 37) on Italian cemeteries, in fact used to illustrate the editorial (with no relation to

61 'The Decisive Moment' in *The Mind's Eye*, p. 25. / **62** *VU* was an illustrated weekly magazine (20 and then 32 pages) founded by Lucien Vogel (21 March 1928). It published more than 700 regular and special issues up to its closing in 1940. It relied essentially on photography, which appeared on all the pages to illustrate news, travel accounts, adventure, serialised novels, social reportages, celebrity portraits or scientific discoveries. *VU* called upon many independent photographers from the 'new photography' and contributed to the birth of the commissioned reportage. *VU* would become the model for picture news magazines such as *Life* and *Paris Match*. Lotar published 'A l'institut des sourds-muets d'Asnières' (At the Institute for the Deaf and Dumb in Asnières), *VU* no. 6 (April 1928); what is held to be Kertész's first reportage was done at the Trappist monastery in Soligny in October 1928 (published in *VU* no. 109, 16 April 1930). / **63** *VU*, nos. 296, 297, 298, dated 15, 22 and 29 November 1933, text by 'special correspondent' Georges Rotvand. HCB wrote on the copy kept at the Fondation, 'My first published reportage!' / **64** The term 'reportage', employed since the late nineteenth century for photography, covers a variety of practices from one individual, period or magazine to another. It should not be taken in a general or permanent sense. **65** The photograph below is credited to the Mondial Agency.

36

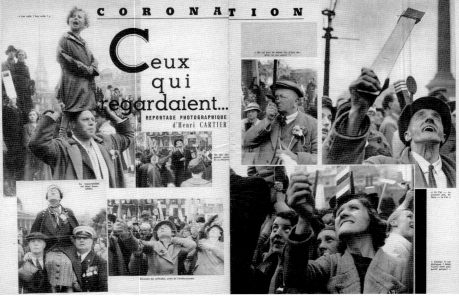

38

37

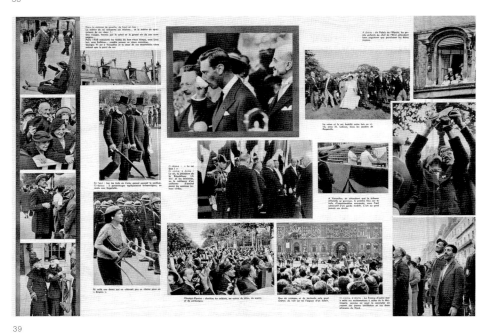

39

the subject)[66]. The compositions of the photos, with their foreground plane and the use of echoes, are not devoid of merit, and there is one female face bathed in tears, looking at the sky (the negative has also been preserved) (fig. 36).

As of 1935, HCB wanted to tell stories through filmmaking. Which led to his contacts with Buñuel and Pabst, and his being hired as an assistant by Renoir. But in 1936, the participation in *A Day in the Country* was not very conclusive; the film would be abandoned in August and never completed; it was only shown in 1946 (when HCB was in the United States). In 1939 he was once again Renoir's assistant on *La règle du jeu* (The Rules of the Game) but the war was in the offing. In three years, he had understood that he was not made for this 'cinema of imagination'.

With the outbreak of the Spanish Civil War, journalists and photographers saw an opportunity to practice their trade while committing themselves to a cause: this was where the 'war' reportage was born, where Capa found his personal style which consisted in large part of capturing gazes and faces up close, like his friend Cartier-Bresson. Alas, Henri himself opted to make films; he did not take any photos in Spain and was to regret it for many years. His films went practically unseen (it was no longer the era of promise for the documentary, as had been the case in the early 1930s), while the photographers (Capa first), whose images were picked up by all the international media, had forged an appropriate practice and an ethic of concerned photography. From 1932 to 1935, Henri had not really prepared himself for the formula of picture stories. In 'The Decisive Moment', he makes this confession (in relation to his taste for the single image): 'The idea of making a photographic reportage, that is to say, of telling a story in a sequence of pictures, never entered my mind at that time. I began to understand more about it later, as a result of looking at the work of my colleagues and at the illustrated

magazines. In fact, it was only in the process of working for them that little by little, I eventually learned how to make a reportage with a camera . . . '[67].

When he joined the AEAR (Revolutionary Artists and Writers Association), Aragon hired him as a photograph for the daily *Ce Soir*, launched by the Communist party (first issue, 1 March 1937)[68]. Indeed, a newspaper needed to produce reportages, series of images which presented a story, an 'event'. In 1937 he was sent to London with writer Paul Nizan to cover the coronation of George VI; out of his element, HCB did not watch the ceremonies, he only saw the people waiting and trying to see, with fervour (fig. 38). The images which remain in the *Scrapbook* (19 photos) almost exclusively show the crowd's attempt to look, to see something: strategies of vision with periscopes and slanted mirrors, home made or bought on the spot (6 photos), human scaffolds of people perched on shoulders (3 photos), and that 'single' photo with its two-part geometry which HCB would keep in his works (SB 175): a crowd of faces all looking in the same direction, on top of a sea of scattered newspapers where a sleeping man, eyes closed, no longer has the desire to look (the double of the rebellious photographer). For *Regards* (a magazine also linked to the Communist party), HCB covered the English sovereigns' visit to Paris, taking up his method once again: there are only people trying to *look*, with the same stratagems (fig. 39)[69].

The photographs before 1936 ('singles' and unique shots) which are not part of a 'story' account for a third of the *Scrapbook* but the bulk of HCB's works are there. For the subsequent years, we find above all stories developed with multiple shots, including the coronation of George VI (19 photographs), the banks of the Marne River and the camping ground (20), the inhabitants of Chouzy (10), the Liberation (6), refugees (7), portraits (110) including Aragon

66 It is possible that other publications of HCB's photographs will be discovered when the contents of the magazines are analysed. / **67** 'The Decisive Moment' in *The Mind's Eye*, p. 22. / **68** The AEAR was founded by Communist party journalist and political figure Paul Vaillant-Couturier in 1932. HCB participated in the exhibition 'Documents de la vie sociale' (Social Documents) organised by the AEAR at La Pléiade Gallery in June 1935 and in 'La photo qui accuse' (The Photo as Accusation) at AEAR headquarters, on Rue de Navarin. See Françoise Denoyelle, *La lumière de Paris. Les usages de la photographie, 1919-1939*, vol. 2, Paris, L'Harmattan, 1997, p. 141. /**69** 'L'accueil de la France aux souverains anglais' (France welcomes the King and Queen of England), *Regards* no. 237, 28 July 1938, pp. 11-13. *Regards* – which, symptomatically, means 'gazes', 'looks' or 'gazes' – began publishing on 25 December 1933 as the successor to *Nos regards* (Our views), which first appeared in May 1928 as a competitor to *VU*, its model; after ceasing publication in October 1929, it reappeared under the title *Regards sur le monde du travail* (Views on the World of Work) in May 1932.

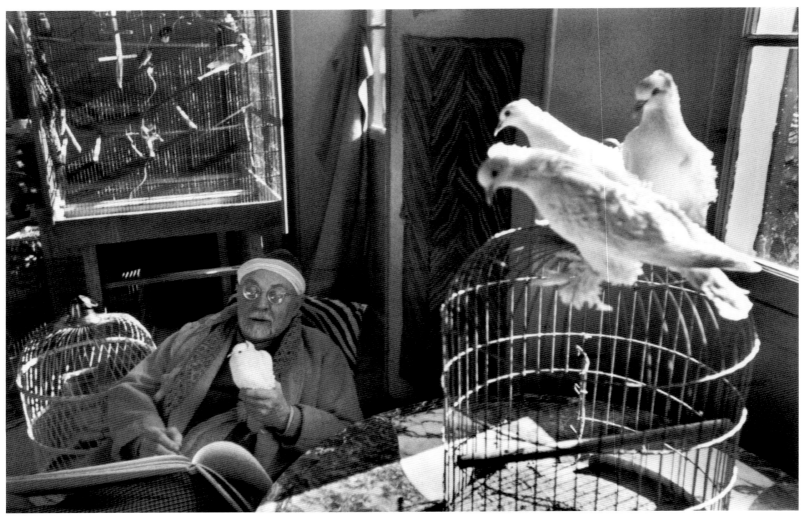

40

(5), Matisse (16), Bonnard (13), Claudel (6), Picasso (10), Rouault (9) and others. Like the coronation of George VI, and although they were devoted not to movement but to the confinement of an individual in his familiar space, these series of portraits turn out to be stories of gazes as well. As if this meaningful geometry imposed itself in all circumstances because it involved 'people' above all, as writer Claude Roy understood in 1952: 'He is interested everywhere in faces, people. Outstretched hands, gleaming eyes of Hindu beggars, the laughing children of Seville in the ruins, and the little cripple on his crutches in the foreground and the hunted expression of the unemployed man in Madrid with his child clutched in his arms.'[70]

Stories of gazes for the scenes of public trials after the liberation of the deportation camp in Dessau, Germany (1945) (SB 288): hatred, shame, the spectator's wait-and-see stance, satisfaction, all manifest themselves in a space lined with curious onlookers. Stories of gazes for those sessions of gratitude with the farmers of Chouzy, near Chambord, in whose home his wife had taken refuge: Henri kept ten photos even if the exercise was tedious, in indoor poses with individuals hardly inclined to let themselves go.

Stories of gazes for all the portraits he made after his escape, when he dug up his Leica and contacted the publisher Braun, who asked him to photograph artists and writers for a series of monographs. Bonnard and Matisse are the most compelling, because of the two painters' palpable reluctance. HCB spent many hours with them. Bonnard was old, depressed and on the decline; he dodged as soon as HCB took up his Leica, but for one instant at least, he could not hide his frightened gaze (SB 265). This was a kind of photography which went far beyond the habitual photos of artists filling out art books. Matisse was just as old, sick, and no more inclined to be photographed, if not rather disagreeable. HCB faded into the woodwork for hours and waited until the painter was caught up in the observation of a dove he was going to sketch (SB 218) (fig.

40). A magnificent story of a gaze in a single episode: from behind the two thick lenses of his glasses, Matisse scrutinises a timid dove with a minuscule eye, the same little circle in which the painter, for his part, probes the mystery of its liveliness. In the front plane, three eyes of other doves perched on a cage respond with amused, impertinent freedom, like a ricochet from Matisse's eye. Rebound, echo, reverberation, like a wave of gazes which flow through the image. Everything is said about the gaze of an old man who is absorbed in the imperceptible, but keeps trying.

The backward glance, always lost

The Leicaphile only looks with one eye, the one behind the viewfinder, which controls the image and the construction and decides on the moment. The other one is closed, withdrawn from its usual task, deactivated, which is to say, opened up to what is inside, behind, imaginary, desired. A forward eye towards the unpredictable, a backward eye towards what has already been accumulated, towards memory. The photographer's immediate consciousness serves as the pivot, the articulation. Which consists of 'letting the lens excavate in the rubble of the unconscious and chance' (HCB, 1995)[71].

Livorno, Tuscany, Italy, 1932 (fig. 41): HCB was going down the street, he saw the man standing there reading his newspaper and the knotted curtain in front of the doorway, which was masking him – which practically made him into a mask. From his standpoint, the knot became a head, and that is what created a gaze. By placing himself in the right spot, it became a photo. HCB made a second one, closer up, in order to eliminate a context which was too identifiable, too contingent (chair, background) and focus in on the torso.

Quai Saint-Bernard, Paris, 1932 (SB 21): The two men along the parapet, viewed from behind: one is leaning over

70 Claude Roy, 'La seconde de vérité (The Second of Truth), *Lettres françaises*, 20 November 1952 (on *The Decisive Moment*). **/ 71** André Breton, *Roi Soleil*, op. cit. The quote from HCB begins: '[André Breton] taught me to let the lens. . . .'

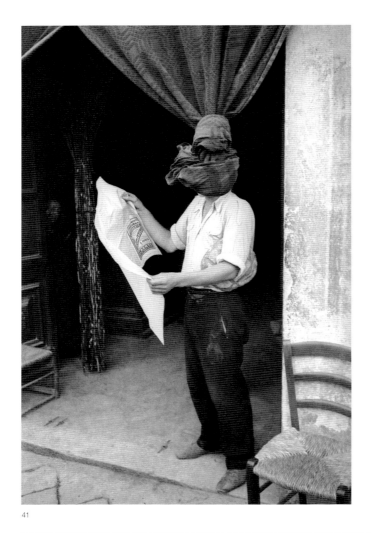
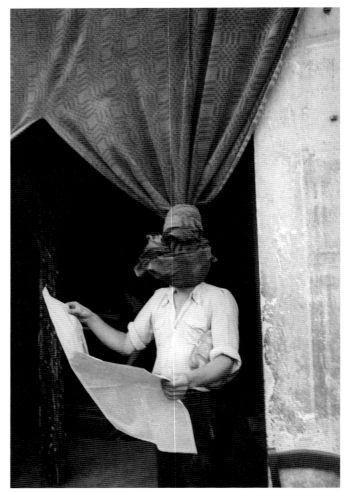

41

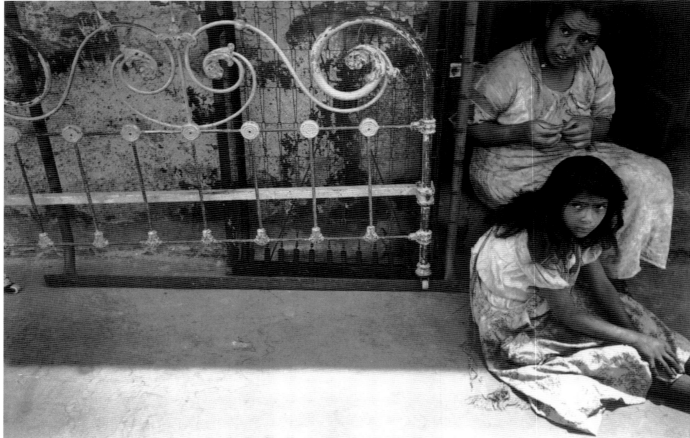

42

41 Henri Cartier-Bresson, *Livorno, Tuscany, Italy,* 1933
42 Henri Cartier-Bresson, *Mexico,* 1934

to see the rails below; together, they form a body with two torsos. They are not looking at the same thing. Two walls spread out in a 'V', like doors opening onto the railway tracks below. On the other side of the walls, a chaotic accumulation of canvas-covered merchandise. Each of the two men is seeing something different, and we, who are looking at the photo, do not see the same thing that they do. A disconnection of gazes, ours and theirs.

Mexico, 1934 (SB 100, 101): A tunic draped over a seated form, one would think it is a headless body. Behind it, high up, a jacket on a hanger is like a flattened body whose legs would be hidden, and without a face once again. In a variant, from farther away, we understand the situation: a clothing merchant's stall, outdoors. A long-haired white dog, a little girl sitting down who turns her eyes away. On this photo, no one plays the expected game.

Mexico, 1934 (SB 133) (fig. 42): A bed frame, with iron scrolls, eyes which emerge in the centre, echoed by a row of openings just below. In the shadow on the right, a mother and her daughter, in the same curled-up position, who looks out from the circle of her hair and her face. So there are two eyes, then two more eyes, with the same kind of worried anticipation, which are not looking at the photographer but at someone next to him, on his left. What looks at 'us' in this photograph is the displacement, the presence of another person, invisible but certain.

In Cartier-Bresson's photographs, there are hidden, absent gazes and gazes which are riveted, on us or on elsewhere. But it amounts to the same thing. The one who has no gaze also gazes at us, and unsettles us just as much. Invites us to look again in order to *seek* that particular gaze.

To make a photo, it is necessary to *find* several lines of force, of mystery, of suspense, which rely on what is a gaze, or on what is not but which takes its place. To wait for what we imagine could be there *already*.

Henri was trying to rediscover what he had already seen somewhere, or what he had imagined, and what he had in any case lost. But in the process of continuously trying, he often found himself. The shot condenses all the expectations of the unpredictable.

The backward glance is the sum of all the glances, of everything we have perceived, knowingly or not, of all the gazes directed towards places, things, beings, images. It can be recognised in what is going to happen but cannot be foreseen. A photographer spots in front of him what he has had behind his eyes for a long time. The backward glances, those of another time mixed with those of yesterday, those of books, of photographers' photographs, photographs by anyone at all, films, situations, imaginations, the merrymakers in a café and the crowd encountered by chance, the hoped-for gazes come back to the photographer. They are going to give him a sign, there, in front. At least, he hopes so, for the time it takes to trigger his camera. After that, he will start over again.

Michel Frizot

Michel Frizot is a photography historian and researcher at the CNRS (CRAL, EHESS, Paris). Among other publications, he is the author of *A New History of Photography* (1998), *E.J. Marey Chronophotographe* (2001) and *Dieter Appelt* (Photo Poche series, 2005), and of many other scientific articles.

1931 Henri Cartier-Bresson finds a place on a wine tanker in Rouen and makes his way, after a stopover, to Douala, in Cameroon. From there, he goes to the Ivory Coast, where he ekes out his living as a game hunter and takes photos with a Krauss camera. After a year's stay and a near-fatal infection, he comes back to France on the *San Firmin* and lands in Le Havre in 1932. On his return, he rejoins his Surrealist friends and decides he will be a photographer. He buys his first Leica in Marseilles. This camera becomes his favourite tool; always at hand, it will accompany him for the rest of his life.

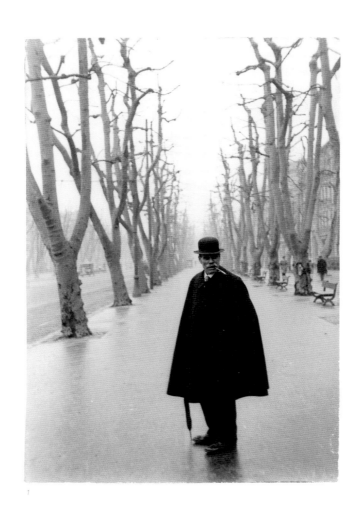

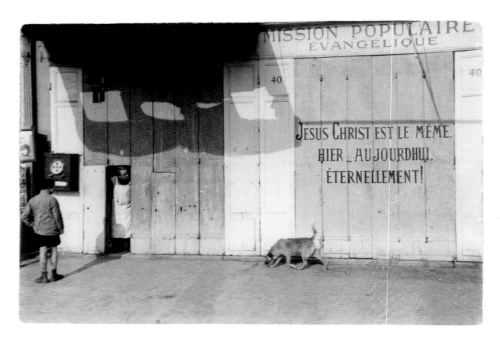

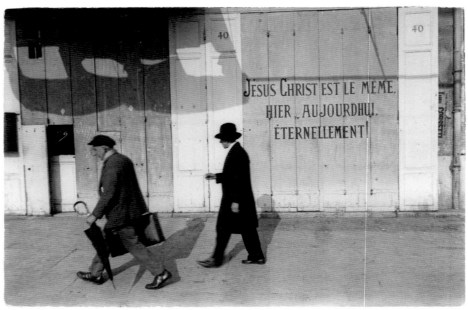

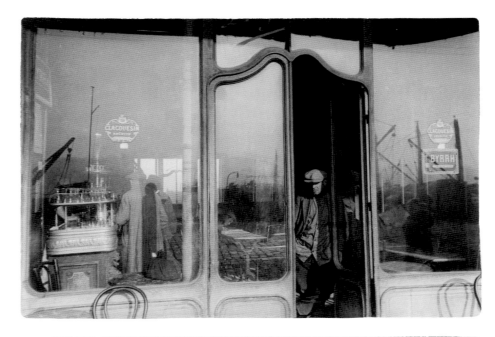

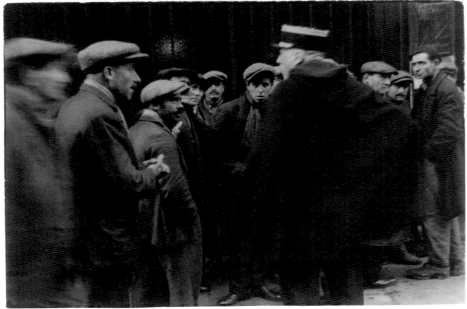

6

7

8 / 9

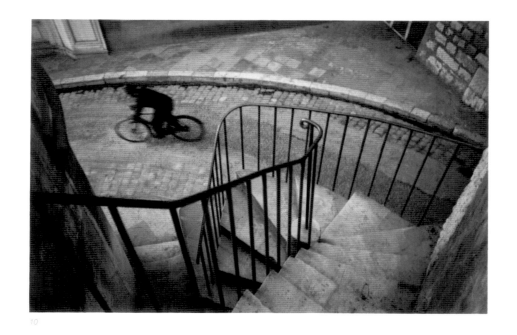

10

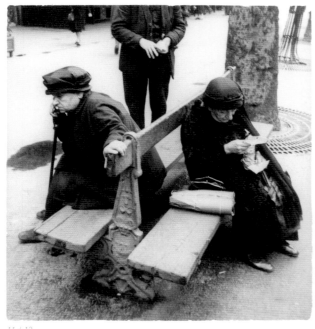

11 / 12

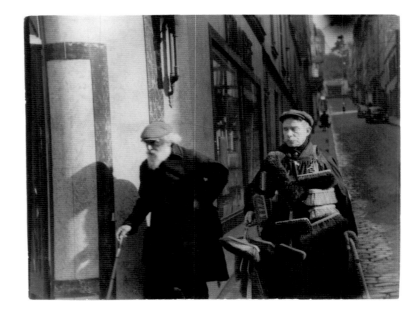

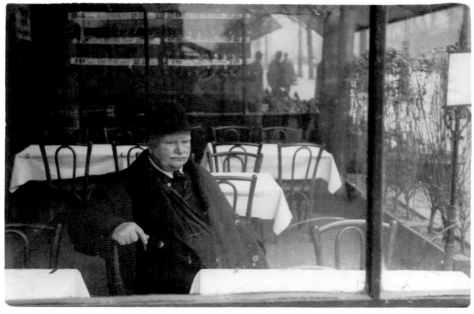

13

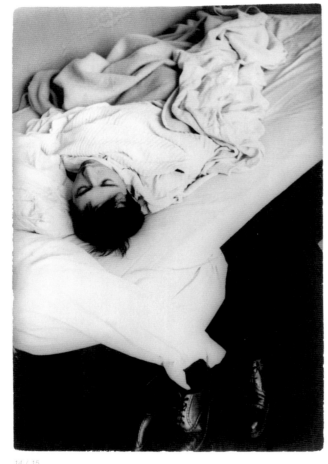
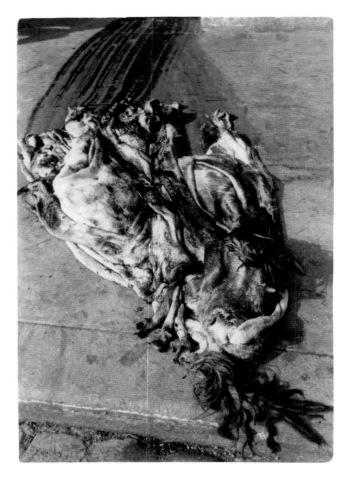

14 / 15

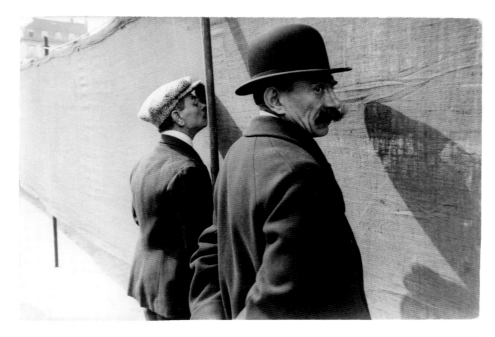

16 / 16 bis

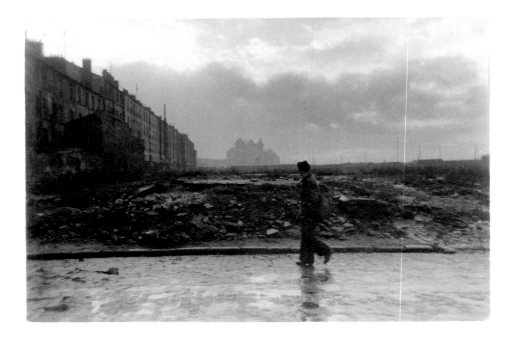

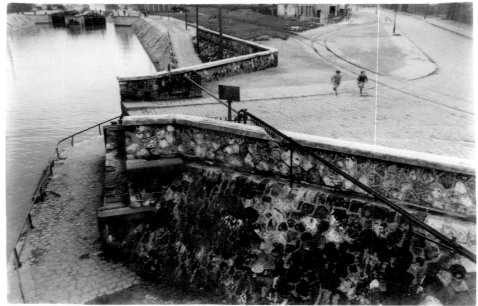

17 / 18

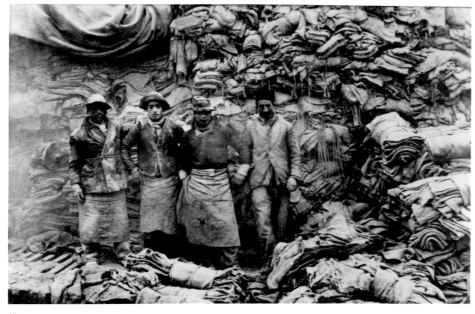

19

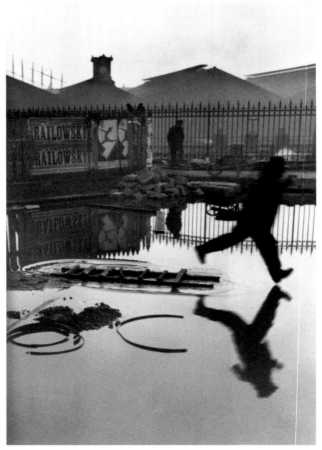

20 a

This photograph is one of the only two images (along with that of Cardinal Pacelli) which Cartier-Bresson decided to crop as soon as he made the shot: he took it – 'it presented itself to him' – with the lens blocked by a fence which he immediately eliminated from the first print. The photo on the right is the only original print which shows the traces of this reframing; afterwards, the image was always printed in its cropped state, as it appears on the left-hand page.

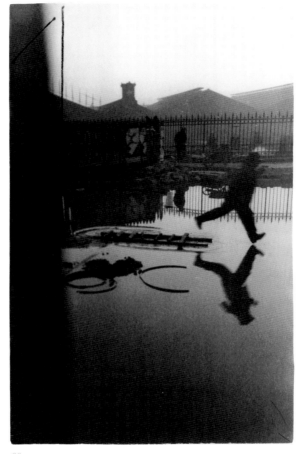

20

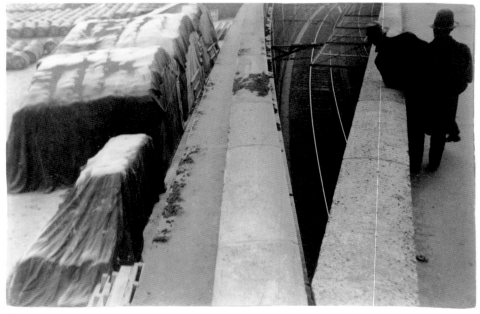

21

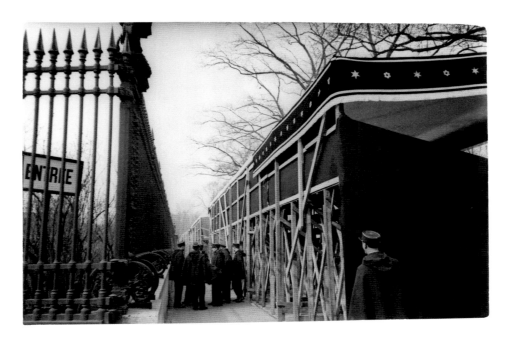

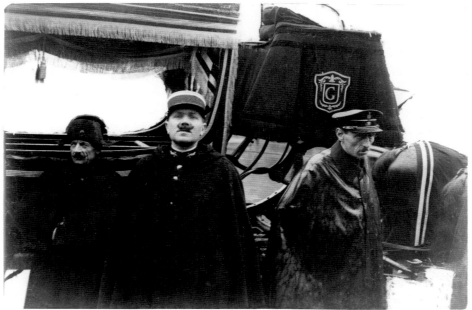

1933 André Pieyre de Mandiargues and Henri Cartier-Bresson, childhood friends from Normandy, spend time together at the same Parisian gatherings in Montparnasse or Pigalle. Mandiargues lives with a young Italian woman, Leonor Fini; the three of them set out in a second-hand Buick to discover Europe. Italy provides a lesson in freedom, photography without a specific aim: recording a *moment de grâce*, an instant of exquisite pleasure, 'shooting' at just the right time.

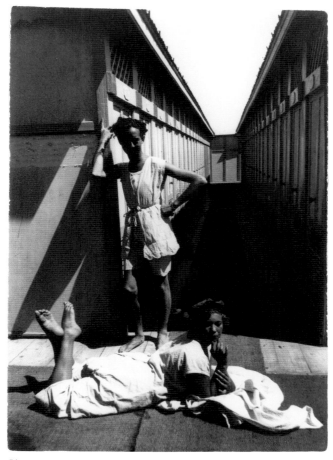

24

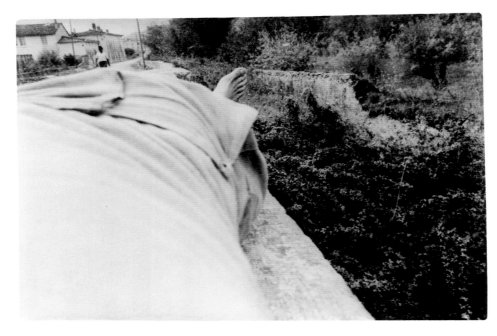

25 / 25 a

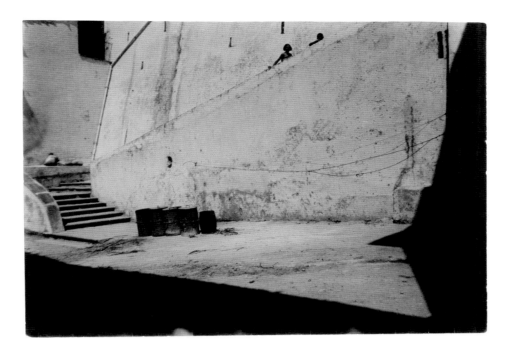

26 / 27 / 28

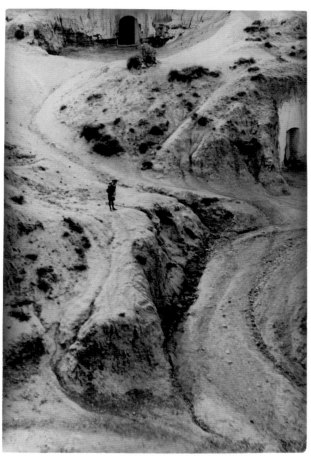

29 / 30

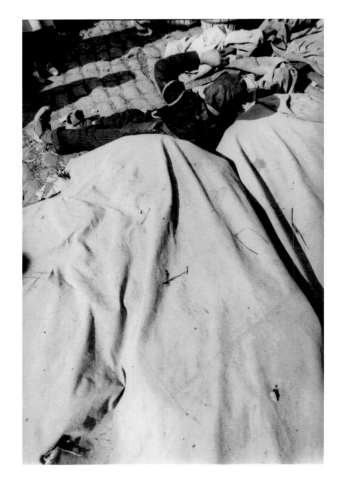

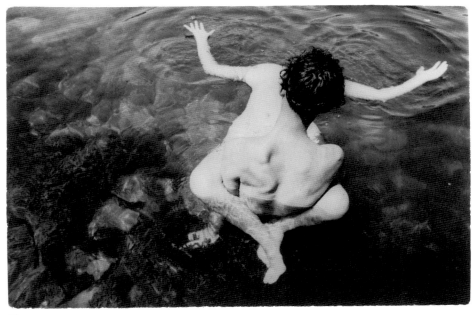

31

32 / 33 / 34

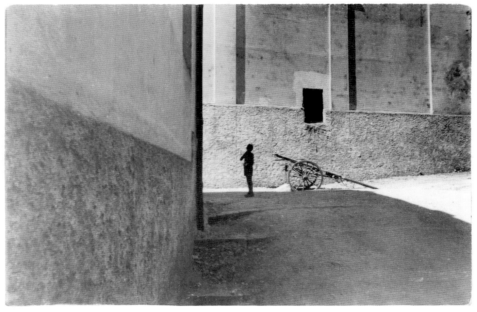

35

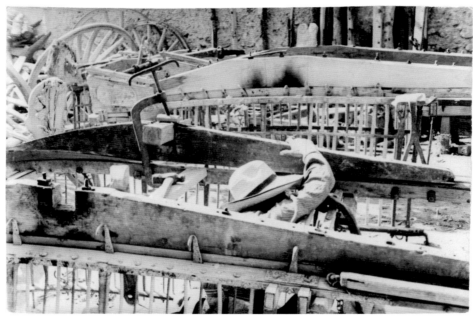

36

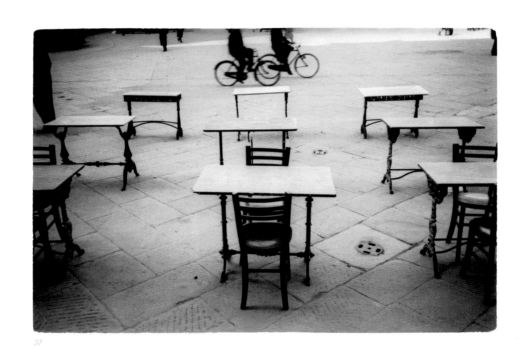

37

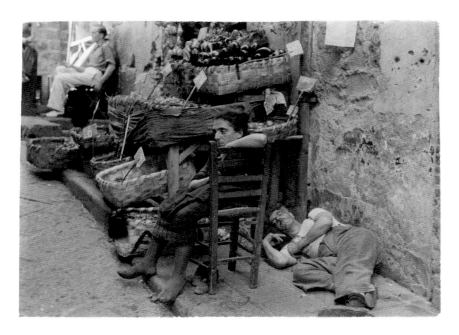

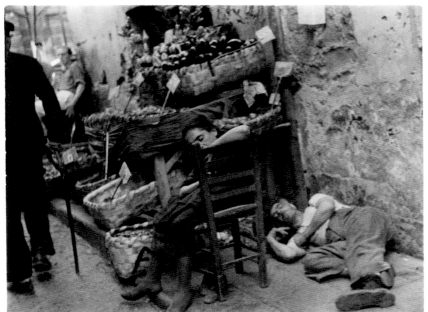

38 / 39

41

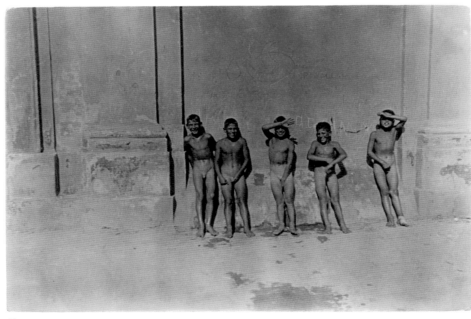

42

43 / 44 / 45

46

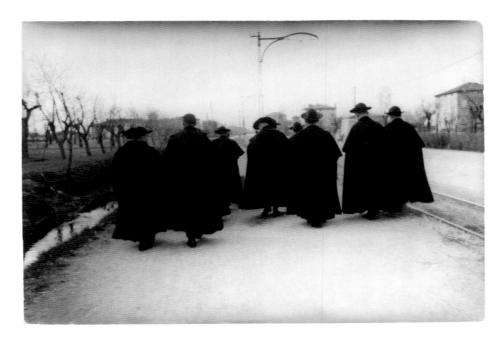

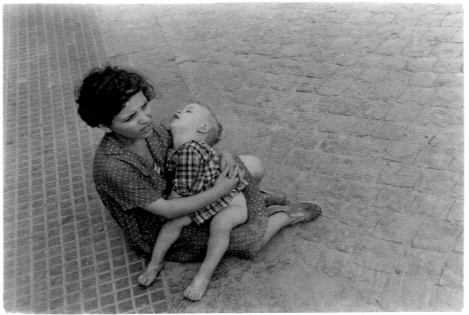

47 / 48

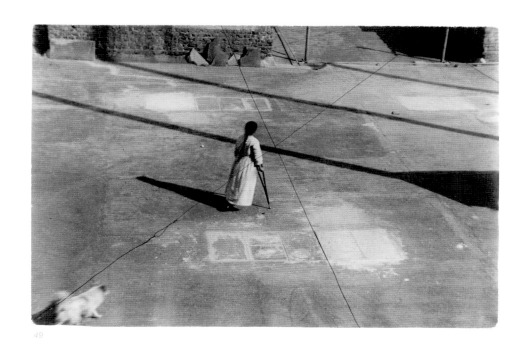

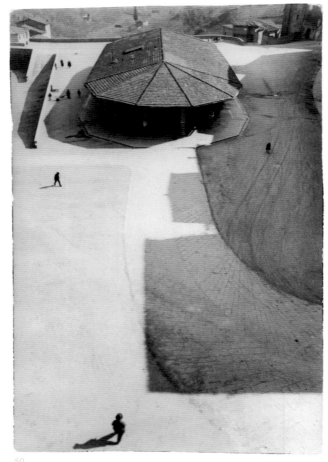

50

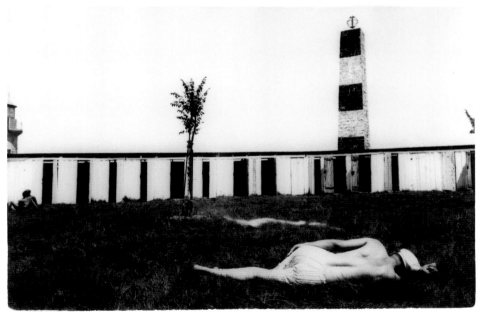

51

1933 Cartier-Bresson goes to Spain. He works for the illustrated weekly *VU*, which devotes three issues to his photos. He is in Barcelona when Julien Levy organises his first exhibition in New York that September. He returns to Spain in November for an exhibition at the Club Ateneo in Madrid. At this time, Spain is the European country he knows best.

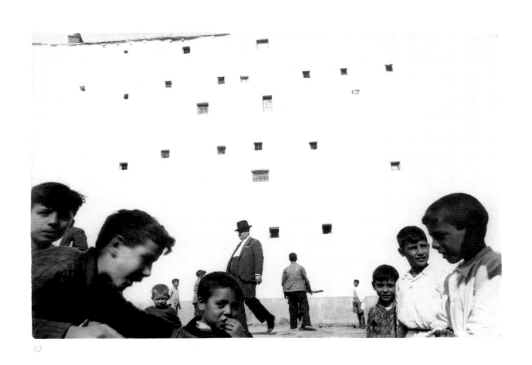

52

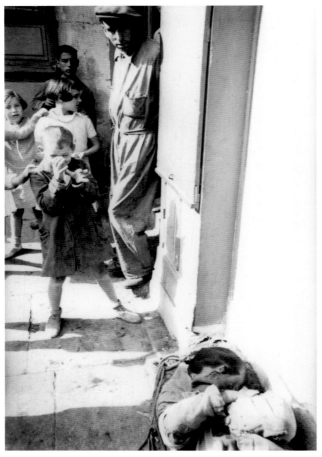

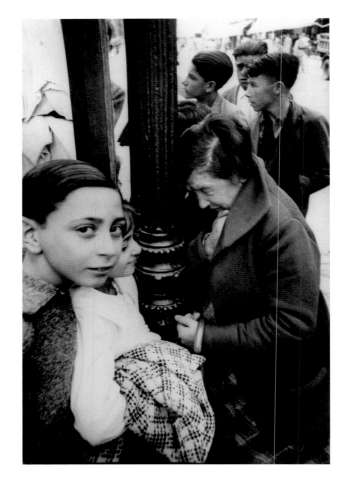

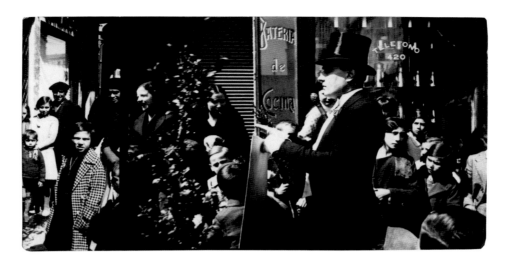

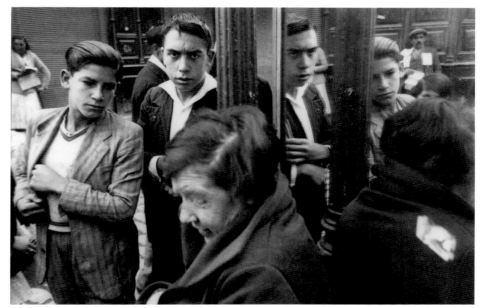

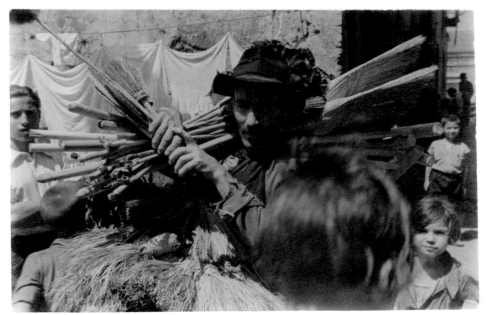

55 / 56 / 57

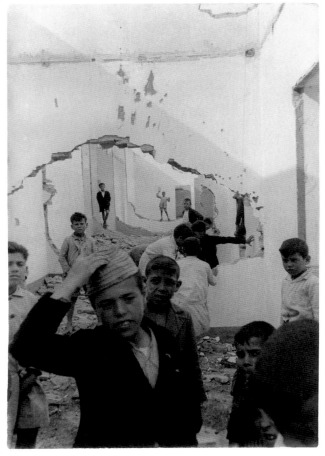

58

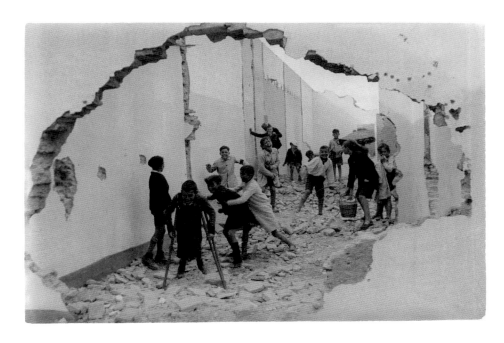

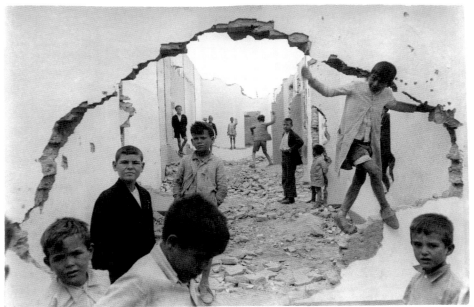

59 / 60

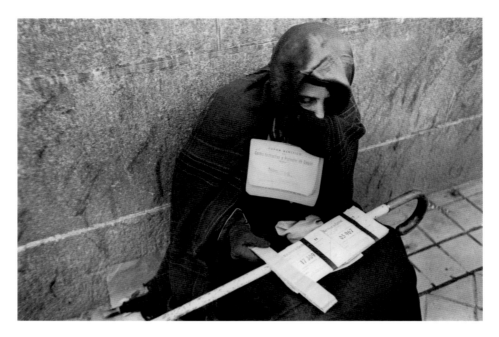

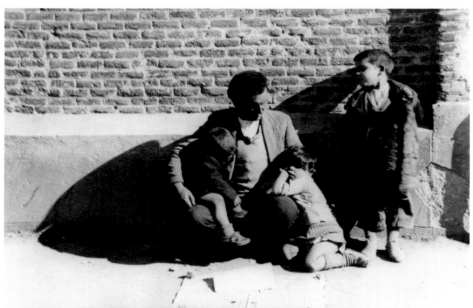

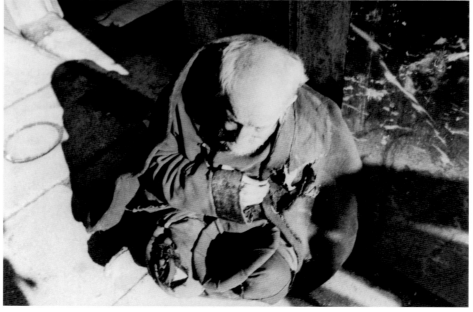

61 / 62 / 63

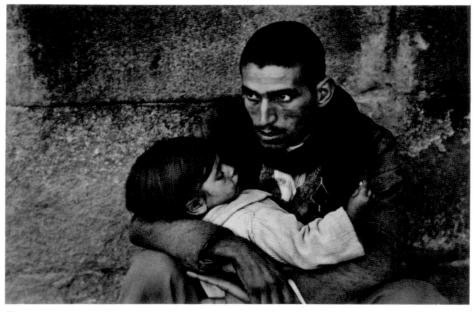

64

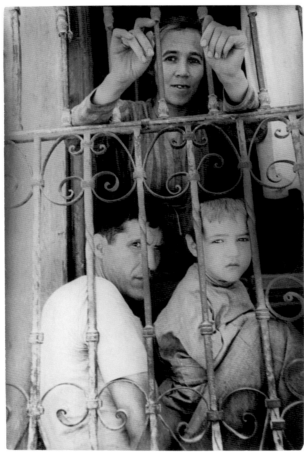
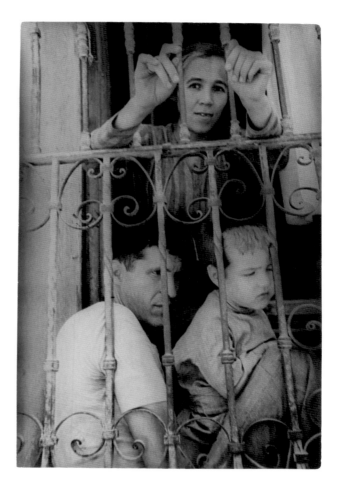

65 / 66

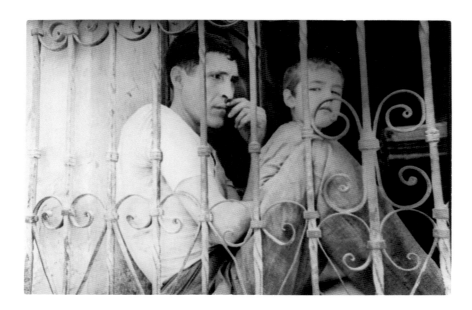

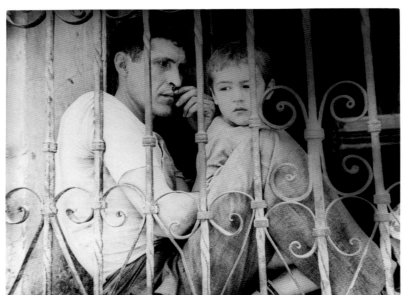

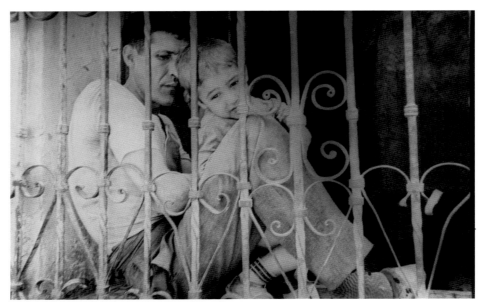

67 / 68 / 69

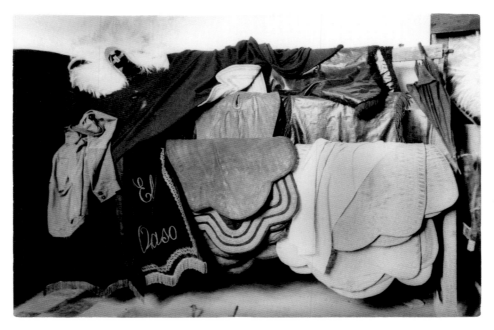

70 / 70 a

71

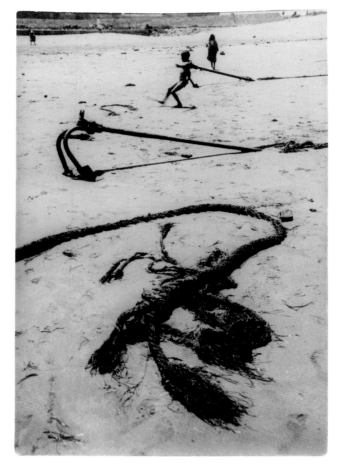

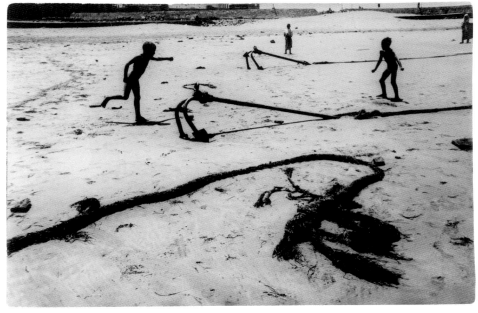

74

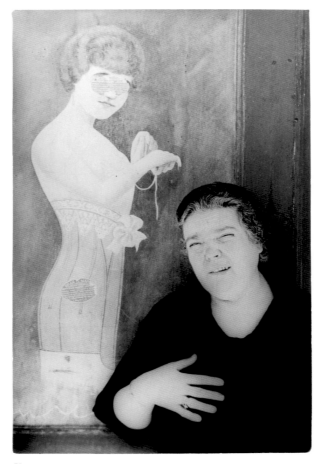

75

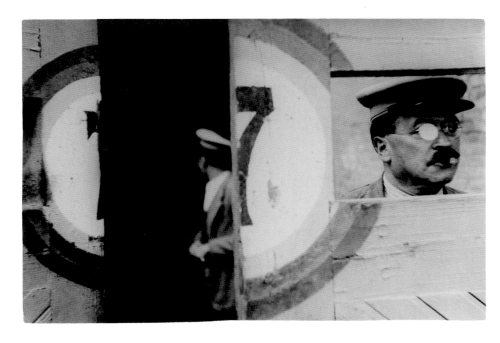

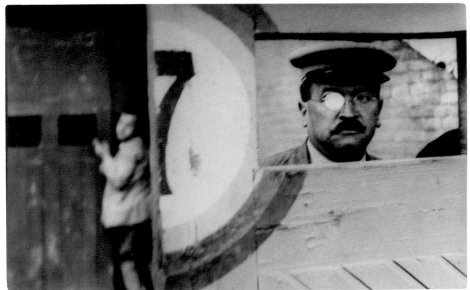

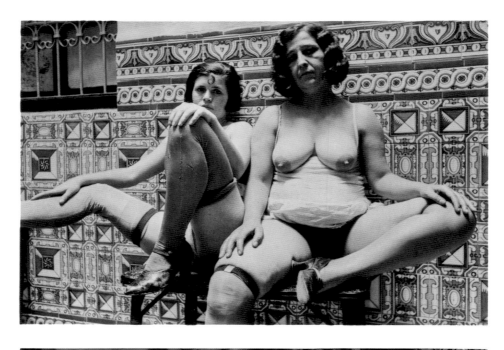

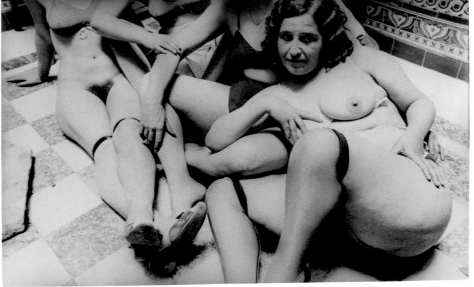

78 / 79

126

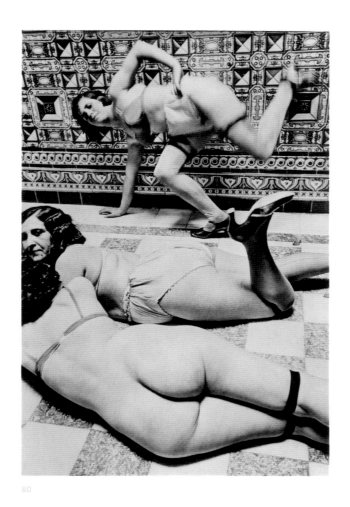

80

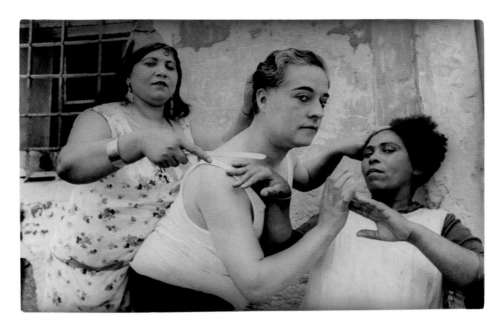

81 / 81 bis

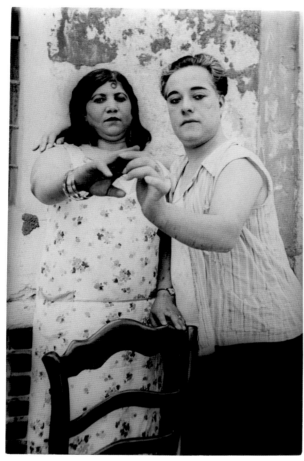

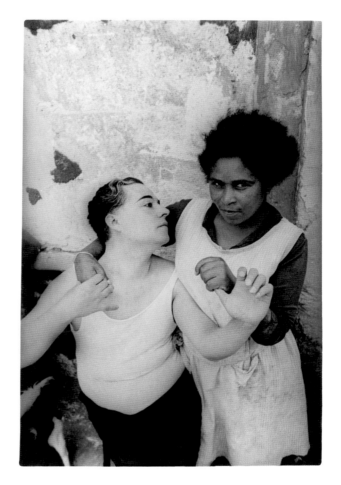

82 / 83

86

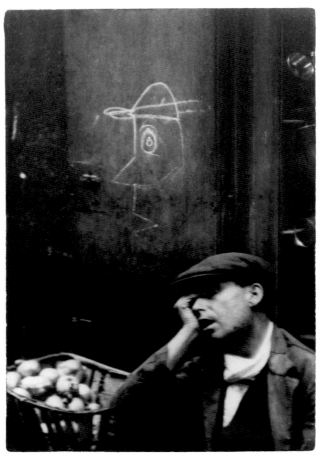

87

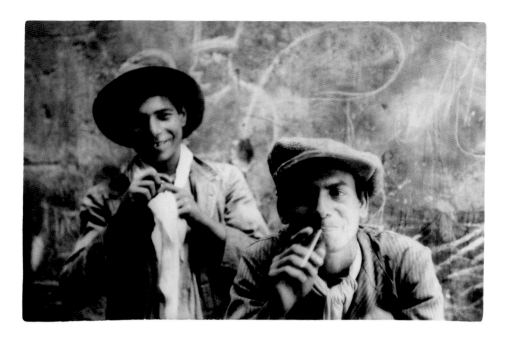

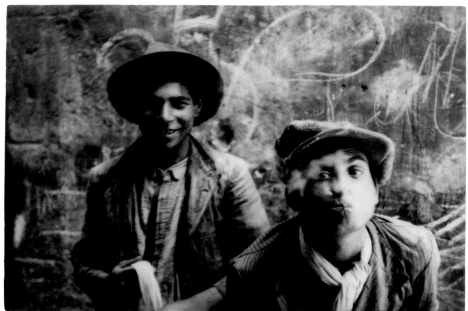

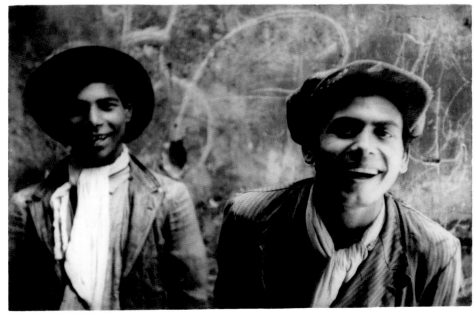

88 / 89 / 90

91 / 92

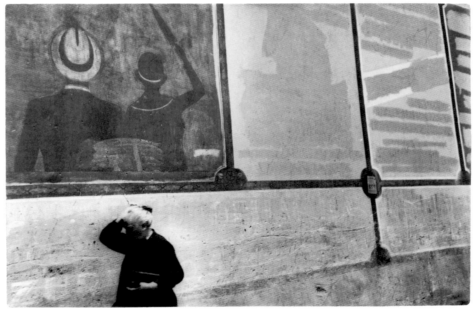

93

94

95

1934 Departure for Mexico on the liner *San Francisco* with a French geographic mission for the Trocadéro Museum. First stop in Havana, followed by the landing in Vera Cruz, where he gets 'robbed' by the head of the mission, which has gone bankrupt (for lack of promised funding). He decides to stay on, with the help of a tiny monthly allowance from his father. He goes to Mexico City, where he meets Harlem poet Langston Hughes and Ignacio Aguirre (known as 'Nacho'), a painter who becomes a close friend. They all live together in a poor neighbourhood of Mexico City. Cartier-Bresson's year in Mexico culminates in an exhibition with Manuel Alvarez Bravo at the Palacio de Bellas Artes, after which he leaves for New York to prepare a joint show at the Julien Levy Gallery with Alvarez Bravo and Walker Evans.

96

97 / 98

140

99

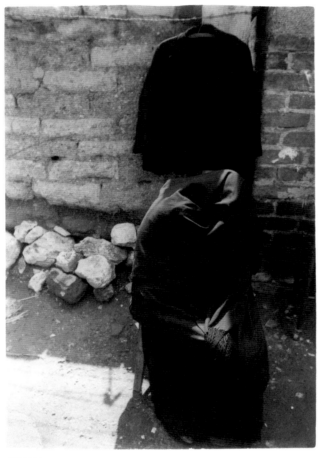
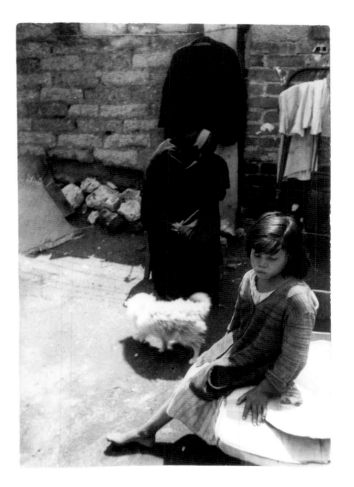

100 / 101

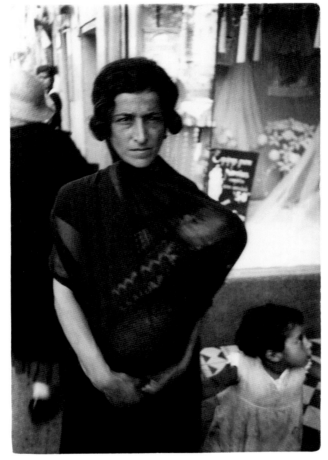

102

103

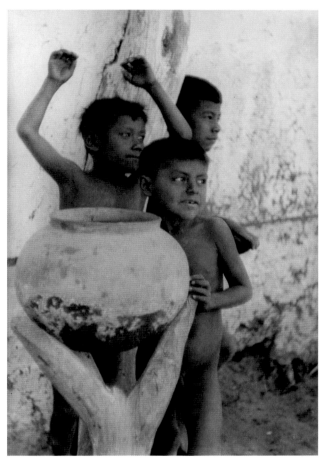
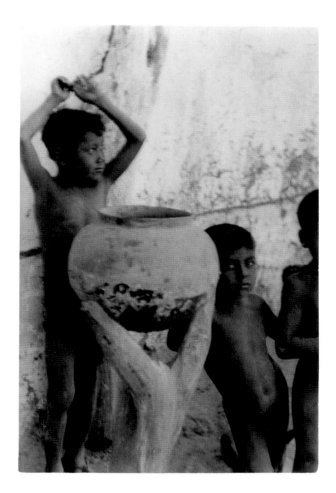

104 / 105

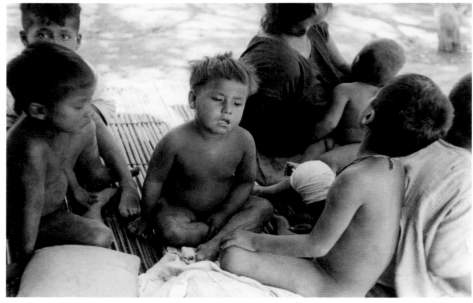

106

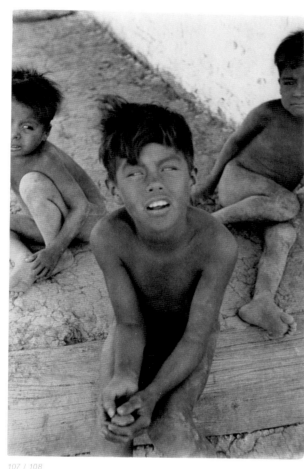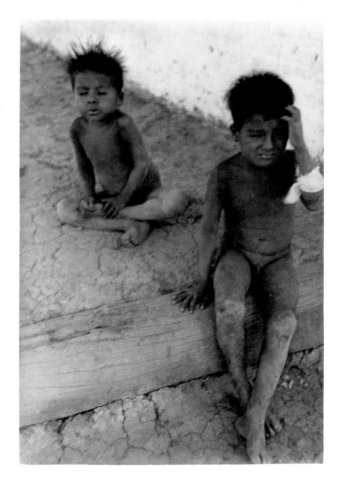

107 / 108

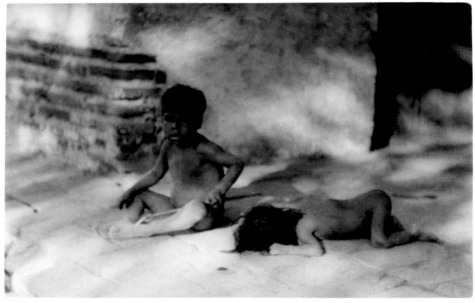

109

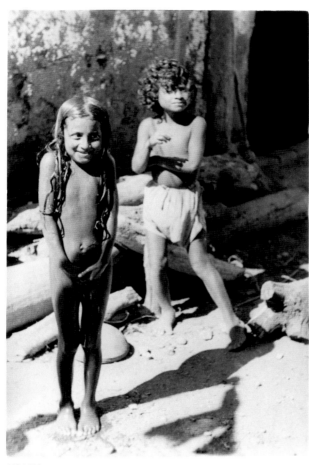

110 / 111

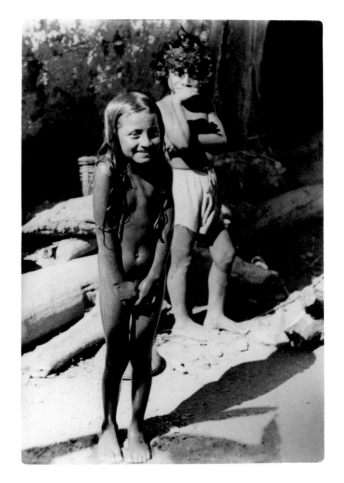

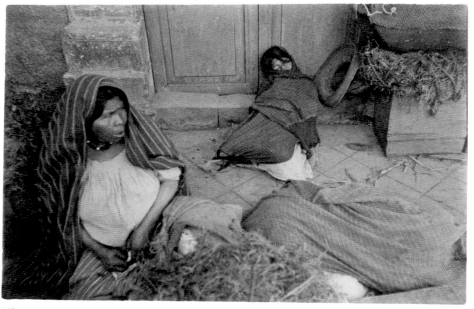

112

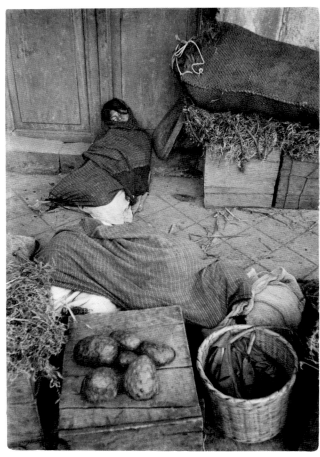

113 / 114

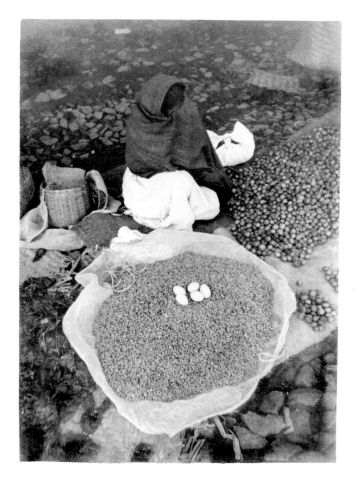

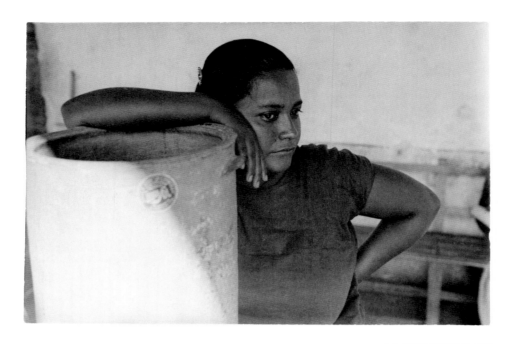

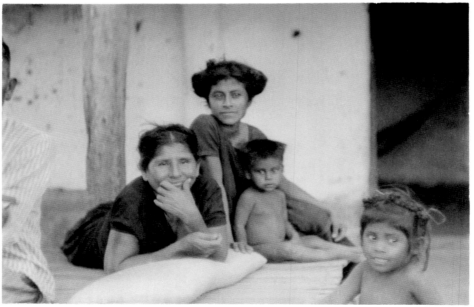

115 / 116

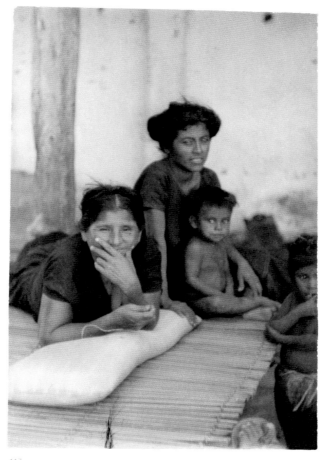

117

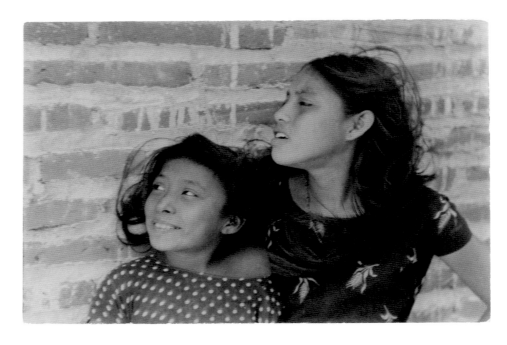

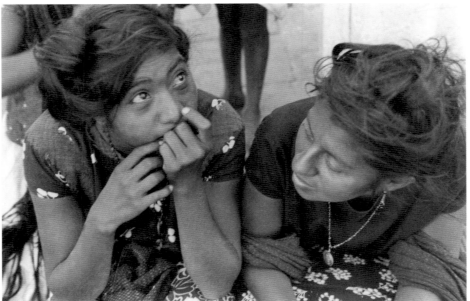

118 / 119

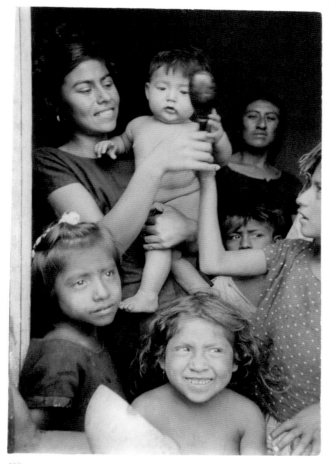

120

121 / 122

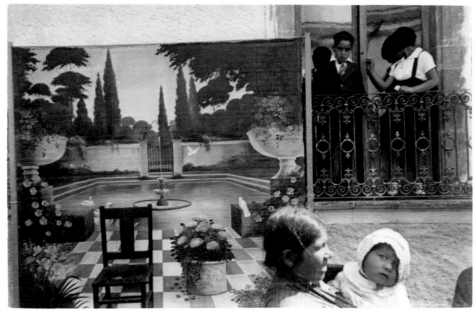

123

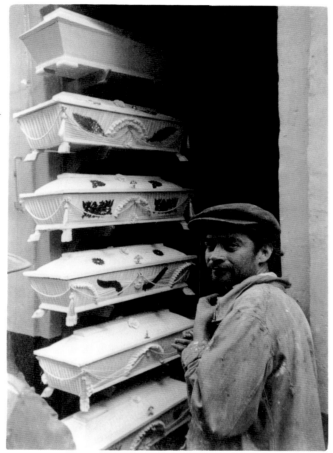

124 / 125

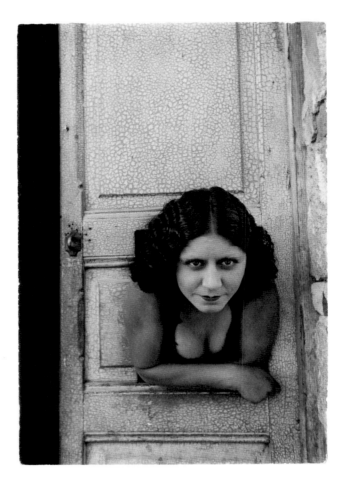

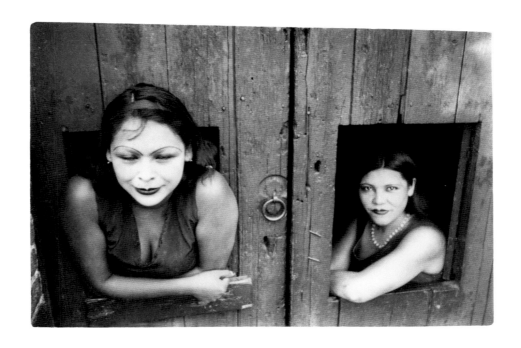

126 / 126 a

127 / 128

129

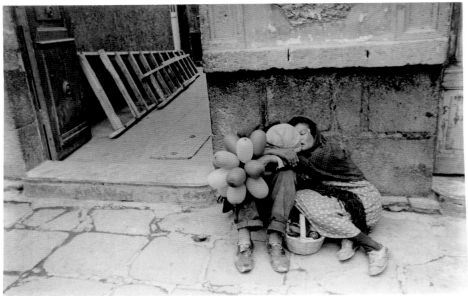

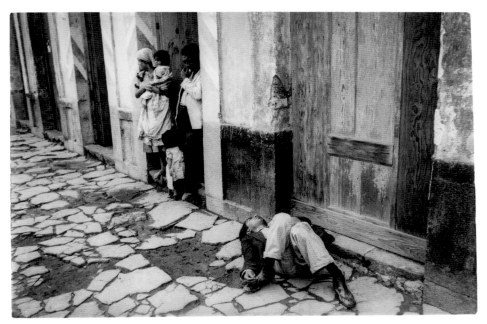

130 / 131 / 132

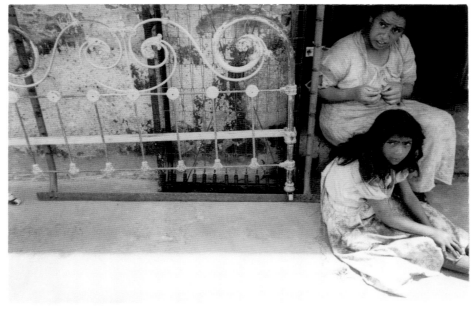

133

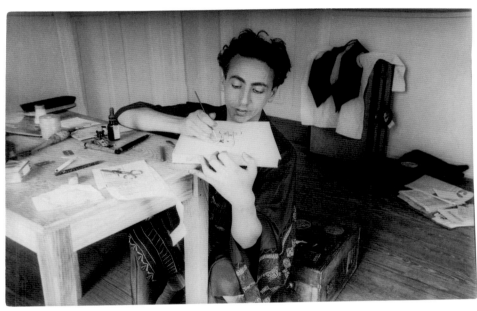

134

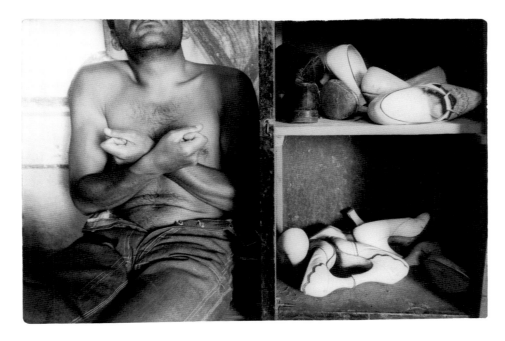

135 / 135 a

1935 Cartier-Bresson spends several months in New York. He stays with composer Nicolas Nabokov, sees photographers Helen Levitt and Walker Evans regularly and spends time in Harlem with Langston Hughes. Despite the success of 'Documentary and Anti-graphic Photographs', the exhibition at the Julien Levy Gallery which presented his work along with that of Alvarez Bravo and Evans in April, he decides to put aside photography and learn the basics of filmmaking with Paul Strand. He prepares a portfolio which he plans to show to Luis Buñuel or G. W. Pabst – in the end he presents it to Jean Renoir – in the hope of becoming an assistant director.

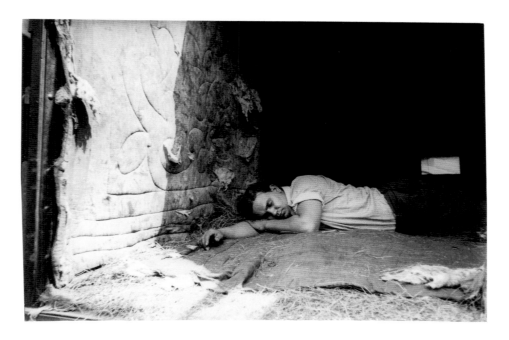

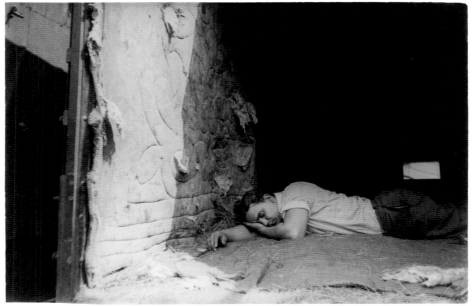

146

1936 On his return to France, Renoir hires him as second assistant director on two films, *La vie est à nous* (The People of France) in spring 1936 and *Une partie de campagne* (A Day in the Country) that June. The Popular Front government which comes to power in May 1936 and continues until 1938 stirs up French society and the introduction of paid vacations provides an opportunity to take photos in the spirit of *Une partie de campagne* (fig. 5, p. 11). But the film itself is abandoned in August, notably because of bad weather.

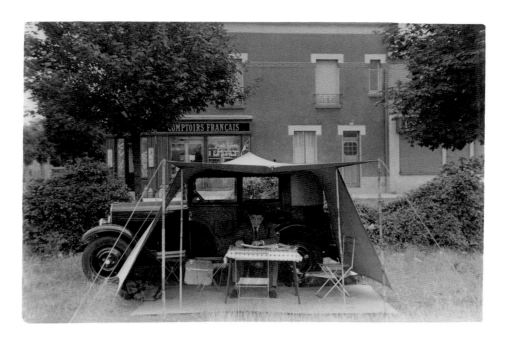

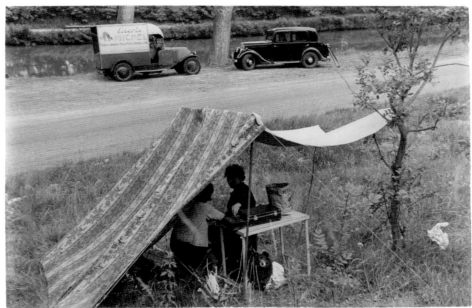

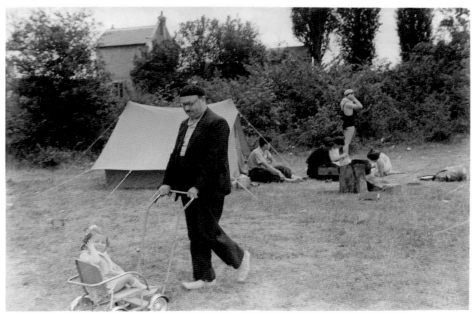

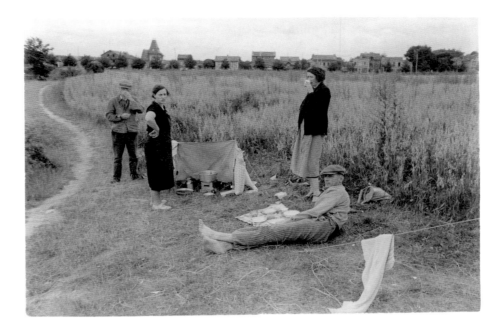

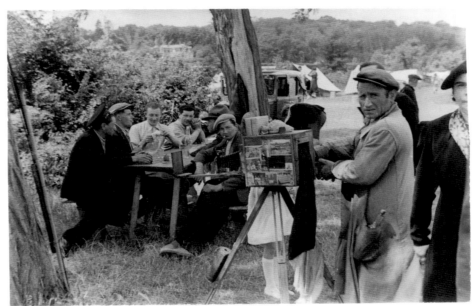

153 / 154

157 / 158

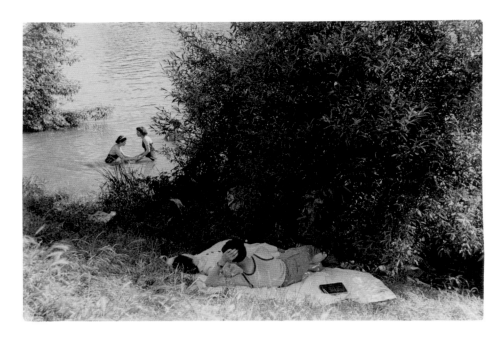

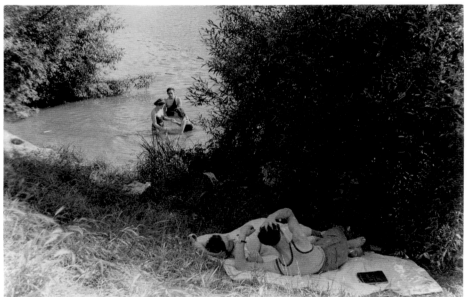

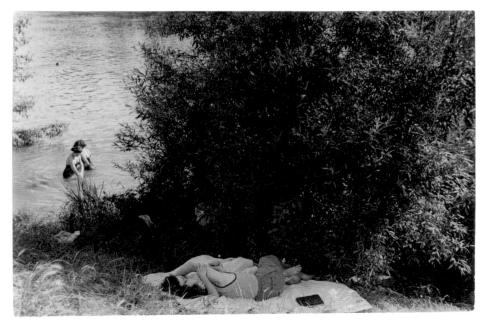

159 / 160 / 161

176

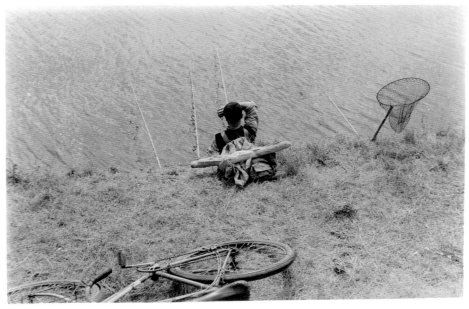

162

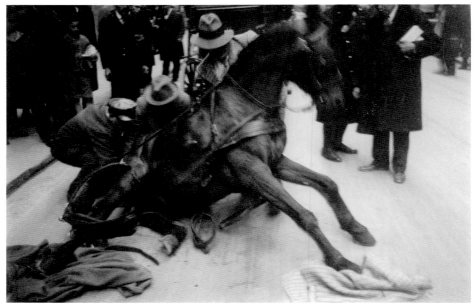

163

164

1937 He marries Ratna Mohini, a Javanese dancer and poet (fig. 6, p. 11). He wants to be independent from his family and earn his own living. He moves to the Rue des Petits Champs and starts working for the Communist Party daily *Ce soir* and its weekly magazine, *Regards*, through poet Louis Aragon, who was then the editor. He covers the coronation of George VI in London with writer Paul Nizan: this is his first reportage and it already bears the HCB 'signature': there is not a single portrait of the king. Preoccupied by the catastrophic situation in Spain, he shoots a first film on the Civil War, *Return to Life*, for the Medical Bureau. He will always regret that he did not take any photos because he was too busy with the movie camera and directing the film. At the end of the year, the first issue of *Verve*, published by Tériade, reproduces three of his photos.

165

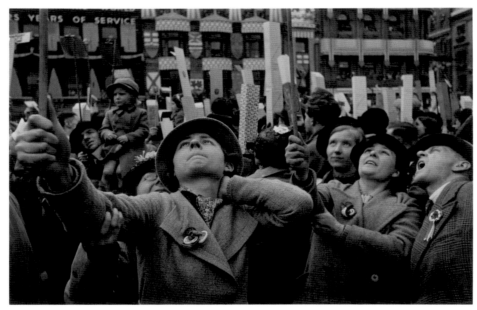

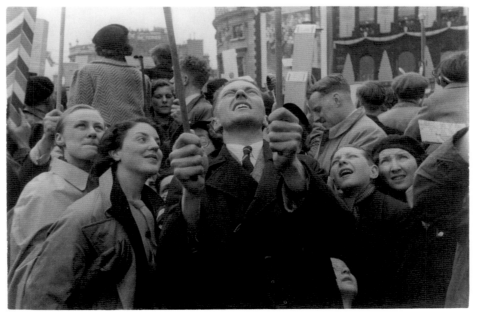

166 / 167 / 168

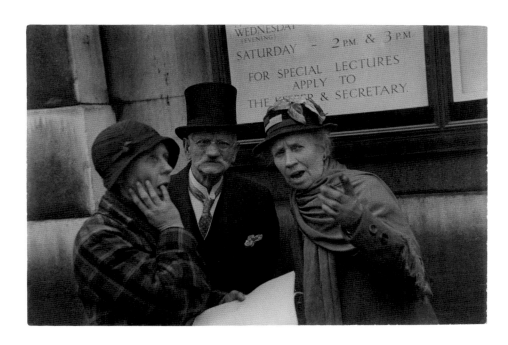

169 / 169 bis

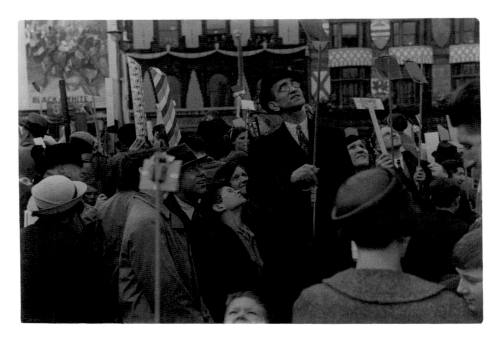

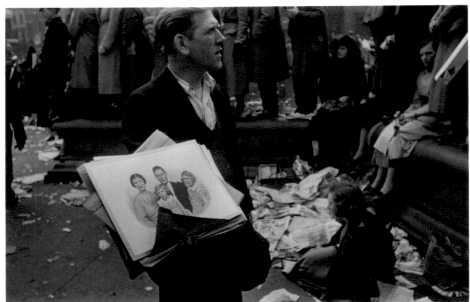

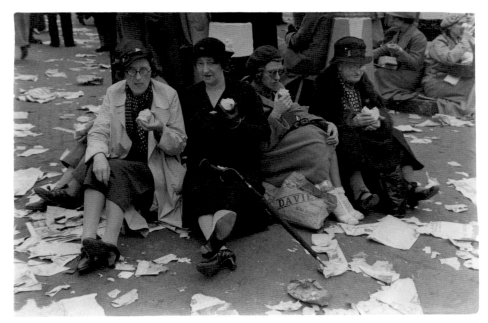

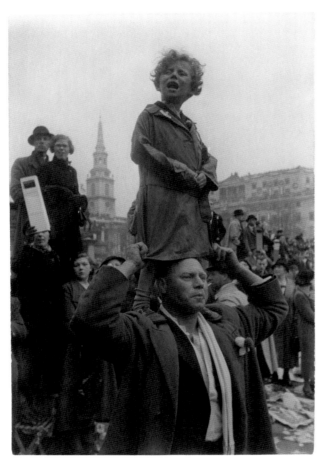

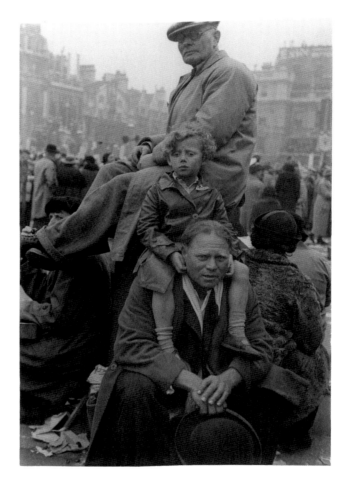

173 / 174

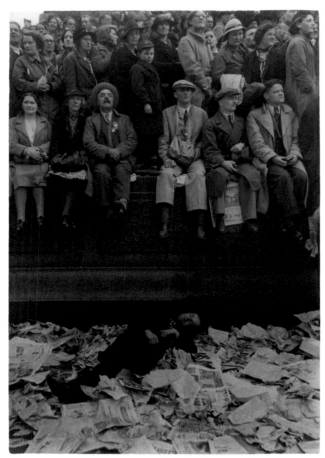

175 / 175 bis

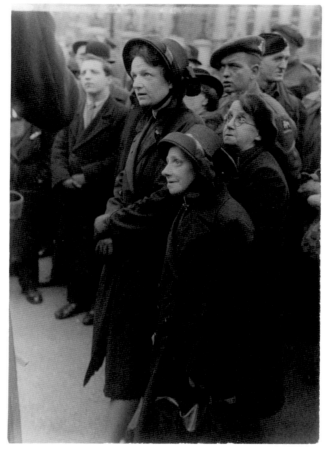

176

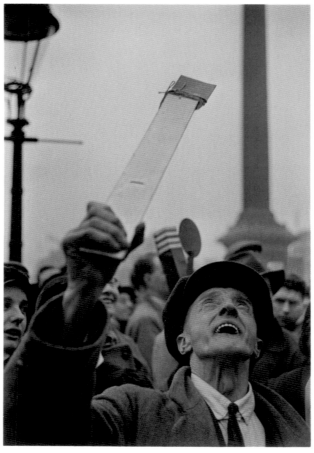
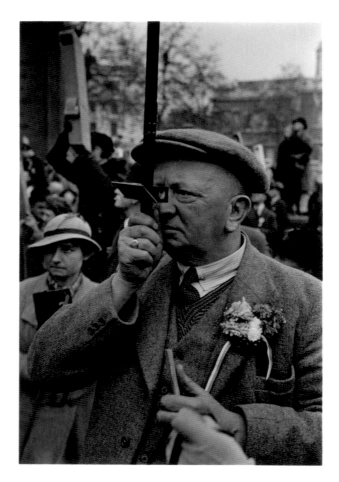

177 / 178

188

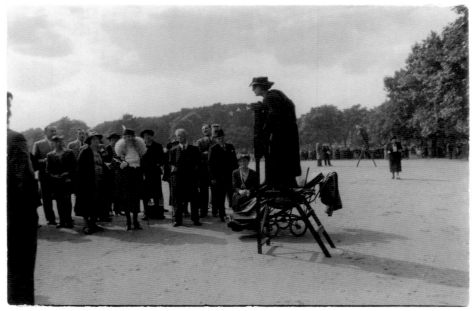

184

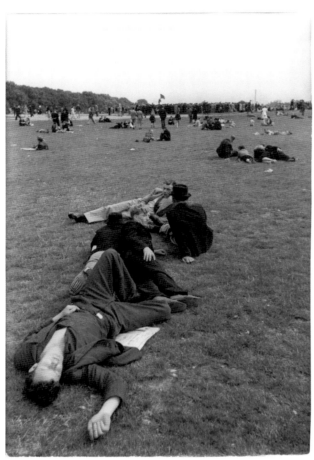

185 / 186

189

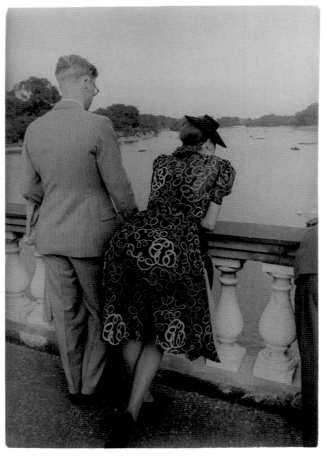

190

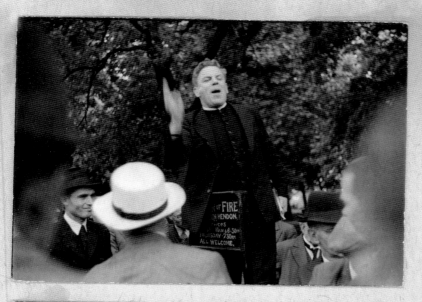

1938-1939 HCB photographs the joyous atmosphere of paid vacations and open-air cafés during the Popular Front. When King George VI visits Versailles, he is drawn to the spectacle. In 1938, he makes a second film on the Spanish Civil War, *L'Espagne vivra* (Spain Will Survive), for France's Secours Populaire (Popular Relief). He spends time with photographer David 'Chim' Seymour (fig. 10, p. 15). In early 1939 Jean Renoir contacts him again to serve as his assistant on *La Règle du jeu* (The Rules of the Game), in which he also appears as an extra. This is a monumental film, where the tensions of the approaching war are manifest.

201

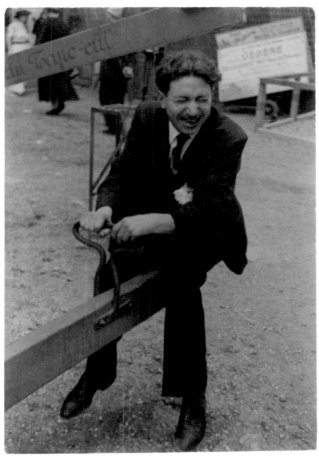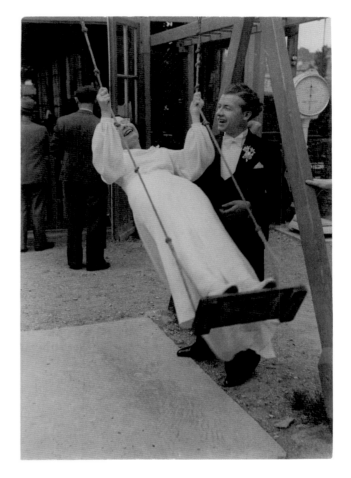

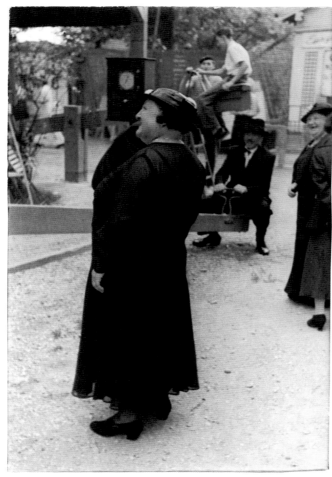

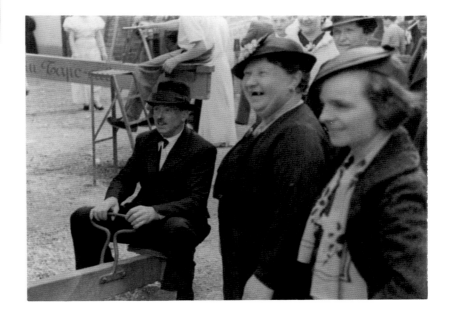

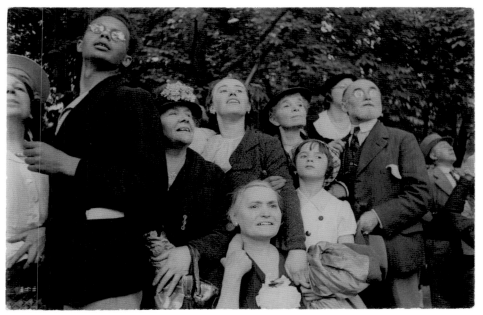

206

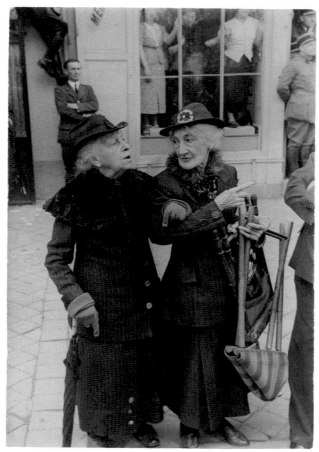

207 / 208

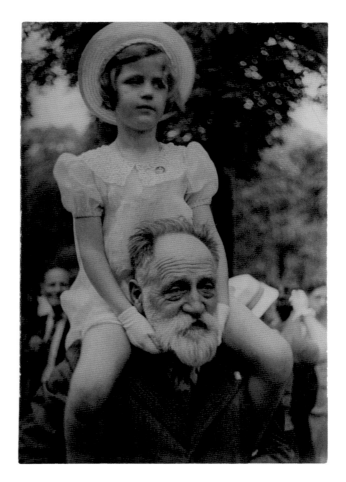

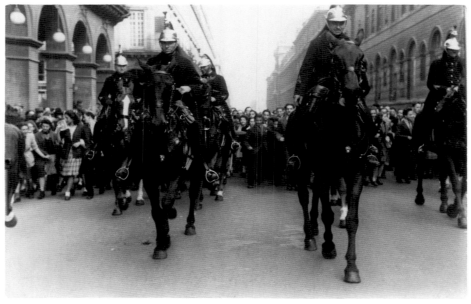

209

1939-1943 Military service had not indelibly marked the young conscript Cartier-Bresson. Called up for the 'phoney war' in 1939, he is first assigned to the infantry but quickly transferred to the French army's Film and Photography Unit in Metz. On 22 June 1940 he is taken prisoner near Saint-Dié in the Vosges Mountains and winds up in a German work camp, Stalag VA (fig. 1, p. 10). After 33 months of captivity and two failed attempts, he manages to escape on 10 February 1943. He gets hold of false papers in the Lyons area, retrieves his Leica, which he had buried on a farm in the Vosges before the war, and while he is in the area, has a meeting which proves crucial for the future: Pierre Braun, publisher and gallery owner, proposes that he photograph writers and artists for a series of monographs. At the same time, he carries out underground Resistance activities through his ties with the MNPGD and FFI (fig. 2, p. 10).

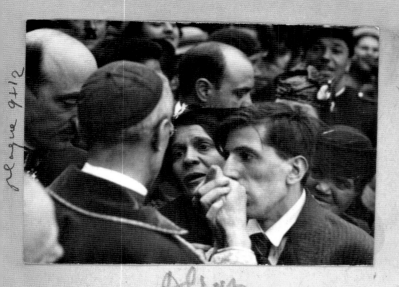

Alben

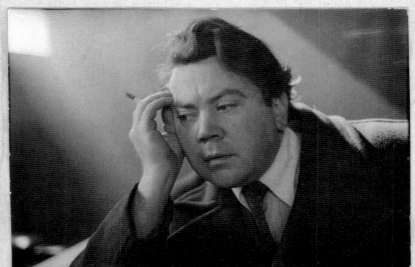

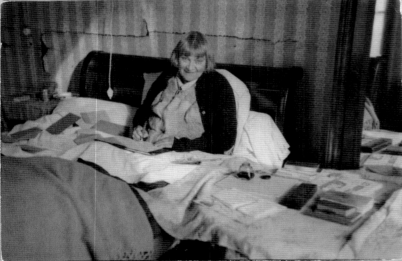

Tono Salazar

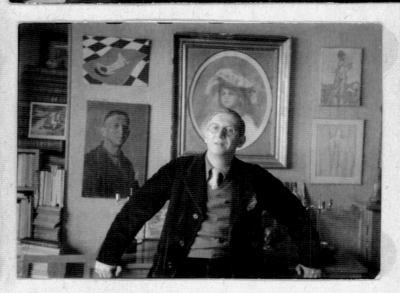

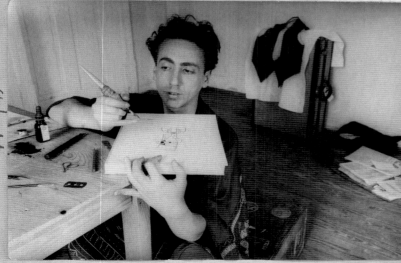

19A14

14A25

14A30

17B22

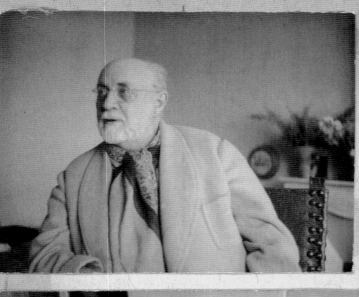

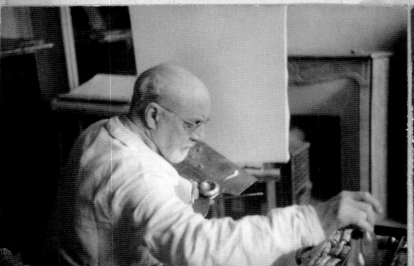 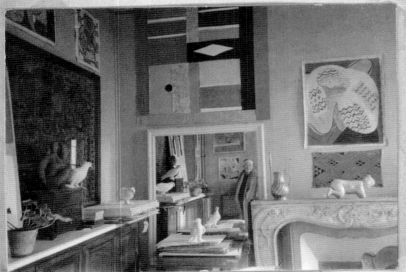

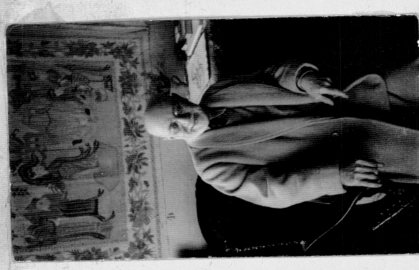

 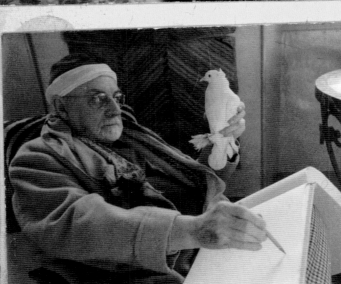

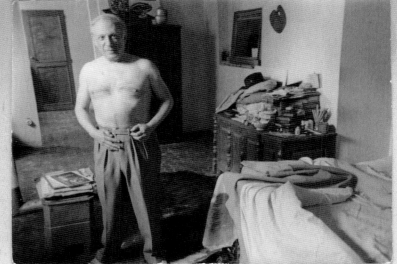

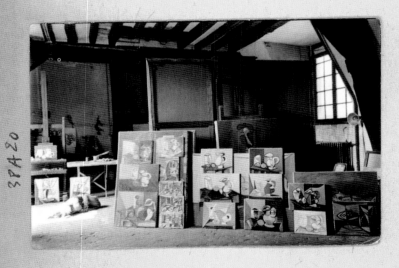

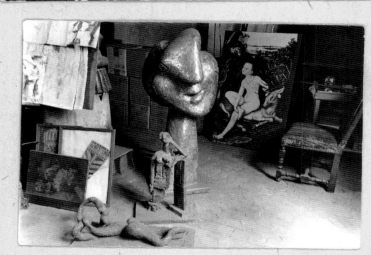

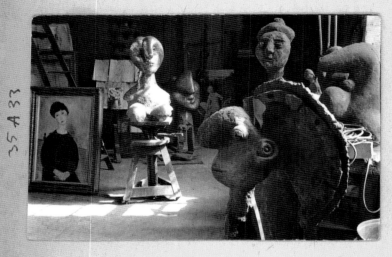

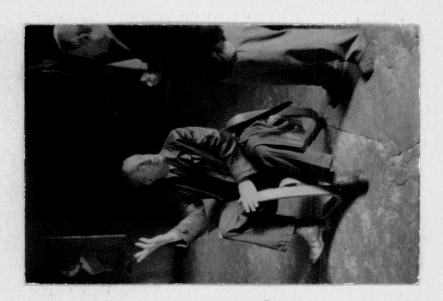

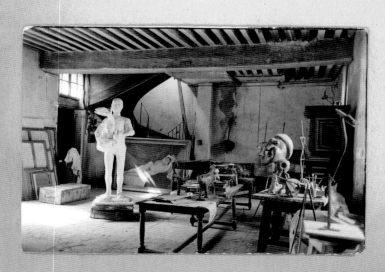

1B30

4C2

4B3

3B28

265

1943-1944 After his mother's death in 1968, Cartier-Bresson was to find a biscuit tin in the family apartment containing all the negatives of his photographs of the Liberation of Paris (as well as others which he had not discarded). He had forgotten these images and it was only then that he sorted through them, making a selection which is now well documented. We know that in 1944 he bicycled back to Paris from his hideout in Indre-et-Loire and that he worked with other photographers such as Robert Doisneau to cover the Liberation. But there is no way of knowing why the *Scrapbook* contains the images which follow, including the interrogation of actor and director Sacha Guitry at a local municipal building in Paris or the ruins of the town of Oradour-sur-Glane after the massacre of its inhabitants. They had probably been kept apart, on another roll of film.

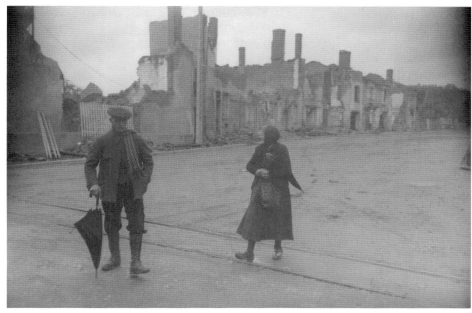

266

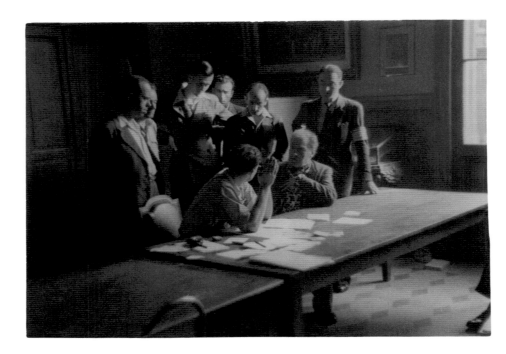

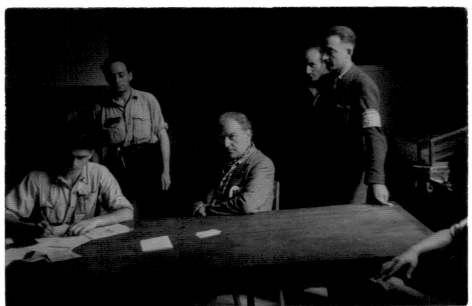

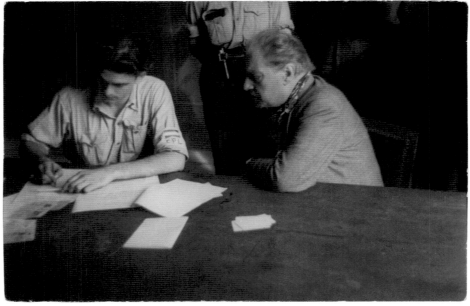

267 / 268 / 269

270

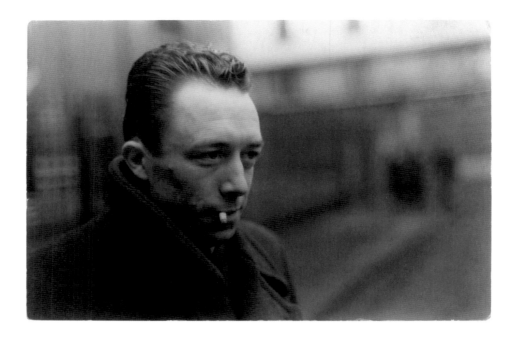

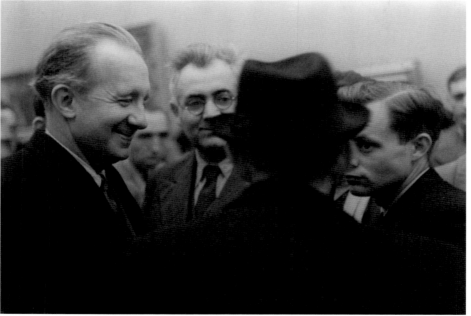

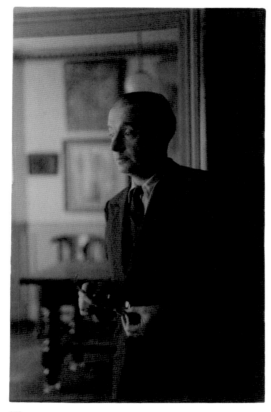

273

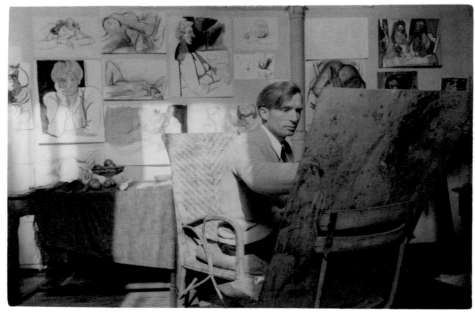

274

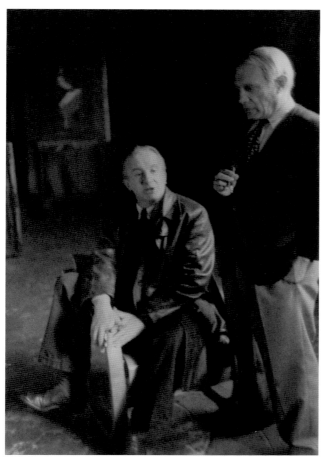

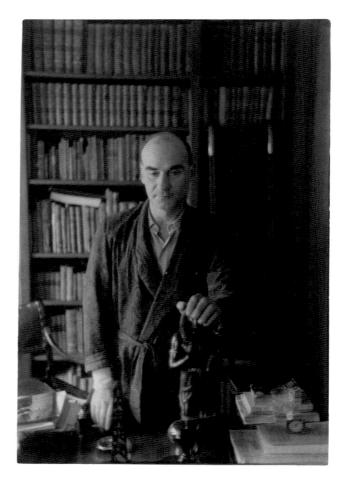

1945 On 12 September 1944, Cartier-Bresson succeeds in obtaining an authorisation from the French Cinema Board to
make a documentary on the return of the prisoners and deportees (fig. 3, p. 10). This film, produced by Noma Ratner for the
US Office of War Information (OWI), is co-directed by Henri Cartier-Bresson and Lieutenant Richard Banks, with a com-
mentary by writer and journalist Claude Roy. A great deal of time and effort goes into organising the production because
of the shortage of equipment and the filming can only get underway in spring 1945, which means that certain material
will have to come from existing newsreel footage. Work on the film continues from April to November 1945. It is shot in
35 mm by US Army cameramen, which explains why Cartier-Bresson has his hands free to photograph with his Leica.
The finished film will be screened at the Museum of Modern Art on the opening night of his exhibition, 4 February 1947.

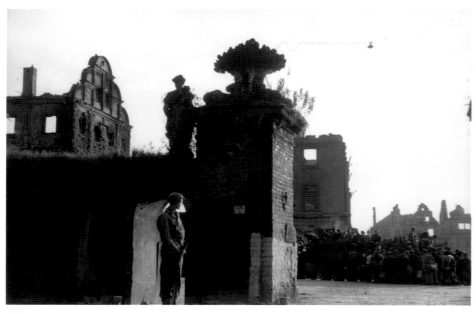

277

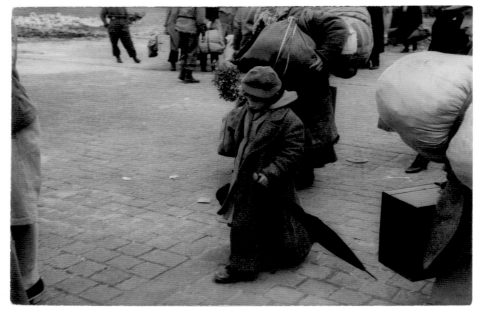

278

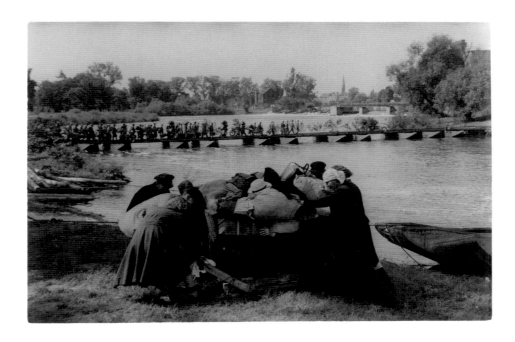

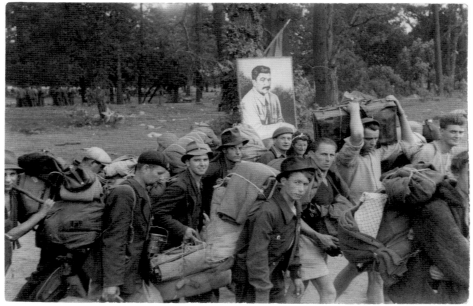

281 / 282

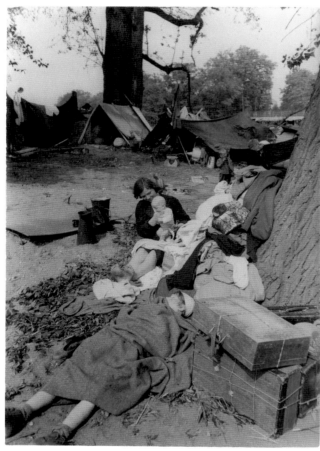

283 / 284

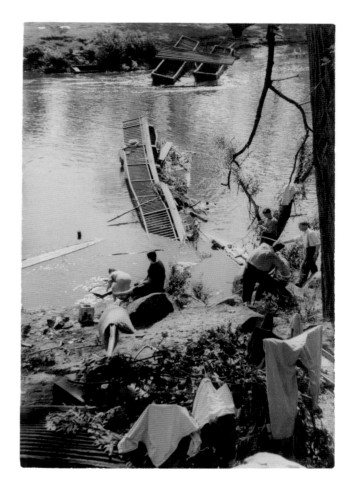

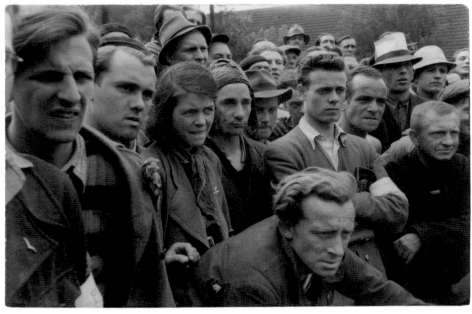

285

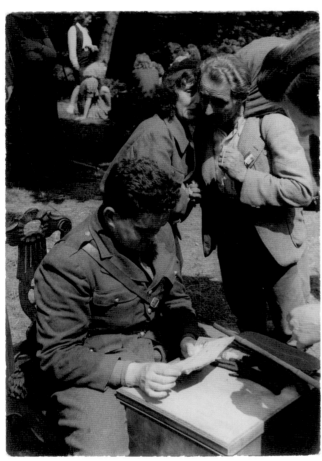

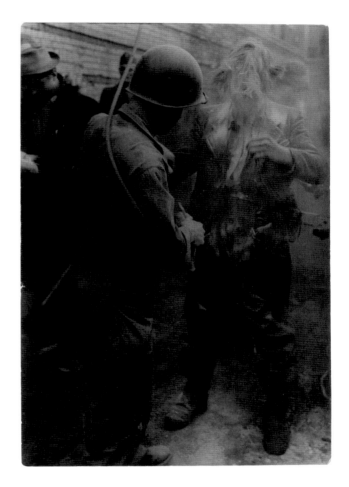

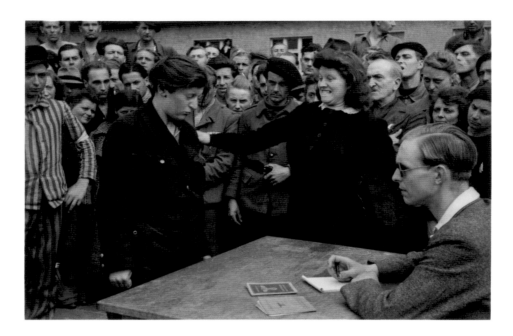

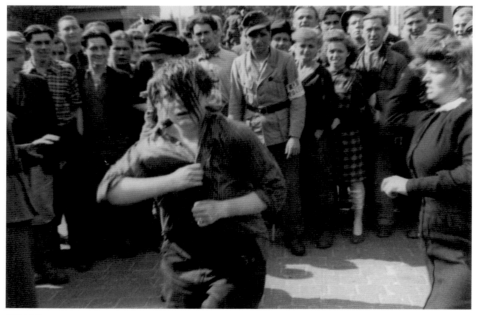

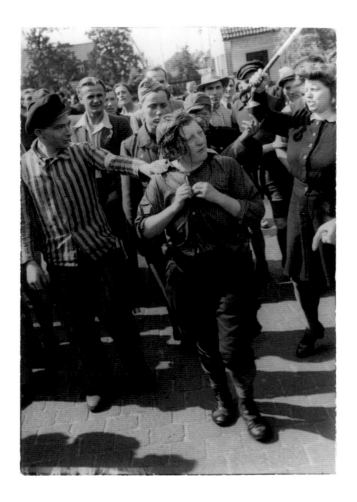

290 a / 290

1944-1945 During the war, Cartier-Bresson's wife takes refuge in Chouzy, near Chambord, in a family of Loir-et-Cher wine growers, where he visits her on several occasions (fig. 6, p. 11). He is himself in hiding not far away, on a farm at Luzillé, in Indre-et-Loire. When he returns to Luzillé at the end of the war, he learns that the family he stayed with has been exposed and deported to Buchenwald; only the farmer's wife, Madame Nolle, has survived. Later on, Cartier-Bresson and his wife purchase a house in the region, at Saint-Dyé-sur-Loire.

291 / 292 / 293

231

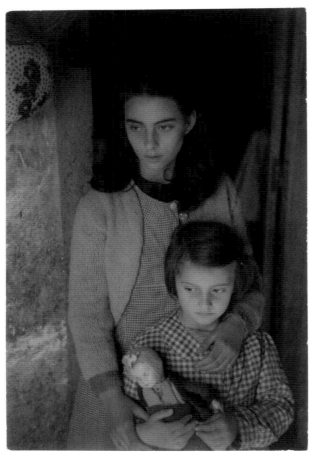
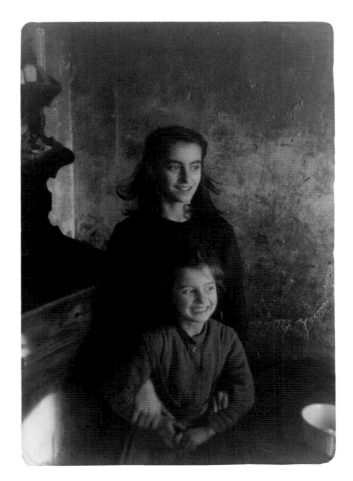

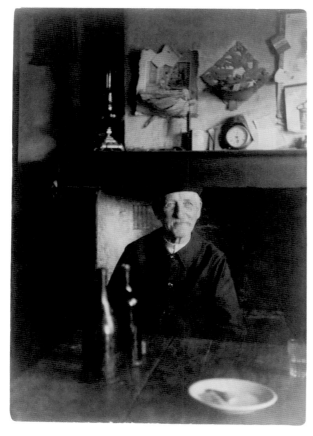

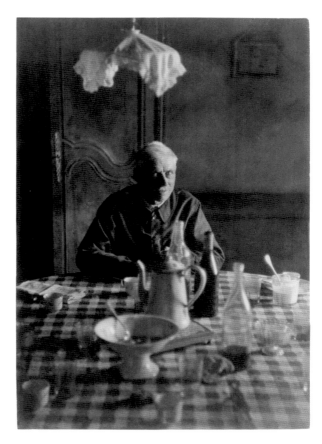

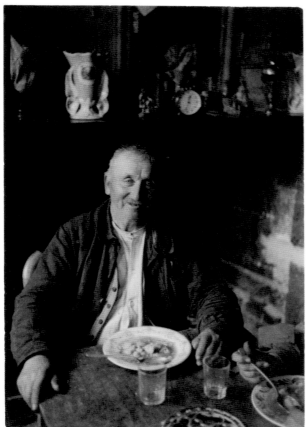

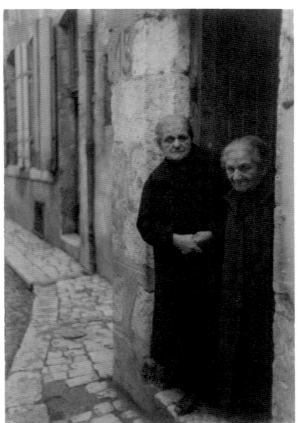

296 / 297 / 298 / 299

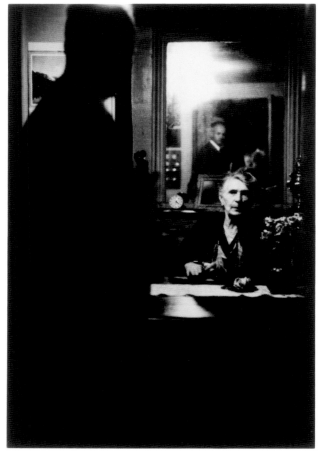

300

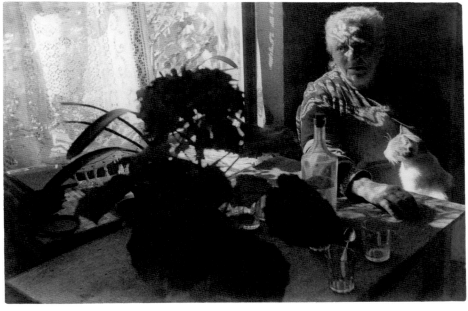

301

1945-1946 As the days go by, HCB continues to photograph faces, for the Braun project (which will never materialise) but also for some magazines. Always in search of what he calls the 'inner silence of a consenting victim', he concentrates his efforts on capturing the unposed moment which will reveal the individual to him. Images of his family bring the *Scrapbook* to a close.

D 127.25

A 49.42

A 49.37

Else Trüeb

D 118.22

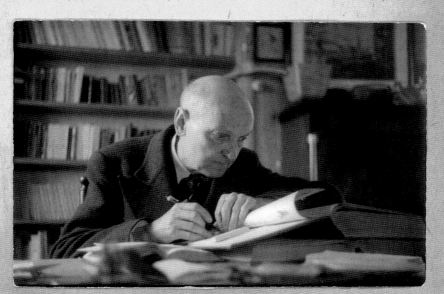

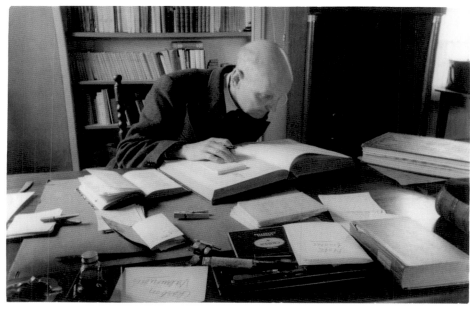

326

327 / 327 bis

241

328

331

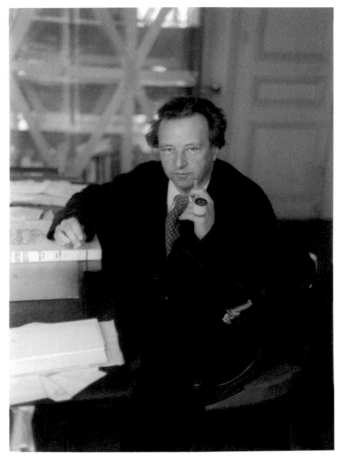

332

333

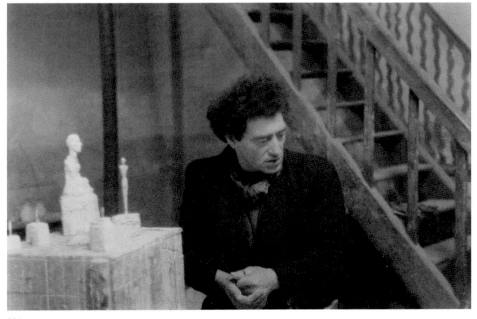

334

335

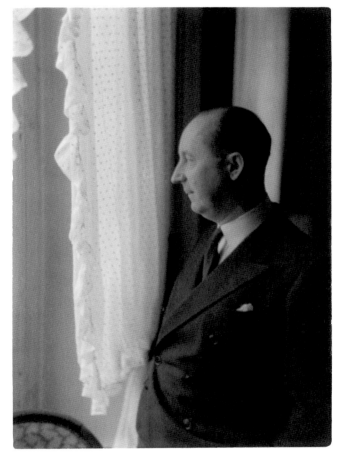

336

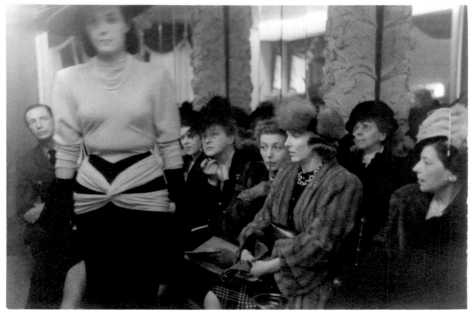

337

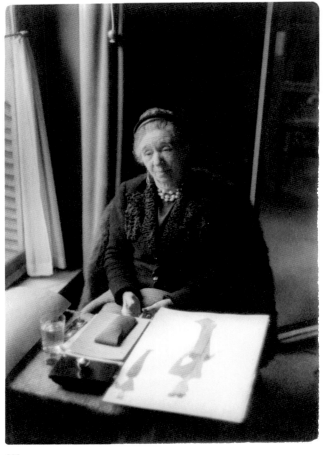

338

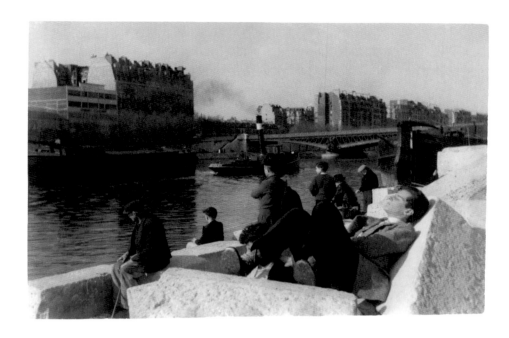

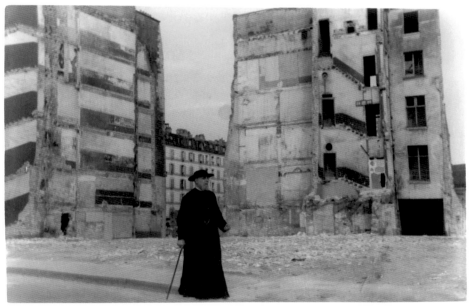

339 / 340

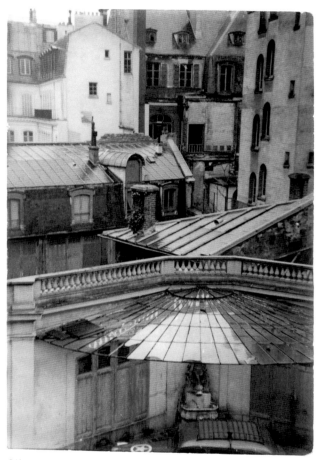

341

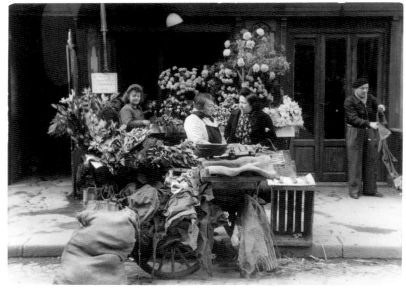

342

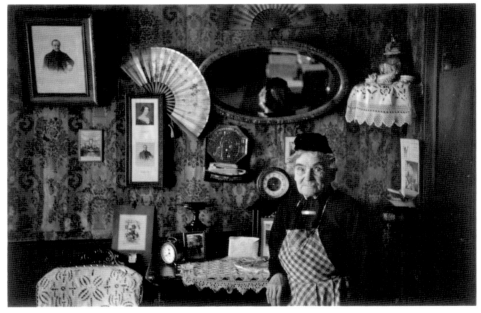

343

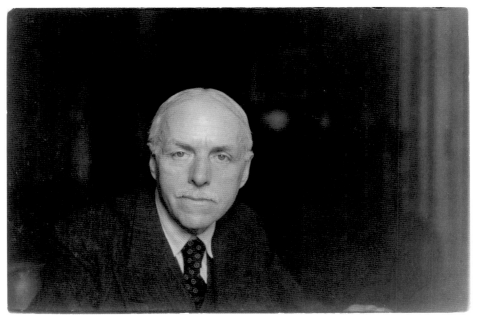

344

345 / 346

The photographs are reproduced at their original size; the original complete pages are reduced by 15%. All the prints belong to the Fondation HCB, except two, kindly lent by the Howard Greenberg Gallery (New York).

The notes on the back of the prints were handwritten by Cartier-Bresson in 2002. All the prints are vintages made by Cartier-Bresson, most of them on Agfa Brovira paper, except for 15 modern prints made by La Chambre Noire for the Fondation HCB on Forte Bergger paper.

The complete pages are numbered from top to bottom, from left to right. The images marked with a bullet (●) were shown at the MoMA exhibition.

1●/ Allée du Prado, Marseilles, France, 1932 / HCB1932004 W00004C//2

2 to 6 / Marseilles, France, 1932
2●/ HCB1932001 W0075C//1
3 / HCB1932001 W0075E//1
4●/ HCB1932001 W0017CC//1
5 / HCB1932001 W0017D//1
6 / HCB1932001 W0065AC//1

7●/ The Old Port, Marseilles, France, 1932 / HCB1932004 W00003C//1

8 / Marseilles, France, 1932 / HCB1932001 W0068C//1

9●/ Martigues, France, 1932 / HCB1932001 W0067DC//4

10●/ Hyères, France, 1932 / Modern print HCB1932001 W0066BC//6

11 / Paris, 1932 / HCB1932001 W0076B//1

12●/ Montmartre, Paris, 1933 / HCB1933009 W00001//1

13●/ Avenue du Maine, Montparnasse, Paris, 1932 / HCB1932001 W0070EC//2

14 / Pierre Colle, Paris, 1932 / HCB1932001 W0068BC//1

15 / La Villette slaughterhouse, Paris, 1932 / HCB1932001 W0065BC//1

16●/ Brussels, 1932 / HCB1932002 W0070CC//3

16 a / Back of image 16
Cartier-Bresson's note: 'une de mes toutes premières fotos' ('one of my very first pictures')

17 / France, 1932 / HCB1932001 W0069E//1

18 / Canal Saint-Denis, France, 1932 / HCB1932001 W0070B//2

19 / Plasterers, Quai de Javel, Paris, 1932 / Modern print / HCB1932004 W00001C//7

20●/ Behind Saint-Lazare station, Place de l'Europe, Paris, 1932 / HCB1932004 W00002C//2

21 ●/ 'La Halle aux vins', as seen from Austerlitz station, Quai Saint-Bernard, Paris, 1932 / HCB1932001 W0066AC//8

22 / Funeral of Aristide Briand, Paris, 1932 / HCB1932001 W0069B//1

23 / Funeral of the comedian Gallipeaux, La Madeleine, Paris, 1932 / HCB1932001 W0070AC//2

24 / André Pieyre de Mandiargues and Leonor Fini, Trieste, Italy, 1933 / HCB1933002 W0029CC//2

25 / Henri Cartier-Bresson, Tuscany, Italy, 1933 / HCB1933002 W0037B//1

25 a / Back of image 25
Cartier-Bresson's note: 'my foot resting near Sienne' [Siena]

26 / Italy, 1933 / HCB1933002 W0029A//1

27 / Livorno, Tuscany, Italy, 1933 / HCB1933002 W0029B//1

28 / Italy, 1933 / HCB1933002 W0032A//1

29 / Matera or Basilicate, Italy, 1933 / HCB1933002 W00008//1

30 / Italy, 1933 / HCB1933001 W0027A//1

31 / André Pieyre de Mandiargues and Leonor Fini, Italy, 1933 / HCB1933002 W0030CC//1

32 to 34 / Italy, 1933
32 / HCB1933002 W0032B//1
33 / HCB1933002 W0035A//1
34 / HCB1933002 W0035C//1

35●/ Salerno, Italy, 1933 / HCB1933006 W00003C//2

36 / Italy, 1933 / HCB1933002 W0038D//1

37●/ Piazza della Signoria, Florence, Italy, 1933 / HCB1933006 W00005//1

38 / Naples, Italy, 1933 / HCB1933006 W00010//1

39 / Naples, Italy, 1933 / HCB1933006 W00009//1

40●/ Tivoli, near Rome, Italy, 1933 / HCB1933006 W00001C//2

41 / Italy, 1933 / HCB1933002 W0033C//1

42 to 45 / Livorno, Tuscany, Italy, 1933
42●/ HCB1933002 W0030A//1
43 / HCB1933002 W0034D//1
44 / HCB1933002 W0038A//1
45●/ HCB1933002 W0034C//1

46 to 49 / Italy, 1933
46●/ HCB1933002 W0051A//2
47●/ HCB1933002 W0039B//1

48 / HCB1933002 W0031C//1
49●/ HCB1933002 W0039C//1

50●/ Siena, Tuscany, Italy, 1933 / HCB1933006 W00002C//3

51 ●/ Trieste, Italy, 1933 / HCB1933002 W0038CC//2

52●/ Madrid, 1933 / Courtesy Howard Greenberg Gallery, New York / HCB1933005 W00005C

53 to 57 / Spain, 1933
53 / HCB1933001 W0004D//1
54 / HCB1933001 W0008B//1
55●/ HCB1933001 W0013D//2
56 / HCB1933001 W0009D//1
57 / HCB1933005 W00010//1

58 / Seville, Andalusia, Spain, 1933 / HCB1933001 W0017A//1

59●/ Seville, Andalusia, Spain, 1933 / HCB1933005 W00006C//1

60●/ Seville, Andalusia, Spain, 1933 / Courtesy Howard Greenberg Gallery, New York / HCB1933001 W0018CC

61 / Beggar, Madrid, 1933 / HCB1933001 W0012D//2

62 / Spain, 1933 / HCB1933001 W0086B//2

63 / Spain, 1933 / HCB1933001 W0014B//1

64●/ Madrid, 1933 / Modern print / HCB1933001 W0007AC//3

65 to 69 / Valencia, Spain, 1933
65●/ HCB1933001 W0011AC//1

276 / Boris Kochno, Paris, 1938 /
HCB1938003 W00043/15//1

277 ●/ Germany, 1945 / Modern print /
HCB1945004 W0086C//5

278 ●/ Return of a Russian child
deported with his parents, Halle,
near Dessau, Germany, April 1945 /
HCB1945004 W0087FC//2

279 / French deportees leaving the
Soviet zone, near Dessau, Germany,
April 1945 / HCB1945003 W00115/04//1

280 ●/ French deportees leaving the
Soviet zone, near Dessau, Germany,
April 1945 / HCB1945003W00104/25//1

281 ●/ Belgian family waiting for the
train, Leipzig, Germany, April 1945 /
HCB1945004 W0086E//1

282 / Belgian family waiting for the
train, Leipzig, Germany, April 1945 /
HCB1945003W00112/18A//1

283 / Refugees in the American zone
waiting to be transported to the Soviet
zone, near Dessau, Germany,
April 1945 / HCB1945005 W00004//1

284 / Refugees in the American zone
waiting to be transported to the Soviet
zone, near Dessau, Germany,
April 1945 / HCB1945005W00003//1

285 ●/ Interrogation, Dessau, Germany,
April 1945 / Modern print / HCB1945004 W0087A//1
286 / Dessau, Germany, April 1945 /
HCB1945003 W00114/18//1

287 / American authorities disinfecting
refugees with DDT, Dessau, Germany,
April 1945 / HCB1945003 W00109/18//2

288 to 290 / Liberation of the deportation
camp, interrogation, a woman recognizes
the Gestapo informant who denounced
her, Dessau, Germany, April 1945
288 ●/ HCB1945003 W00115/25C
289 / HCB1945003W00115/15R//2
290 / HCB1945003W00115/18//1
290 a / Back of image 290
Cartier-Bresson's note: 'une collabo elle
criait "ne me tuez pas, je donnerai leurs
noms…"' ('a collaborator she was yelling
"don't kill me, I'll give their names…"')

291 / 'Mr and Mrs Blondiau',
Chouzy-sur-Cissé, France, 1945 /
HCB1945002 W00211/27//1

292 / 'Mélie and her husband',
Chouzy-sur-Cissé, France, 1944 /
HCB1944001 W0302B//1

293 / 'Mélie', Chouzy-sur-Cissé, France,
1944 / HCB1944001 W0300E//1

294 / Chouzy-sur-Cissé, 1944 /
HCB1944003 W00204//22//1

295 ●/ Chouzy-sur-Cissé, France, 1945 /
HCB1945001 W0087B//1

296 ●/ 'The Baron', Chouzy-sur-Cissé,
France, 1945 / HCB1945001 W0088C//1

297 ●/ 'Mr Datte in Chouzy',
Chouzy-sur-Cissé, France, 1945 /
HCB19XXXXXW0000X/X02//1

298 ●/ Winegrower, Chouzy-sur-Cissé,
France, 1945 / HCB1945001 WSAU5//1

299 / Chouzy-sur-Cissé, 1944 /
HCB1944003 W00203/11A//1

300 ●/ 'Madame ma concierge', Paris,
c. 1945 / Modern print /
HCB1945XXXWXXXXX/X01//2

301 ●/ 'Mélie', Chouzy-sur-Cissé, France,
1944 / HCB1944001 W0083C//1

Agnès Sire's text:
Illustrations n°7, 8, 11 to 13, 15, 16, 19, 24 and 25
belong to the collection of the Museum of Modern Art, New York;
illustrations n°1 to 3, 6, 9, 10, 14, 18, 22, 21, 26 belong to the collection
of the Fondation Henri Cartier-Bresson

Michel Frizot's essay:
Illustrations 1 and 2, 11 to 20, 26 and 32 to 42
belong to the collection of the Fondation Henri Cartier-Bresson

Translated from the French by Miriam Rosen

First published in the United Kingdom in 2006 by
Thames & Hudson Ltd, 181A High Holborn, London WC1V 7QX

www.thamesandhudson.com

First published in 2007 in hardcover in the United States of America by
Thames & Hudson Inc., 500 Fifth Avenue, New York, New York 10110

thamesandhudsonusa.com

Reprinted 2007, 2008

Photographs © 2006 Henri Cartier-Bresson / Fondation HCB
Texts © 2006 Martine Franck, Agnès Sire, Michel Frizot
Original edition © 2006 Steidl, Göttingen
This edition © 2006 Thames & Hudson Ltd, London

British Library Cataloguing-in-Publication Data
A catalogue record for this book is available from the British Library

Library of Congress Catalog Card Number 2006906994

ISBN: 978-0-500-54333-7

Printed and bound in Germany